The Robert Lehman Collection

Foreword by
Joseph A. Thomas
President,
Robert Lehman Foundation, Inc.

Preface by
Thomas Hoving
Director,
The Metropolitan Museum of Art

The Robert Lehman Collection

A Guide by George Szabó
Curator of the Collection

The Metropolitan Museum of Art

First Edition
Published 1975 by The Metropolitan Museum of Art.
All rights reserved. No part of this book may be
reproduced without the written permission of the
publisher, The Metropolitan Museum of Art.

Editor: Anne M. Preuss

Photography: Malcolm Varon, with the exception of plates
69, 150, 151, 154, 155, 156, 157, 158 by William F. Pons.

The quote on page 87 is reprinted by permission of
George Braziller, Inc., translation by Marianne Sinclair.

Designed and produced by Chanticleer Press, Inc., New York.
Art director: Roberta Savage
Production: Gudrun Buettner, Helga Lose
Printed and bound by Amilcare Pizzi, S.p.A., Milan, Italy.

Library of Congress Cataloging in Publication Data

New York (City). Metropolitan Museum of Art.
 The Robert Lehman Collection.

 1. Lehman, Robert, 1892–1969—Art collections.
 2. New York (City). Metropolitan Museum of Art.
 I. Szabó, George. II. Title.

 N611.L43N48 1975 708′.147′1 74–34207

 ISBN 0–87099–127–2

How to Use the Guide

The guide to the Lehman Collection has been prepared
to enhance your enjoyment of these works of art. You
can use the guide while visiting the collection or you can
read it at your leisure.
The objects illustrated and described here are numbered
from 1 to 198. The number appearing in the text in
parentheses after the title is the same as the number in
the illustration section.
In addition, each caption in the illustration section gives
the room where the object is exhibited and the page
number where it is discussed in the text.

Contents

In 1957 Robert Lehman was en route to Paris for the opening of the great exhibition at the Orangerie, at the Louvre, of many of the paintings, drawings, and other objets d'art from the Lehman Collection. Reproduced below is a significant statement of his philosophy, written by him at the time:

French Line

"LIBERTÉ"

I think that important works of art, privately owned, should be beyond one's own private enjoyment and the public at large should be afforded some means of seeing them.

Foreword

What you are about to see is the culmination and product of the response of a civilized and imaginative man to the impulse, the creativity, and, in some cases, the desperation of the artist to make the world, its beauty and meaning, come true. Above all else Robert Lehman cared for quality and beauty, however expressed. His continuous search for it together with his humanity produced this Collection and made him unique.

It is sad that the tragically early death of Theodore Rousseau, Jr., Vice-Director and Curator in Chief of the Metropolitan, left uncompleted his work on the Introduction to this Guide. Ted Rousseau had known Robert Lehman for many years and shared his sensitivity and enthusiasm for artistic quality. Like us, he recognized that Robert Lehman was a remarkable man as well as a dear friend and I cherish, as Ted did, the opportunity to write a few words about him.

I cannot give you the overall appraisal of the significance of the Collection which undoubtedly would have been the principal subject of Ted's introduction. However, I wish to present to you, in a personal way, my friend Robert Lehman, who devoted his talents and wisdom to creating this mirror of his appreciation of quality and beauty. I hope that my comments will give you some perspective in the perusal of the Guide to the Collection prepared by George Szabó, Bobbie's long-time Curator.

I first met Robert Lehman, the *collector,* in 1930. Mr. Lehman had asked to see me, a neophyte in the Lehman banking house. He welcomed me by the glow on his face as he was unpacking a lovely Tiepolo drawing which had just arrived from London. He was so preoccupied that he had forgotten whatever banking business required my presence. He began to talk about the pleasure of opening one's eyes to see and enjoy the magic of nature and the human form through the interpretation of the artist. He spoke with such intense feeling that one might have thought he was so engrossed in the arts that his other interests and obligations were neglected.

To the contrary, he had one of the truly imaginative minds of the financial community. His conception of investment banking was unorthodox and far-seeing. He supported the embryo airline industry and helped the oil industry, then, strange to say, struggling in the thirties with problems of excess supply at home and abroad. He believed that opportunities in business as well as collecting could be discovered everywhere. Best, he had a profound confidence in the future of our country. He was devoted to his employees and working partners and backed them with complete loyalty. To him, it was always "the team." He was modest, and shy in the extreme, but he was dedicated, above all, to the well-being and happiness of those who worked with him—not for him. Under his unobtrusive direction, Lehman Brothers was a top-level operation of dignity and charm. So outgoing and human he was that his cheerful, yet self-effacing "hello and good morning" was totally sincere to all of us. We were his working family.

Sometimes he would call, "Come down for an ice cream soda and let's go uptown to see the new Picasso or Renoir or whatever has turned up." So to Sam Salz or Perls or many others to see what had arrived. Bobbie Lehman's eye for new, promising painters was unerring. In Jamaica, a Polish friend, Michael Lester, was taking it out on the Caribbean by interpreting Chopin on an untuned piano in a bizarre hilltop house, but meanwhile capturing subtly the feeling and charm of the Island and its people in his pictures. His ability was recognized and his talent appreciated when Robert Lehman praised and acquired some of Lester's best pictures.

When, after months of agonizing, Bobbie called and said "I bought it! The Ingres! and

now I am happy—let's go see it," he, Ed Weisl, and I went to 625 Park Avenue, Bobbie's apartment. It was a marvelous experience to see in his expression and manner no trace of the greedy acquisitor, but of some pilgrim just admitted to Ingres's particular Mecca.

To Robert Lehman, a wonderful Saturday consisted in doing something really nice for his friends and, through their enjoyment, for himself. With Ted Rousseau, or Charlie Zadok, and sometimes with Al Pearson or Michael Thomas or me, we would visit the galleries on Madison Avenue and 57th Street and elsewhere to see a new painting or an exhibition of old ones. Bobbie always focused his feeling and sympathy on the artist, for his childhood had nurtured his own desire to paint. Bobbie loved collecting, but he never sought things he did not love. His discernment of quality was remarkable.

This man, Robert Lehman, not only welcomed these glorious pictures, drawings, frames, maiolica, furniture, porcelain to join him in life, he was as generous in his life to human beings. He was not a deacon or a priest, he was a virile man and he loved the company of charming and beautiful women just as he loved the friendship of bright, witty, and amusing men. He never asked for, and really resented, slavish agreement. His generosity (usually denied by him) was legendary.

A historical comment seems indicated. Philip Lehman, Bobbie's father, one of the handsomest and one of the kindest and most understanding of men, began the Collection with a group of early Italian pictures. When Bobbie began to feel the stirrings of his own artistic urge, he combed Europe and actually bought for his father's collection some of the best of the Sienese and Florentine group, and in 1928 he prepared the handsome catalogue of the paintings that can be seen immediately next to the entrance of the Wing.

Now why is this collection here? Had security and proper access been possible, perhaps it would have still been at 54th Street. Much as he loved the house where he first collected, Bobbie realized that 54th Street was too small to make the Collection accessible to all with whom he wanted to share it. Many others had offered it a warm home, and some have suggested it be broken up and dispersed to many destinations. The latter would have seemed to Robert Lehman like the destruction of a family to which he never would have agreed. But it is here in the Metropolitan—this glowing montage of the taste and love and discernment of a remarkable American. Fortunately, Bobbie lived long enough to work out the basic plans for the Wing. So he is responsible not only for this marvelous collection, but also for the concept of its new home, which takes us back to the 54th Street house. The courtship between the Metropolitan Museum and him was like one of two strong wills who discovered they both wanted the same thing, and, when an understanding finally occurred, the happiest union resulted. The patience and goodwill and hours spent by Douglas Dillon, Arthur Houghton, Roswell Gilpatric, Tom Hoving, Ashton Hawkins, and Arthur Rosenblatt for the Museum and the efforts of Ed Weisl, Charles Zadok, Al Pearson, and George Szabó, among others, for the Foundation, produced a splendid arrangement for the blessing of the Muse.

So here we are—the 54th Street house truly recreated and surrounded by sufficient space to accommodate a collection that had outgrown a private home. An invaluable gift not for the glorification of a rich man but dedicated to the human spirit and the happiness of his fellow men by a sensitive, artistic soul.

Joseph A. Thomas
President, Robert Lehman Foundation, Inc.

Preface

From the moment when Robert Lehman informed me that he had decided to leave to the Metropolitan Museum the magnificent collection he and his father Philip had acquired over a period of seventy years, until he approved of the general design for the Lehman Wing, he followed the project day to day with the deepest of enthusiasm.

In December of 1966, not long after having been designated Director, I met Robert Lehman at his offices and presented a series of arguments why he should bequeath the collection to the Museum. He told me frankly he was sceptical but would give the proposition serious thought. Aside from a few brief discussions the matter was hardly mentioned for almost a year. With a man like Robert Lehman you presented your case but once, and as effectively as possible. His acute, businesslike mind needed no prompting, no prodding.

After almost a year his answer came in a typically cryptic and almost offhand manner. Symbolic of his high sense of connoisseurship and symbolic, too, of the entire endeavor, the messenger of the stunning news was itself a splendid work of art.

During that year Mr. Lehman and I had searched the world market for works of art of the highest quality for acquisition by the Museum; this, of course, was one of Mr. Lehman's continuing great interests. After months, we had finally focused upon two portrait panels of luminescent beauty, each no larger than a playing card, painted at the end of the 15th century by the Venetian master Jacometto Veneziano. These, we believed, were among the finest objects of their kind on the market anywhere. But the price, we believed, was too high and the acquisition faltered. Finally, after a more satisfactory price had been negotiated, I called Robert Lehman to say that I intended to bring them before the Acquisitions Committee of the Board of Trustees for purchase and desired his support as a key member of that Committee.

He told me that I was too late, the panels had been sold. As I was expressing my disappointment, he interrupted, laughing. He explained that the day before he had arranged, subject to my approval, for his Foundation to purchase the panels. He also informed me that the panels would come to the Museum; but only on one condition. The condition was that they would have to form a part of the Robert Lehman Collection—which he had now decided would come to the Metropolitan after his death. One can imagine the joy with which the loss of this acquisition was now greeted!

Robert Lehman had carefully considered and rejected the possibility of establishing a separate museum for the collection in another part of New York City or in another city of the United States. I believe he rejected the idea primarily because the Lehman Collection was a highly personal manifestation and therefore inappropriate as an isolated museum. Furthermore, many parts of the collection which he had acquired complemented the Metropolitan's own holdings.

From the outset he felt strongly that because the Lehman Collection had such a uniquely rich and highly individual character it would be more beneficial to the public to exhibit it separately in a background which resembled the way it had been shown over the years. In this I fully concurred. The developing comprehensive plan for the Metropolitan called for the establishment of a series of small museums within the overall complex. Each of these would be devoted to a civilization or singular department—Islamic, Egyptian including the massive Temple of Dendur, Primitive Art, Western European Arts, and the American Bicentennial Wing. For the Lehman Collection we both envisioned a comparably small, brilliant private museum within the vast encyclopedia of the Museum collections—a sort of

oasis where the visiting public might quench their thirst for beauty in a tranquil atmosphere.

The Lehman Wing, we decided, must be linked physically, organically, and harmoniously with the monumental architecture of the Metropolitan, while at the same time retaining an intimate, private character of its own. In lengthy discussions with the architects, Kevin Roche, John Dinkeloo and Associates, it was recommended by them and approved by Robert Lehman that the Wing be placed on an axis with the central bay of the Great Hall, flanked by the Western European Arts Wing to be built to the south, and the American Bicentennial Wing, an expansion of the 1924 American Wing, which is under construction to the north. So as to have a physical as well as spiritual link with the Fifth Avenue building, the Lehman Wing was to be given proportions almost identical with the Great Hall's central bay and was to be constructed in the same subtle buff Indiana limestone.

It was also decided that the Wing be formed with a distinct eye to human and classical proportions and be comprised of four interrelated parts: a grand gallery on the main floor for paintings linked to a series of intimate galleries which would reflect precisely a number of rooms from the Lehman family house at 7 West 54th Street. On the lower floor there would be a series of galleries, protected from natural light for the superb collection of drawings, and a spacious, pleasant courtyard, comfortably furnished, where the visiting public could retire for pure relaxation and leisure. According to Robert Lehman's specific wishes, the Wing was to be covered with a clear glass skylight so that the visitor would have an experience wholly unlike any other at the Museum. Finally, at the request of the Landmarks Preservation Commission, the original red brick and granite Victorian Gothic façade of the Metropolitan was to be rehabilitated and conserved, providing an historical continuity between the earliest beginnings of the Metropolitan and the completion of a long-dreamed-of master plan.

In conclusion, I would like to give appropriate recognition to the late Ted Rousseau, who in his role as Curator of European Paintings and then Curator-in-Chief, and as an advisor and close friend of Robert Lehman, did so much to sustain and strengthen the link between Mr. Lehman and the Museum over the years.

I also wish to acknowledge the efforts of certain other individuals who helped to ensure that the splendid Lehman Collection has forever become a part of the Metropolitan and a shining possession of the citizens of New York City. These individuals include Mrs. Robert Lehman, the donor's widow; Robert Owen Lehman, his son; the members of the Lehman Foundation, and in particular the late Edwin L. Weisl, Sr., former President of the Lehman Foundation, Joseph A. Thomas, the current President, and Paul C. Guth, its counsel. They also include, on the part of the Metropolitan, Arthur A. Houghton, Jr., under whose presidency and keen guidance the project was initiated; C. Douglas Dillon, his successor, under whose sensitive leadership the project was completed; Devereux C. Josephs and Andre Meyer, Trustees Emeriti; and Charles B. Wrightsman, J. Richardson Dilworth, Frank Rogers, and Roswell Gilpatric, Trustees; and a good friend, Louis Goldenberg.

Thomas Hoving
Director, The Metropolitan Museum of Art

Guide to the Rooms and Galleries

First Room

This first room displays a large part of the Italian paintings in the Robert Lehman Collection. The majority of these paintings are by masters of the Sienese school, but painters of Florence and Venice are represented too. This dominance of the Sienese brings up natural questions, which must be answered right here: Why did the Lehmans collect Italian art so avidly and what were the roots of Robert Lehman's preference for Sienese painting?

At the turn of the century and in its first decades, many American connoisseurs followed the example of James Jackson Jarves, whose pioneer collection of Italian primitives—mainly fourteenth- and fifteenth-century paintings—finally ended up at Yale University's Art Gallery. Mrs. Gardner in her Fenway Court *palazzo* in Boston, Dan Fellows Platt in Englewood, New Jersey, John G. Johnson in Philadelphia, and George Blumenthal in New York gathered distinguished collections of Italian paintings, among them many important Sienese works. In this respect the Lehmans followed the interest of the period, which in no small way was influenced by the work of Bernard Berenson.

Berenson, educated at Harvard and, to the very end of his life, living and working in Italy, left a definitive mark on American collecting. The results of his studies, published in a style that was easily comprehended and therefore very appealing to wealthy collectors, further deepened interest in early Italian art.

Robert Lehman was a graduate of Yale University, where he spent most of his free time among the primitives of the Jarves Collection. Berenson's writings were not unknown to him; and to his father, Philip Lehman, the advice of the already famous connoisseur-scholar was available through the firm of Duveen, the internationally known art dealer. Robert Lehman maintained a lifelong friendship with Berenson, first as an admirer and a disciple, later as a fellow connoisseur and scholar of Sienese art. The several hundred unpublished letters and other documents of the Berenson–Lehman relationship are priceless documents of the history of American collecting and scholarship.

As Robert Lehman acquired a profound knowledge of Sienese art, his keen business sense guided him successfully through the pitfalls of the international art market. He recognized opportunities when they arose, spotted and followed unrecognized paintings and masters, and purchased them at the right moment. He also enjoyed his father's complete confidence and, most important, his financial support when the need arose. The correspondence on many now famous acquisitions starts with a telegram from Siena, Florence, the Riviera, or Paris: "Discovered Madonna and Child stop by Ugolino stop urgently need money stop love stop Robert stop." And there is always a copy of the answer: "Money sent stop all well stop love Father stop."

But the roots of Robert Lehman's interest in Sienese art go even deeper. He enjoyed the mixture of brilliant colors and the muted luxury of gold backgrounds, so typical of Sienese paintings. He profoundly appreciated Sienese art, because, as he explained many times, it was initiated and supported not only by the popes, kings, and great princes of religious and secular realms, but also by the wealthy bankers and merchants, the craftsmen and townspeople of the proud town. It seems that Robert Lehman felt and understood the great pride the Sienese took in the art of the painters, sculptors, goldsmiths, embroiderers, and other artists as being close to his pride and total absorption in his collection of their creations. This understanding was also associated in him with restraint, an avoidance of loud expressions of feelings, opinions, and tastes, very much akin to what we can observe in the paintings of these masters, a restraint that is one of the ever-present and indelible marks of Sienese art.

There is no better indication of the high esteem in which the arts were held in Siena than the story of Duccio's *Maestà*. Duccio di Buoninsegna (active 1278–1318/19), the first well-known Sienese painter, was commissioned to paint a new altarpiece for the Cathedral in 1308. It consisted of a large Madonna and Child in the center of the front and a Crucifixion in the center of the back. Both were surrounded and topped with numerous smaller compositions, angels and apostle figures, and predella paintings: altogether close to one hundred subordinate panels. The elaborate framework with its richly carved and gilded pinnacles, finials, gables, and moldings was an integral part of the majestically gleaming and glittering whole.

The adoration by the Sienese of this *Maestà* began on June 9, 1311, the day when it was installed in the Cathedral, or Duomo. A contemporary chronicle describes this solemn occasion: "And on that day when the Majestas was carried to the Cathedral, the shops were closed and an order was given by the Bishop for a large and devoted company of priests and friars to form a solemn procession. In this procession were included nine governors and municipal officers and all the townspeople, the most important personages grouped according to rank, standing near the painting holding lighted candles, and behind them women and children in attitudes of devotion; and they accompanied the painting right into the Cathedral, the procession passing around the city square as was the custom, the bells chiming in honor of so noble a panel. And all day they prayed and gave to charity." Although this magnificent work was taken down from the high altar of the Cathedral in 1506, and later its front and back were separated and many smaller panels, gables, and pinnacles were removed from it and scattered, it exerted an influence on Sienese paintings for centuries to come.

Thus there are two panels in this room that closely reflect the art of Duccio and the influence of the *Maestà*. They constitute

a two-winged altarpiece, or diptych, and were painted by a close follower of Duccio, whose name is unknown to us, around 1320. The painter simplified Duccio's large and rich composition. The enthroned *Madonna and Child* (2) are surrounded by only nine angels instead of the numerous saints and apostles on the *Maestà*. The *Crucifixion* on the right panel (1) is also less crowded: the groups of mourners are smaller, and the crucified thieves of the *Maestà* are omitted. Therefore, and also because of the reduced scale and size, these two panels are more intimate, much closer to the worshiper than the imposing *Maestà*. There is also a human tenderness in the way the Madonna is holding her child, and in his reaching for his mother's cheek. The angels are not arranged in hieratic ceremonial rows; although they retain a basic symmetry, they surround the throne in a gently undulating circle. The artist is trying to liberate himself from the Byzantine tradition in the modeling of the figures, as well. The wings of the angels still recall the stiff lines of *cloisonné* enamels, but the folds of their robes begin to follow the natural shapes of their bodies.

Two panels that once probably belonged to a large altarpiece with manifold panels and wings (therefore called a polyptych) are the early work of Lippo Vanni. He was a Sienese artist, active between 1341 and 1375, and known first as a manuscript illuminator and later as a painter of panels. In the early 1350s, when he painted these pictures, he was working under the strong influence of Simone Martini and Lippo Memmi, the two dominant figures among Sienese painters in the generation following Duccio. Vanni followed these two masters carefully, and probably this is the reason why these panels, and others belonging to the same altarpiece, are considered his best works.

The *Madonna and Child* (10) is believed to be the central panel of the altarpiece. The calm and serene expressions, the rich, sinuous drapery following the movements of the bodies, are mostly due to Simone Martini's influence. Lippo Vanni further refined his manner on the *St. Ansanus* panel (9), now flanking the *Madonna and Child*. The figure of St. Ansanus was also inspired by the representation of the same saint on one of Lippo Memmi's altarpieces. On our panel the young saint is shown holding in his right hand the palm branch of martyrs. The black-and-white banner of Siena topped with a cross that is held in his left hand indicates that he was the main patron saint of that city. Because of his presence, it might also be assumed that the polyptych was painted for one of the churches in Siena.

The panels are in different states of preservation. On the *Madonna and Child,* the original gold-leaf background has been worn down to the underpaint and was recently replaced, while the *St. Ansanus* panel still retains traces of the original gold leaf. This difference in condition is due to the varying misfortunes that these panels suffered after they had been removed from the

church and separated. The *Madonna and Child,* along with a *St. Peter* panel, was still in Italy, near Siena, by the second half of the nineteenth century; both panels then crossed the Atlantic twice before the *Madonna* entered this collection. The *St. Ansanus* panel was discovered by two famous English classicists, Professor J. D. Beazley and Andrew Gow, in a bookstore near the Seine in Paris; the bookseller supposed it to be a portrait of Jeanne d'Arc!

Two small panels representing *St. Peter* (6) and *St. Mary Magdalen* are by Barna da Siena, another follower of Duccio. This somewhat mysterious artist was active in the middle of the fourteenth century, and our two pictures are generally dated in the 1350s. The delicate colors, the muted glow of the gold background, and the rich tooling of the halo and the cusped arch are all characteristic of Barna. These two panels were once also parts of an altarpiece, other parts of which are still in Siena.

Bartolo di Fredi, a major artist in Siena in the second half of the fourteenth century, painted a large *Adoration of the Magi* (8). It is a work of his maturity and may be dated around 1480, as is another composition of the same subject by him in the Siena gallery. Comparison with the Siena painting demonstrates that our panel must originally have been higher and wider. It is easily noticeable that on the top the camels and figures from the retinue of the approaching caravan of the Magi are cut off, as is part of the figure of the bearded attendant with a sword on the left side. The painting is a dramatic composition uniting the Holy Family, the richly attired, gift-bearing kings, and the realistically represented common people and horses. The contrasting colors are vivid and almost fantastic. Noticeable is the disappearance of the gold background, as it is replaced by the rocky landscape dotted with trees and shrubs.

Two small panels with scenes from the life of St. Catherine of Siena (20, 21) once decorated the predella of an altar commissioned by the Pizzicaiuoli (meat-picklers or pork-butchers) of Siena, for their chapel of the Purification in the hospital of Santa Maria della Scala. It was in this hospital that the great mystic Caterina Benincasa, the later St. Catherine of Siena (1347–1388), tended the sick and poor. In 1447, the year of the hundredth anniversary of St. Catherine's birth, one of the most important Sienese painters, Giovanni di Paolo (1403–1483), was asked by the rectors of the Pizzicaiuoli to paint an altarpiece. The commission stipulated that it must be completed by All Saints' Day, 1449. A later description mentioned that this altarpiece had a beautiful wooden predella. (In general, a predella is composed of small paintings of different widths to mask a massive horizontal wooden beam, to which the large panels of the altarpiece are fastened, and which connects them to the altar proper.) Our two small paintings, with eight others now dispersed in American collections, were on the predella of

the Pizzicaiuoli altarpiece by Giovanni di Paolo.

One represents *St. Catherine Receiving the Stigmata* (20). It shows the white-robed, half-kneeling saint, her hands raised in ecstasy, receiving the replicas of the wounds of the crucified Christ. The scene takes place in a small, barren chapel where the only decorations are a crucifix and a precious golden cross on the simple altar. On the panel to the right, the scene of *St. Catherine's Prayer and Christ Resuscitating Her Mother* (21) is represented. The miracle here takes place in a chamber equipped with a canopied bed on a raised platform. The atmosphere in both paintings reflects the simple but transcendent life of St. Catherine and the surroundings in which she lived. The brilliant colors of the small figures and the carefully painted precious details demonstrate Giovanni di Paolo's talent as a miniature painter. These two paintings clearly show his highly individual style, which fuses the Sienese tradition of serenity both with the flamboyance of Florentine art of the Quattrocento and with the love of naturalistic details borrowed from the French and Flemish schools of the International Style of the late Gothic Period.

The chest (132) beneath this group of paintings is called a *cassone*. Since there are more than a dozen of these fourteenth-to fifteenth-century Italian pieces of furniture in the collection, a few words about their use and decoration might be said here. These chests were used in everyday life mainly for the storage of clothes, precious fabrics, and valuables. According to contemporary representations their tops served also for the display of utensils such as mortars, ceramic ewers, and plates. Besides this utilitarian purpose, *cassoni* played an important role in the marriage ceremonies of the time. As we know from narrative and pictorial sources, the richly decorated chests laden with the dowry were prominently carried in the marriage procession that accompanied the bride to the house of the groom, her future home. As a consequence most cassoni bear the armorial shields or coats-of-arms of the families of the young couple. Because of their role in the marriage ceremony many of these cassoni are decorated with painted scenes referring to mythology, stories of heavenly and earthly love, marriage and marital fidelity. A considerable and respectable part of any painter's work consisted of painting these chests; therefore, many of these cassone paintings are by the best artists of the time.

Other types of cassoni were decorated with ornamental and figural carvings and inlays of various kinds. Our late fifteenth-century Florentine cassone is embellished with a pattern of facing eagles, two armorial shields on the front, and a fleur-de-lys pattern on the sides. These raised decorations were modeled in gesso on the wooden base with the use of a mold, then gilded with gold foil (gesso is a mixture of plaster of Paris, white paint, and size).

Giovanni di Paolo's *Bishop Saint* (23) is a fragment of a larger painting, probably from a still unidentified altarpiece. It was painted around 1460. The elaborately tooled halo signifies that a saint is represented. He has been called both St. Ambrose and St. Fabriano; unfortunately, his attributes, an open book and a whip, are not specific enough for closer identification. The elaborate miter, studded with pearls and rubies set in gold, bespeaks the artist's love of precious details. The bishop's vestment is decorated with figural and ornamental embroidery; the gold stitches and multicolored silk are painted with great care.

Ugolino da Siena, or Ugolino da Nerio (born before 1296—died 1339 or 1349) was the foremost of Duccio's pupils. His closeness to the great master is reflected in this *Madonna and Child* (4) and in the diverse attributions given to it. Berenson thought it to be by Ugolino, others have given the panel to Duccio. All the critics agree, however, that the picture—probably the central panel of a polyptych—was directly influenced by Duccio's *Maestà* of 1311 and was painted several years later. Ugolino's Madonna, because of its calm and simple character, has a distinctive monumentality. There is also a reserve in the use of color: the gold background gently contrasts with the blue of the Madonna's mantle and the pink of the Child's robe.

Giovanni di Paolo's *Annunciation to Zachariah* (18) once belonged to a complex masterpiece by that artist. With eleven other panels—six of which are now in the Art Institute of Chicago—it was part of an altar-tabernacle devoted to St. John the Baptist. The tabernacle is a rectangular structure, composed of folding panels surrounding and enclosing a painting or a statue. While it is still uncertain what was in the center of this tabernacle, the panels on the wings represented episodes from the life of St. John the Baptist. Our panel shows the angel announcing his birth to the prophet Zachariah. Because of this, it must have been the first of the narrative scenes; therefore, in all the numerous reconstructions it has been placed in the upper left corner of the left wing. That the wings of the tabernacle folded is proved by the somewhat battered figure of the *Angel of the Annunciation* painted on the back of the panel. This makes the painting a key piece for the reconstruction of the whole, since the versos of all the other surviving panels have been removed.

The front of the painting is in good condition; thus all the mastery of the artist, his fine brushstrokes, his talent for characterization, and his obvious enjoyment in the minutest details may be observed and appreciated. The scene takes place in a hexagon in an imaginary church. Both the interior and the exterior of the church are shown, probably for the first time in Italian painting. The architectural setting, its details, and the warrior figures on the top of the columns effectively frame the principal figures through the open sides of the hexagon. Zacha-

riah and the angel are placed on a raised platform flanking an altar-like hexagonal structure. A finely wrought censer, or incense-burner, stands upon the altar. Its top is touched by the angel while its chains are held by the prophet, thus ingeniously creating a physical connection between the two figures. The groups of believing and disbelieving onlookers are placed on either side of the platform so as not to distract from the action in the center. Attention is rather drawn from the two figures by the use of a primitive perspective to the far end of the church, to an elaborately pinnacled tabernacle standing in the apse. It has been suggested that in composing this architectural setting Giovanni di Paolo might have utilized some elements from Ambrogio Lorenzetti's famous *Presentation in the Temple*, now in the Uffizi, Florence.

There is no surviving documentary evidence for the origin and dating of our painting and the others associated with it. It has been proposed that the tabernacle-altar might have been commissioned by a confraternity devoted to the special worship of St. John the Baptist. By means of comparison with other works by Giovanni di Paolo, it has been dated by some scholars to a period shortly before 1450, by others between 1455 and 1460. Be that as it may, the whole painting exudes that wondrous mixture of muted colors, minute details, and delicately drawn sensitive figures that makes Giovanni di Paolo's mature period so appealing.

Paolo di Giovanni Fei's *Madonna and Child with Saints, Angels, and Eve* (13) is considered one of the most important late works of this lesser-known Sienese painter (active 1369–1411). The colors and gold on the panel are brilliant; its iconography is unusually interesting; and it is still in the original frame. The enthroned Madonna with the nursing Christ Child on her lap is surrounded by a choir of nine angels holding a brightly patterned dossal behind her. The saints standing on both sides on the steps of the throne include the four virgin martyrs and Sts. Jerome, Peter, and John the Baptist. In the spandrels of the upper corners of the frame two octofoil medallions contain delicately painted representations of the Virgin and the angel of the Annunciation.

In the lower part of the painting the figure of Eve, clad in a transparent garment and furred robe and with a hexagonal halo, reclines at the base of the throne. In her right hand she holds a scroll, inscribed EVA, in her left a branch of a fig tree. Close to her left foot is the fig tree, a female-headed serpent twisted around its trunk. The presence of Eve is a reference to certain theological interpretations of the life of the Virgin popular in the fourteenth and fifteenth centuries. According to these, Eve, both the originator of mankind and the cause of its fall, was considered to be the first Mary, and also to be the antithesis of the Virgin, who bore the redeemer of mankind's sins. The fig

branch and the serpent signify original sin; the Annunciation and the Christ Child, redemption and salvation.

No less interesting than the iconography is the original frame built around and joined to the painting, most probably by Paolo di Giovanni Fei himself. Its raised leaf motifs, quatrefoils, and rosettes are modeled in gesso (the technique already described in connection with the Florentine cassone) and then gilded, and finally the contours are emphasized by punched-in lines. The rosettes are further embellished with small glass beads of various colors. (This kind of frame seems to have been a specialty of Fei's; another *Madonna and Child* by him in the Metropolitan Museum has a similar elaborate frame decorated with small gold-glass [*verre églomisé*] plaques, representing saints and apostles.)

Two small paintings represent two popularly venerated Sienese men known for their piety. The *Blessed Andrea Gallerani* (24) bears the letter M topped with a cross, probably the emblem of a society devoted to the Virgin Mary. The second little painting (25) represents the *Blessed Ambrogio Sansedoni* in the habit of a Dominican friar. Recent research has established that both panels decorated the sides of the altar of the Pizzicaiuoli and probably were painted by Pellegrino di Mariano (active 1449–1492), a contemporary of Giovanni di Paolo. This is the beginning of the long and interesting provenance of these two little panels. During the sixteenth and seventeenth centuries they shared the fate of the altar: removed from the chapel in Santa Maria della Scala, dismantled, and dispersed. In the early nineteenth century the two panels were in the collection in Cologne of Johan Anton Ramboux, a painter and collector of early Italian pictures. He probably acquired them during his travels in Italy. Their last stop, before entering the Lehman Collection, was in Bruges. Robert Lehman described their purchase as follows: "From a small dealer in Bruges, September 1923. While visiting the Bruges Museum I asked the curator whether he knew of any pictures for sale. He referred me to a friend of his whom he said had brought a Flemish painting for his judgement and which he said he thought was close to Memling. I accordingly went to his shop and asked to see the picture. Upon the table were these two panels close to Giovanni di Paolo. The picture which he produced, which I had gone to see, proved to be a mediocre sixteenth-century Flemish picture. I asked him what he wanted for the other two panels. He said they were Spanish and I purchased them."

Spinello Aretino (1333–1410), a Florentine painter who also worked in and around Siena, painted *St. Philip* (30) and an *Unidentified Saint,* both fragments of an altar he painted in 1385 for the famous monastery of Camaldolese brothers in Monte Oliveto, south of Siena.

A gem-like little panel with the *Coronation of the Virgin* (14)

is the work of Niccolo da Buonaccorso, a fourteenth-century Sienese artist, active 1356–1388. The painting is in an excellent state of preservation, and is therefore a good example for demonstrating the dexterity of the painter. The brilliant colors of the orange-red cherubim and the blue seraphim surrounding the Virgin are very carefully balanced against the gleaming gold of the framework. In the lower third, kneeling on an intricately patterned floor covered with blue and red tiles, a delightful group of six angels is playing various musical instruments in heavenly harmony with the choir of angels in the upper half. The recognizable instruments include a double flute, a portable organ, a hurdy-gurdy, a violin-like rebec, and a recorder. Although our painting is not signed, it is so closely related to the only known signed work of Niccolo da Buonaccorso, a *Marriage of the Virgin* in the National Gallery in London, that it can be unquestionably attributed to him. It is very probable that the London and Lehman panels, and a third with the *Presentation of the Virgin* in Florence, may have belonged to the same polyptych, one of the most important works of the artist.

The following two paintings are witnesses to the great influence that the arts of Siena exerted in Italy and the other countries of medieval Europe. From documents and extant paintings we know that Sienese painters traveled to many cities and courts to execute important commissions. Their importance was rivaled only by that of the artists of Florence. Simone Martini in 1317 went to Naples at the request of King Robert of Anjou, who paid him five hundred ounces in gold to paint a large panel representing St. Louis of Toulouse. Lippo Vanni also painted several altarpieces for the court in Naples. Under their influence a whole new school of painting developed there, fusing the local tradition with the achievements of Sienese art. Simone Martini also worked in Assisi and then in 1339, at the invitation of Pope Benedict XII, he settled in Avignon to paint frescoes and to illuminate manuscripts, dying there in 1344. Sienese goldsmiths were employed in the fourteenth-century Angevin court of Hungary; one of them became a high court official connected with the administration of the gold mines and the minting of coins. There were Sienese artists in Spain and possibly in England; as to their influence in Paris, it was recently suggested that the famed French illuminator Pucelle—who painted the famous little prayerbook of Jeanne d'Evreux, now in the Cloisters Collection of the Metropolitan Museum—was also a Sienese goldsmith-painter, originally called Pucelli.

A large painting representing *Sts. John and Mary Magdalen* (38) is a famous example of the Sienese and Florentine influence in Naples. Because of its importance it has been attributed to many great masters. The panel originally was the right wing of a diptych (the left wing, portraying the *Dead Christ and the Virgin,* is preserved in the National Gallery, London).

The half-length figures with their narrow, slit eyes and dramatic expressions on their faces, and the little angels hovering over them, represent the impact of Florentine art. The Sienese traits are the rich gold tooling of the halos and the strange script-like ornamentation (an imitation of the so-called Kufic characters in Arabic) framing the composition. Names such as the Florentine Bernardo Daddi, or a follower of Giotto, or a Sienese master influenced by Simone Martini have been mentioned in connection with these panels. However, the latest scholarly research attributes the diptych to a major artist of the Angevin court of Naples, Roberto d'Odorisio, and dates it around 1350.

A smaller panel with the *Adoration of the Magi* (7) is also a well-known and much-debated example of Sienese influence. The precious little picture, still in its original frame, was one of the favorites of Robert Lehman. In the big catalogue of his father's collection he described it very sensitively: "The deep blue mantle of the Madonna is contrasted with the rich brocaded robes of old gold which adorn the Magi and the Angels. The three diminutive Moorish attendants wear delicate colors of white, yellow and pink. The flesh tones have a patina of old ivory in harmony with the mellow tones of the whole picture. The pink architecture, in its oriental scale is reminiscent of the Persian miniaturists. The border is of incised gold."

This *Adoration* once was part of a series or of an altarpiece, two panels of which, the *Annunciation* and the *Nativity,* are in the museum at Aix-en-Provence, in France. The dimensions of the three paintings are identical, as is their style. The delicately painted little figures and the attention paid to the minutest details (such as the little cage with a bird suspended in the balcony above the Madonna's head) are indicative that the artist was primarily a miniature painter. While Robert Lehman wrote in his catalogue of 1928, ". . . the master was, perhaps, some French miniaturist, who came under the influence of Simone Martini, while he worked in Avignon," others tried to attribute these paintings to masters as diverse as Sienese and Catalan. Recent scholarly opinion accepts Robert Lehman's earlier identification, adding that this talented artist, who painted these panels around 1345, might have also been influenced by the Neapolitan school of Roberto d'Odorisio.

A choir stall (134) (*stallum* in Latin or *stallo* in Italian) was as the name indicates originally placed in the choir of a church, where it served as a resting place for a bishop or a high-ranking priest during long Masses or other celebrations. As a freestanding piece of furniture, it is decorated with rich ornamental carvings on every side. The back of the seat and the top are further embellished with wood inlay in various colors (*intarsia* in Italian) . Although there is no information about its place of manufacture or the church it comes from, there are similar chairs in the church of San Simpliciano in Milan. The shape

and the decoration both indicate Lombard origin—possibly from Milan—and a date in the middle of the sixteenth century.

A large *Madonna and Child* (46) by Lorenzo Veneziano (active 1356–1372) is probably the earliest Venetian painting in the Collection. This imposing panel is an introduction to a large and distinguished group of works of art created in Venice and carefully gathered by both Lehmans in the course of sixty years.

Venice, the rich city of merchants, bankers, and craftsmen, ruled the Adriatic Sea for half a millennium during the Middle Ages and the Renaissance. With an armada of merchant vessels and warships, the Venetians traded not only in the Mediterranean but with the Eastern half of the world. They produced luxurious objects, colorful enamels, fragile glass in the furnaces of Murano, bronzes in their foundries, richly enameled mounts for rock-crystal carvings, shimmering brocades and velvets on their looms. These sumptuous arts are well represented in the Robert Lehman Collection.

There are large altarpieces and intimate portraits from the fifteenth century, as well as glass vessels of every variety, enamels and jewels, velvets and richly carved furniture pieces. This assembly of extraordinary objects is accompanied chronologically by a unique collection of Venetian drawings starting with the early fifteenth century and ending with hundreds of eighteenth-century drawings by the Tiepolos and their contemporaries.

The Venetians' love of luxury and the proud expression of their achievements are mirrored in Veneziano's large panel. The Madonna is seated on an elaborate throne, supporting the Christ Child on her left knee. Both are dressed in brocaded and embroidered garments. The Madonna's light pink dress is embellished with precious stones and pearls, demonstrating the richness of contemporary Venetian dress. Her blue mantle delicately contrasts not only with her dress, but also with the pale gold, fur-lined robe of the Child. The head of the Virgin is slightly tilted toward her Child. This gesture and her oval face with the almond-shaped eyes convey a tenderness that is both heavenly and human. The intimacy is heightened by the colorful figure of a goldfinch gingerly perched on the thumb of the Madonna's raised left hand.

The heavenly idyll is shared by earthly mortals, the two donors kneeling at the base of the throne. On the Madonna's right is a secular person: judging by his ermine-trimmed red robe, he must have been a rich merchant. Facing him, in dark habit and with tonsured head, is a Franciscan friar. The gestures of their upraised hands suggest that they are offering something to the Madonna and Child.

The presence of the goldfinch and the donors on this painting is of special significance. This colorful little bird has a great

variety of symbolic meanings in early Italian paintings. In the hands of the Christ Child it symbolizes the sacrifice and passion of the Savior and His resurrection. The goldfinch is also described in many legends and pious stories as a good omen in time of disease and the plague, especially as helpful for the recovery of children. This last symbolic meaning and the presence of two donors suggest the possibility that our *Madonna and Child* panel was commissioned as a votive offering, to give thanks for and to commemorate the Virgin's intercession at some grave time. We may also assume that the secular donor represented could have provided the funds for the painting and that the Franciscan might have been the head of the monastery to which it was presented.

Because of its rich colors, gentle emotions, and symbolism, this painting is one of the early masterpieces of Lorenzo Veneziano. Since there is neither inscription nor date on this painting, it can be dated only by comparison with his dated works. The so-called Lion polyptych in Venice (1357–1359) is simpler in composition, while a later *Madonna and Child* in Padua (1361) has a more elaborate throne represented on it. Judging by these and other comparisons, Lorenzo Veneziano must have painted our panel around 1360.

The strong ties to Byzantine tradition in Venetian art are clearly apparent on two small panels representing the *Flagellation* and the *Entombment* of Christ (47, 48). The rigid lines on the faces and the folds of the garments and drapery, the emotionless figures arranged in lifeless groups, all reflect the almost thousand-year-old conventions of Byzantine art, especially of manuscript illumination. The rigidity of this tradition is broken only by the cruel facial expressions of the two torturers and by the two little angels sorrowfully burying their faces in their hands while hovering above the entombment scene. This intrusion of Italian, more precisely Florentine, artistic ideas dates these paintings around the middle of the fourteenth century.

The edges of the panels have been cut down, but in some places, such as the bottom of the *Flagellation* scene, enough is left of the gilt framework to indicate that the panels must have belonged to a larger, composite object. Judging by their size they might have come from an altar-frontal, or dossal, that was decorated with a series of similar small pictures representing the Passion of Christ. There is also a strong possibility that our panels may have been set into a large gold and silver reliquary holder, such as the famous one containing remains of the Holy Cross, owned by Cardinal Bessarion, papal legate to Venice in 1463. Reliquary holders embellished with similar small paintings of Passion scenes are frequently seen in Venetian paintings of the fourteenth and fifteenth centuries. This adds strength to the possibility that these precious little pictures were parts of such an elaborate and venerated object.

An excellent example of early sixteenth-century Venetian furniture-making is a cassone (133) made of walnut and profusely decorated with carving in low relief. The form is derived from that of antique sarcophagi, which were richly carved, monumental stone coffins. The decoration also reflects the influence of antique, especially Roman imperial, art. On the front panel the crisply carved acanthus scrolls are filled with birds. The frieze under the lid is embellished with winged half-horses facing urns, while the feet are decorated with grotesque masks. The sides are carved with bulls' skulls and bear forged iron rings for carrying. The coats-of-arms on the front are unidentified, still withholding clues as to the names of the pair and to the date of their marriage. The cassone thus may be dated by the style of the carvings to about 1500.

Second Room

While in the first room the Sienese masters predominate, here we find representatives of other important schools of Italian painting, such as the Florentine. Smaller, regional centers of art are also represented here, cities such as Rimini, Camerino, etc. The visitor is confronted with a large number of small paintings. Most of these panels once were parts of altars: they were sometimes centerpieces or wings of such larger works, but more often they decorate the altar-frontals, sides, predellas, or pinnacles. It was common practice in the workshops of fourteenth- and fifteenth-century Italian painters for the master to paint only the main parts of such large compositions; the less important ones were left to his assistants. Consequently, opinions differ concerning the attribution of these paintings. This problem of attribution is reflected in some of the following descriptions, and even more so on the labels attached to the paintings.

A large triangular panel (27) is an excellent example of this difficulty. Judging by its size, it once must have been the uppermost part of an altarpiece. Its subject is the Virgin, sitting in a mandorla supported by six angels and throwing her girdle to the apostle Thomas, whose right hand is recognizable in the lower left edge of the fragment. This indicates that the theme of the altarpiece was the *Assumption of the Virgin*. The colorful panel has been traditionally attributed to the Florentine master Bernardo Daddi (active about 1290 to 1355). He is said to have painted it for a chapel in the cathedral of Prato, where the Virgin's girdle (in Italian, *cintola*) had been preserved and venerated as a precious relic since the thirteenth century.

The famous medieval book on the lives and legends of the saints, the *Legenda Aurea* (*Golden Legend*) of Jacobus de Voragine, Bishop of Genoa (about 1230–1298), summarizes the

story of the *cintola* as follows. After the Virgin died ". . . the Apostles laid Mary in the tomb, and sat about her as the Lord had commanded. On the third day Jesus, coming with a multitude of angels, said to the Apostles 'What of grace and honour, think ye, shall I now confer on my mother?' They answered 'To Thy servants, O Lord, it seems right that as Thou, having vanquished death, reignest unto the ages, so Thou, Jesus, shouldst raise up the body of Thy mother, and place her at Thy right hand for all eternity.' He nodded his consent, and instantly Michael archangel appeared and presented Mary's soul before the Lord. Then the Saviour spoke saying: 'Arise, my dear one, my dove, tabernacle of glory, vessel of life, heavenly temple, in order that as thou mayst not suffer the corruption of the body in the grave!' And straightway Mary's soul went to her little body, and she came forth glorious from the tomb, and was assumed into the heavenly bride chamber, a multitude of angels mounting withal. . . . Thomas however was absent when these things took place, and on his return refused to believe. But suddenly the girdle wherewith her body has been begirt fell unopened in to his hands, so that he might understand that she had been assumed entire."

At variance with the legend, in our painting the Virgin is shown deliberately throwing down her long girdle to Thomas. By altering the legend the artist has created a compositional and visual connection with the lower part of the altar, which must have represented the Virgin's tomb surrounded by the Apostles, as we may see on many contemporary depictions of the scene. An altar like the one from which our panel must have come, when completed with its necessary components such as the predella, the frontal, and the pinnacles, would have been so large that it could not have fitted into a chapel. Recently discovered building accounts of the cathedral of Prato indicated that in 1367 a large panel was painted for the main altar of the cathedral. It is highly probable that our painting was the upper part of this altarpiece.

A little rectangular panel representing the *Last Supper* (3) is an important document for the reconstruction of the oeuvre of the most gifted and individual follower of Duccio, Ugolino da Siena, or Ugolino da Nerio (born shortly before 1296—died 1339 or 1349). Ugolino earned a great reputation that extended from Siena to Florence. Giorgio Vasari—the first art historian in a modern sense—in his book *The Lives of the Most Important Painters, Sculptors, and Architects*, published in 1550, recorded his activity as follows: ". . . there lived a Sienese painter called Ugolino, of considerable repute. . . . He did many pictures and chapels in all parts of Italy. . . . His works consist of a picture for the high altar of Santa Croce on a gold ground, and another picture which stood for many years on the high altar of Santa Maria Novella (both in Florence). . . . Beside these he

did many other things in a good style but without in the least departing from the manner of his master." Only one of these works described by Vasari survives in parts and serves as the sole basis for the attribution of other works to Ugolino. It is the altarpiece that formerly stood on the high altar of Santa Croce, and its surviving fragments are scattered in museums and private collections all over Europe, England, and the United States. Our little *Last Supper* belonged to the predella, which contained seven scenes from the Passion of Christ.

Christ and the Apostles in colorful robes are shown sitting around a long table set in a room with an elaborate, coffered ceiling. On the white tablecloth a careful arrangement of viands, bread, wine in glasses, and eating utensils illustrates the artist's love for detail. It is also apparent in the richly tooled halos of Christ and the Apostles; close observation will reveal that each is decorated with a different pattern. Ugolino's *Last Supper* can be dated shortly after 1321, since the whole altarpiece is likely to have been commissioned after the church of Santa Croce was opened for services in that year.

Even more predilection for detail, but coupled with an inventiveness in storytelling, or narrative, is evident in another small panel representing the *Feast of Herod* (39) from the legend of St. John the Baptist. Traditionally this panel has been ascribed to Giovanni Baronzio, a painter from Rimini (died before 1365). More recent catalogues of the Collection, however, have attributed it to a painter called the Master of the Life of St. John the Baptist.

The cheerful colors and delightful details contrast with the gruesome story to create a strange effect reminiscent of Oriental tales and their depictions. The story as it was best recounted, in the *Golden Legend,* was a perfect subject for the painter. John the Baptist was imprisoned by King Herod Antipas because he harshly reproached the king for unlawfully consorting with his brother's wife, Herodias. The king and his wife finally agreed on a plot to put an end to John: "Herod would make a great feast on his birthday for the prince and chief men of Galilee, at which the daughter of Herodias would dance. Then he would swear to give the damsel whatever she should ask of him, whereupon she would demand the head of John the Baptist. . . . So the banquet was held, the damsel was present, she danced to the delight of all, the king promised with an oath to give her whatever she asked, she obeyed her mother's behest and demanded John's head, the turncoat Herod feigned to be struck sad. . . . But the sadness was only in his face and gladness was in his heart. . . . The headsman was dispatched, John's head fell and was brought to the damsel, and by her presented to her adulterous mother."

The successive episodes of the story are depicted by the inventive and talented painter in a manner close to that of today's

comic strips. A large banquet room with elaborate balconies and walls covered with colorful hangings serves as a stage for the unfolding story. The crowned king and queen, seated at the table on a dais, are flanked by richly attired guests and are waited upon by attendants in bicolored liveries. At the right side the attention of Herod and his group is focused on the dancing damsel, Salome, stylishly dressed in a long garment. Since she has already made her demand, one's eye is drawn to the left, outside the room, to the large figure of the headsman already swinging his sword and aiming at the neck of the prostrate St. John. The scabbard of the sword held by the executioner points to the next episode: the damsel, accompanied by a servant, offers the Baptist's head to her coolly onlooking mother, flanked by two astonished and horrified ladies. There is a great variety of facial expressions, hand gestures, and movements in the little painting, almost guiding the onlooker through the maze of the story and to the dramatis personae. The figures are characterized by a realistic earthiness; the personality of a gifted and individualistic artist emanates from them. This is in contrast to the style of Giovanni Baronzio, who, judging by his signed paintings, retained the influence and most of the refined qualities and delicate mannerisms of his Florentine predecessors, Cavallini and Giotto.

The same earthy manner, rugged character, and strong modeling of our panel, however, are recognizable in a whole series of paintings representing various scenes from the life of John the Baptist. These panels were once presumably arranged in two rows, flanking a *Madonna and Child with Angels,* now in the National Gallery in Washington. It may not be too farfetched to assume that this polyptych was commissioned for the church of St. John the Baptist in Rimini, from a local artist, a contemporary of Giovanni Baronzio in the second quarter of the fourteenth century. Since no signed painting by this artist is known today, he is named the Master of the Life of St. John the Baptist. These characteristics induced the change in attribution adopted by Robert Lehman.

The next painting, a *Crucifixion* (40) , is generally attributed to Giovanni Boccati (1410–1480) . Born in the town of Camerino of the Marches, he is typical of many lesser artists who traveled and worked in many parts of Italy. Boccati, after leaving his native town in 1445, first worked in Perugia, where as a "most expert" painter he painted a large Madonna. Later he went to Padua and then to Florence, where, as an already highly esteemed artist, he was the guest of the great patron of the arts Cosimo de' Medici. He returned to Camerino around 1465 and remained there until his death, steadily painting panels for churches of the surrounding towns while making occasional trips, such as one to Urbino to paint frescoes of illustrious men for one of the rooms in the ducal palace. During these travels

his artistic personality was influenced by the work of the great masters such as Domenico Veneziano, Gentile da Fabriano, and Piero della Francesca. Boccati was also familiar with the achievements of the Flemish artists, possibly through the works of Veneziano, or through seeing some of their paintings in the collection of the Medici and other Florentines who spent some time in the northern cities.

The *Crucifixion* is composed of elements from both Italian and Northern sources. The ashen body of Christ, silhouetted against a rich gold background, is very reminiscent of the corpora on paintings by the followers of Jan van Eyck. Three small angels surround Christ; their hardly visible, lithe figures are composed of countless small dots carefully punched into the gold background. This elegant technique originated in Flemish and Burgundian art around 1400 and spread to Italy in the middle of the fifteenth century, as Boccati's use of it demonstrates. Mary Magdalen embracing the base of the cross shows the influence of Piero della Francesca, while the slender standing figures of St. Sebastian, St. John, and the Virgin reflect the art of Florence. The figure on the extreme left holds a small model of the city of Camerino, by which and by his other attribute—the flag—he is identified as St. Venantius, the patron saint of Camerino. The presence of this saint is also an indication that this *Crucifixion* might have been painted for a patron or a church in Camerino, probably after 1465, after Boccati's return to his native city.

Two masterpieces by the Florentine Lorenzo Monaco are relatively late additions made by Robert Lehman to the Collection. This fact and their importance require a closer look at the artist and his work. Lorenzo Monaco was probably the most important Quattrocento painter in Florence before Masolino and Masaccio. This prolific painter typifies the quiet, reserved Italian artists who spent most of their lives in the same city, working either in the peaceful surroundings of a monastery or in the seclusion of their houses.

His original name was Piero di Giovanni, and he probably was born in Siena about 1370–1372. He came to Florence at an unknown date. When entering the monastery of Santa Maria degli Angeli in 1391, he changed his name to Lorenzo—hence Lorenzo Monaco, or Lorenzo the Monk. Sometime before 1406 he left the monastery, probably because of poor health, and bought a house, where he lived until 1422–1424. The Camaldolese monastery of Santa Maria degli Angeli at the time of Lorenzo's entering had a famous school of book-illuminators in which masters carrying on both the Sienese and Florentine traditions of miniature painting were very active. Lorenzo Monaco mastered the technique of illumination here and turned to panel painting after leaving the monastery.

The *Crucifixion* panel (32) is a painting from this period.

The Sienese tradition is evident in the powerful design and the linear elaboration of the three figures. The well-organized space has strong Florentine roots: the figures are placed between rocky eminences that create a reverse arch echoing the arch of the top. Lorenzo's schooling as a miniature painter is revealed in the delicate coloring and detailed modeling of Christ's body and loincloth, as well as in the faces of Mary and St. John. These strong facial expressions are also present in a fundamental early painting of Lorenzo Monaco, a triptych in the museum of Empoli bearing his signature and the date 1404. The analogies with this work date our panel close to the same year, and tie it to other early Crucifixions by this master, such as the extremely similar one in the Jarves Collection of Yale University's Art Gallery.

The appreciation of the painting's simple beauties and its importance is reflected in the provenance. There is no indication of its earliest owners, or of the larger work to which it might have belonged; in the second half of the nineteenth century it is recorded as being in the Bardini collection in Florence. Around 1900 it passed to the distinguished collector of Italian art Charles Loeser, also of Florence. When, after a long hibernation, it appeared on the art market in the 1950s, Robert Lehman instantly purchased it. He sought the painting not only because of its obvious beauty, nor merely to fill a gap in his collection, but also to re-create the sense of enjoyment he had experienced while studying the *Crucifixion* by Lorenzo in the Jarves Collection, and probably to fulfill his desire of close to half a century to own one.

Lorenzo Monaco's small *Nativity* (31) once belonged to a predella that in turn was part of a still unidentified altarpiece. The little panel, and three others in different collections, each enclosed in a composite quatrefoil framework, are usually dated shortly before 1413. The *Nativity* is an important and always warmly appreciated painting. The following description by a distinguished scholar of Italian art summarizes the best of its values: "There is no more perfect example of Lorenzo at his best performance. He works, as ever when on this scale, with an enchanted brush. There are, as it were, two color ranges. The background of night effect and relatively neutral tone takes in the gilded, moonlit figures of the shepherd and the angel, the fantastic woodland of giant, step-like rocks, and the trees lightly touched on the left. Between these episodes the pent-roofed shed comes admirably into tangency with the point of the Gothic frame. The neutral zone of the foreground, a rocky crevassed platform, belongs to this basic plane of color. Before it, in an amazingly startling color contrast, float the exquisitely tinted figures of Mary, with her lilac and blue, and Joseph in rose red with, between them, the rayed form of the recumbent, resplendent Babe . . . with this deliberately fantastic color and

line, Lorenzo is as sure a creator of fairyland as was, for instance and not so long after him, Giovanni di Paolo."

The art of Lorenzo Monaco is exceptionally well represented in the Metropolitan Museum with the addition of these two paintings. Together with four beautiful enthroned prophets, acquired in 1965, they completely illustrate the master's early development from intimate, small compositions to large-scale altarpieces, from the delicate details reminiscent of miniature paintings to the extensive color surfaces and dramatic figures of large-scale panels.

The *Apostle with Scroll* (52) by the Venetian Carlo Crivelli (1430–1495) has a monumental feeling in spite of its smallness. This is due to the powerful modeling of the face, the folds of the robe, and the strong black contours that define their volumes. The half-length figure's right hand holds a partially unrolled scroll filled with indecipherable writing, while his left hand points upward, to where the face is turned. This gesture and the size of the panel are both indications that it formed part of a predella, which in turn, according to eighteenth-century descriptions, belonged to an altarpiece in the church of the Frati Conventuali Riformati at Montefiore dell'Aso, near Fermo. This altarpiece is described as a triptych having in the center the Virgin and Child flanked by St. Francis and St. Peter Martyr. Above was the dead Christ supported by angels. The predella contained half-length pictures of Christ and the twelve Apostles. This large altarpiece—an important work from Crivelli's middle period—was broken up shortly after the French Revolutionary armies entered Italy. Now it is dispersed on two continents; several parts are in American collections: the Christ from the predella in the Clark Institute in Williamstown, Mass., St. John and St. Peter in Detroit, another Apostle in the Kress Collection.

As Robert Lehman improved and enlarged his holdings, several paintings left the Collection during and after the 1940s. Many of these were sold to the Kress Collection and with it finally were deposited at the National Gallery of Art in Washington, D.C. Also, a large number of paintings and other works of art were given by Robert Lehman to public and university collections. Thus, several panels in this room have their companions in museums in the United States.

Robert Lehman in his catalogue of 1928 attributed the large panel with the full figures of *Two Standing Saints* (26) to the Florentine artist Bicci di Lorenzo (1373–1452). He identified the saint dressed in animal skins and holding a long-stemmed cross as St. John the Baptist, and the elderly one with the book as St. John the Evangelist. He also deduced that because the saints look and turn slightly to the left, the panel must have been the right wing of an altarpiece. His assumption proved right. Not long ago the Italian scholar Federico Zeri identified

our panel as the right wing of an altarpiece painted by Bicci di Lorenzo for the church of San Niccolo in Caffagio, Florence. He further identified the center part of the altar, an enthroned Madonna and Child now in the Pinacoteca in Parma, and its left wing, the standing figures of Sts. Nicholas and Benedict now in the Museum of the Badia at Grottaferrata near Rome. In proving the identification, Zeri showed that the three panels are the same size and that their iconography agrees with the eighteenth-century descriptions of the San Niccolo triptych in Caffagio. Zeri completed the reconstruction of this important altarpiece with the discovery that the small panels in the Metropolitan Museum, representing miracles of St. Nicholas, were parts of the predella. But this was not the end of the interesting investigation. A few years ago, another scholar, the late W. Kahn, building on Zeri's research, discovered, in the account books of San Niccolo in Caffagio, that the altarpiece had been painted in 1433. By means of this persistent research the history of Florentine art gained an important and well-documented reconstructed altarpiece, large parts of which are now together in the Metropolitan Museum.

The small panel representing *Sts. Bartholomew and Simon* (37) is the earliest painting in the Collection. Its artist is called the Master of St. Francis after a portrait of St. Francis in Assisi, which he painted between 1270 and 1280. Our panel, with several others (two of them formerly in the Philip Lehman Collection, now in the National Gallery of Art, Washington, D.C.), once was set in the high altar in the lower church of San Francesco in Assisi. Its style shows strong Byzantine influence, especially in the stiff facial lines and the symmetrical arrangement of the beard. The gold background and the richly tooled halos still glitter, just as they did when thousands of pilgrims adored the altarpiece in the shimmering candlelight of the lower church in Assisi. This effect was further heightened by the colored glass medallions which, mounted on gold foils, were embedded in the now empty round holes in the spandrels.

Looking at the *Apostle* (5), probably St. John the Evangelist, by Ugolino da Siena, it is worthwhile to recall this artist's other painting in this room, the *Last Supper* (3). It has already been said that this little panel and the altarpiece to which it belonged are the only keys to the identification of Ugolino's other works. Knowing this, it is interesting to compare this Apostle with the one in the red robe, third to the left of Christ, in the Last Supper scene. The masterful modeling of the face, the intent look, the careful waves of the beard, and the luxuriously decorated halo all bear the mark of Ugolino's hand. These qualities prompted one of the best living connoisseurs of Sienese art, Enzo Carli, to write: "This is certainly one of his masterpieces and probably of his late period."

Niccolo da Foligno, called Il Alunno (1430/32—around

1502), the painter of the large panel representing *St. Anne and the Madonna and Child Surrounded by Angels* (45), was influenced by the great Sienese and Florentine masters, as well as by local painters of the Marches, such as Giovanni Boccati. He successfully blended these borrowed elements into a pleasing, if somewhat placid manner, evident in this painting. St. Anne and the Madonna and Child are seated on an elaborate throne composed of elements of Renaissance architecture already fashionable in Florentine painting, such as pilasters and garlands. The canopy of the throne is in the shape of a large, stylized shell, which encircles the three figures, forming, as it were, another all-enveloping large halo around their heads. Besides the structural role, it has a hidden meaning. The shell enclosing and nurturing the precious pearl was a widely used symbol of the Virgin and her Child in the Middle Ages. Here it symbolizes three generations of the Holy Family. The throne is surrounded by a choir of singing angels; two of them on the front are playing a harp and a lute. This motif seems to be borrowed from Sienese painters. The painting can be dated between 1459 and 1461 by its style. It was the central part of an altarpiece; another panel representing *St. Michael Archangel* is now in the Art Museum of Princeton University.

Most of the paintings discussed were once parts of large altarpieces that stood in churches. Consequently, they were venerated and adored by large crowds of onlookers. By contrast, some of the little panels belonged to small-scale devotional pictures, portable altars, or altars in private chapels. Such a devotional picture is a little Florentine predella panel (29), by a follower of Agnolo Gaddi (1333–1396). The legend represented is that of St. Catherine of Alexandria, who, as she prays before a picture of the Madonna in a bare, private chapel, is rewarded for her faith by the bodily appearance of the Madonna and Child. A *Crucifixion* by Allegretto Nuzi (active 1346–1373), or a small diptych with the *Enthroned Madonna* (11) on one wing and the *Crucifixion* (12) on the other, by Paolo di Giovanni Fei (active 1369–1411) might have graced the altar of a house chapel. (Such a little chapel from fifteenth-century Siena, with an altar and an elaborately framed triptych, is depicted on Giovanni di Paolo's *Miraculous Communion of St. Catherine of Siena,* from between 1447 and 1449, in the Metropolitan Museum.) Two brilliant, jewel-like panels with *St. George and St. Nicholas* by Stefano di Giovanni, called Sassetta (1392–1450), might have been the wings of a portable altarpiece, similar to many mentioned in the inventories of popes, kings, and princes of both realms, and carried by them for their private devotions during their innumerable trips.

The two vitrines in this room display a considerable part of the extraordinary collection of Italian maiolica, which was gathered, for the most part, by Robert Lehman. Maiolica is a

special type of "earthenware with a glaze or enamel made opaque by an admixture of oxide of tin in its composition." This definition is by Bernard Rackham, the late, great scholar and connoisseur of maiolica, on whose works and catalogues the following comments are generally based. The name derives from that of Majorca, which in early Italian was called Maiolica. The accepted theory is that this kind of earthenware, imported from Spain in the early fifteenth century, was either shipped through Majorca or carried by ships based on that island. This type of glaze is believed to have originated in Western Asia, probably in Persia and Mesopotamia; it was known in Egypt and was taken over by the various Islamic peoples of the Near East. It is possible that the technique was carried to South Italy and Spain by the Moorish conquerors in the early Middle Ages. North Italian potters of the fifteenth century, who were already well versed in the ceramic tradition of the Greeks, Etruscans, and Romans, might have learned it from Levantine craftsmen or from the Moorish potters of Spain. The importance of this glazing was, as Rackham aptly stated: ". . . that it provided a surface unsurpassed for painted decoration: for greater fineness of execution now became possible than with any other surface at that time known to European potters." It is not surprising that maiolica was manufactured in the big centers of art, such as Siena, Florence, Venice, and Urbino; and there were smaller centers that became famous only because of their maiolica production, such as Deruta, Castel Durante, Gubbio, and Caffaggiolo.

Maiolica was subjected to two or three firings. The object was first formed from a fine clay on a simple potter's wheel, then submitted to the kiln for the first firing, emerging in what is generally called the biscuit state. The vessel was then submerged in a liquid white enamel base, which, when dry, was ready to receive the painted decoration. This unfired surface, because of its porous nature, absorbed paint rapidly. Therefore the design had to be applied with a steady brush and a very high degree of dexterity, coupled with a clear preconception of the composition. These factors required considerable talent from the painter and a perfect knowledge of his colors.

The pigments used in the decoration of maiolica were obtained from various metallic oxides: blue from cobalt, yellow from antimony, orange and various shades of brown from rusty iron, green from copper, and different shades of purple and violet from manganese. In the early period only a few colors were available; by the middle of the sixteenth century the mixing of pigments was so highly developed that almost every color was produced.

After painting, the maiolica piece was generally submitted to the second and final firing. For a very special and appealing class of maiolica—the so-called lustrewares—a third firing was

necessary. The lustre—which reminds one of the iridescent hues of the mother of pearl—was produced by using metallic pigments containing the oxides of silver or copper or their combination. These pigments, when applied to certain parts of the already finished maiolica and fired a third time at a relatively low temperature, produced the brilliant hues of lustre. Where the silver dominated the combination a pale, brassy yellow was the result; where the copper dominated, a vivid, ruby-red lustre. This was the specialty of the maiolica painters of Gubbio. Very often wares from neighboring towns were sent to Gubbio to be finished with this lustre embellishment.

In the decoration of maiolica almost every facet of art was used by the painters. Decorative motifs, single figures, or heads were copied from pattern books. Drawings or engravings made after the works of famous masters were also widely used. For the illustration of stories from classical mythology (mostly after Ovid's *Metamorphoses*) motifs and figures were often culled from several sources; objects decorated with these scenes are called *istoriato* ware. Special subjects were designed for large sets commissioned by popes, kings, or princes, every piece in these sets being marked with the coat-of-arms of the owner. Sometimes the mottos of such patrons would also be incorporated into the design, making the set a totally personal one.

The early maiolica pieces were mostly utilitarian objects such as apothecary jars, wine jugs, or pavement tiles. But as their design changed from the simple ornamental to the figural and narrative, and as their colors became more precious, pottery vessels were made not for use but for receiving pictorial decorations. They were hung as paintings on walls, or displayed on sideboards, chests, etc., in a manner similar to that seen in the rooms of this Collection.

Maiolica has always been treasured. In the nineteenth and early twentieth century large collections of it were formed both in Europe and in the United States. Robert Lehman, encouraged by a substantial nucleus already gathered by his parents, with sensitive connoisseurship amassed his objects from such distinguished sources as the sales of the Pringsheim collection in Munich, the Damiron collection in Lyon, the Oppenheimer collection in London, the Pierpont Morgan, Mortimer L. Schiff, and Randolph Hearst collections in the United States, and many others.

A large, two-handled jar (143) is the earliest example of Italian maiolica in the Collection. It is the work of Florentine potters, dating from about 1440. The decoration is simple but bold in color and execution. The body is covered with a pattern of large blue oak leaves on a white background. On the viewer's side two large branches surround a stylized crane, outlined in manganese. On the heavy strap handles there are partly modeled, partly painted crutches, which indicate that the jar was probably

made for the hospital of Santa Maria Nuova in Florence. This
and other similar vessels were made mainly for the use of phar-
macies, in this case for that of the famous hospital. Two some-
what later Florentine jugs or pitchers date from about 1470
(142) . One with stylized, so-called parsley-leaf decoration shows
the influence of Spanish lustreware from Valencia. The winged
putti are holding a heavy laurel wreath surrounding the arms of
the Rucellai family. On the other jug the decoration is composed
of heavy, swirling foliage on a background covered with small
flowers and leaves. The arms are those of the city of Florence.
Both jugs were part of large sets, which must have been used
for occasions such as royal entries or civic feasts. A prominent
scholar of maiolica has noted that these jugs are "noble ex-
amples of the severe style—a blend of Gothic, oriental and
renaissance elements. The powerful turn of their shapes, the
stylized yet poised children that hold the wreaths, bear the un-
mistakable mark of the early Florentine Renaissance."

The influence of early Florentine art on maiolica may be
seen best on three large plates (144, 145, 146) . They represent
episodes from the Labors of Hercules, and all three reflect im-
portant compositions by one of the great artists of the early
Renaissance, Antonio Pollaiuolo (1433–1498) .

Around 1460 Antonio Pollaiuolo painted three large compo-
sitions for the Sala Grande of the Medici Palace in Florence.
These paintings, which represented the first truly Renaissance
conception of the Labors of Hercules, are now lost. Giorgio
Vasari, who had seen the paintings, described them: "The first
– which is slaying Antaeus, is a very beautiful figure, in which
the strength of Hercules as he crushed the other is seen very
vividly, for the muscles and nerves of that figure are strained
in the struggle to destroy Antaeus. The head of Hercules shows
the gnashing of the teeth so well in harmony with the other
parts, that even the toes of his feet are raised in the effort. Nor
did he take less pains with Antaeus, who, crushed in the arms
of Hercules, is seen sinking and losing all his strength, and
giving up his breath through his open mouth." After describing
the second picture, showing Hercules slaying the lion, Vasari
continues with the third, representing Hercules slaying the
Hydra, which "is something truly marvelous, particularly the
serpent, which he made so lively and so natural in coloring that
nothing could be made more life-like. In that beast are seen
venom, fire, ferocity, rage, and such vivacity that he deserves to
be celebrated and to be closely imitated by all good craftsmen."

The compositions of these lost Hercules paintings fortunately
survived in many forms. On two small panels now in the Uffizi,
Pollaiuolo recreated the slaying of Antaeus and the struggle
with the Hydra. His engravings and drawings and those of his
followers repeat whole episodes of the Hercules series or single
figures. That the maiolica painters of Deruta especially appreci-

ated these compositions by Pollaiuolo is demonstrated by these three plates, which, thanks to Robert Lehman, have been brought together here.

The large, deep-centered dish with *Hercules and Antaeus* (144) is the earliest of the three. The decorative patterns around the rim and the subdued colors indicate that it was made in Deruta, around 1500 or slightly earlier. Unfortunately, there is no date, inscription, or signature on the back. The composition in the center is very closely related to Pollaiuolo's *Hercules and Antaeus* as we know it from the Uffizi painting. Antaeus, his whole body clasped in the arms of Hercules and pressing down on the hero's forehead, is an almost literal transference of the original composition to maiolica. That Hercules is gnashing his teeth, and that Antaeus' breath is being squeezed out of him through his open mouth, are clearly visible. The maiolica painter even copied certain particulars of the landscape from the Uffizi painting, such as the little tufts of grass in the foreground and the triangular trees lined up in the background. He emphasized the outlines of the figures, leaving the bodies almost flat, with no indication of muscles. The linear quality of the design suggests that another source must have been a drawing or an engraving, closely related to the work of Pollaiuolo. If it was an engraving, this plate might be the only surviving proof of the existence of such a graphic work by the master or by his circle.

The second plate (145) is also large, and it shows the wear and tear of centuries: there is a well-repaired break almost halving it. This plate was also made in Deruta, around 1510. It has a richly colored and lustered scrollwork frame, and a superbly drawn scene in the center, *Hercules Slaying the Giants,* set against a floral background. The subject is a curious mixture of known prototypes by Pollaiuolo, in painting, drawing, and engraving. The shield-bearing giants hark back to the nude figures in his famous engraving *The Battle of Naked Men.* The club-wielding Hercules with the lion skull and skin on his head is similar to the one in the Uffizi *Hercules and the Hydra.*

The maiolica painter apparently had a set of prints representing the various Labors of Hercules, by or after Pollaiuolo, and made up his own composition as most suitable for the space available. Thus he took a further creative step than the painter of the previous plate. He also had a better grasp of an important characteristic of Pollaiuolo's designs: the masterly treatment of muscles. This maiolica painter in Deruta must have shared the opinion of the many admirers of Pollaiuolo, put so aptly by Vasari: "He had a more modern grasp of the nude than the masters of his day, and he dissected many bodies in order to study their anatomy."

On the third plate, showing *Hercules Slaying the Hydra* (146), the rich crimson lustre and the rhythmical floral border

decoration clearly indicate that it was made in Deruta around 1515. The central composition is derived from elements taken from many of Pollaiuolo's designs. The Hydra has all the "venom, fire, ferocity, rage, and vivacity" mentioned by Vasari in the description of the Medici original; it is also very reminiscent of the beast on the Uffizi painting. The Hercules figure is harder to trace; the back view has very little in common with that of the *Hercules and Antaeus* in the Uffizi and has no relation to Pollaiuolo's known drawings and engravings. Thus we must assume either that there were drawings or engravings from the master's circle showing this back view of Hercules or that the maiolica painter created the pose. To be sure, he could have used the pose (reversed) of the Hercules on the previous plate.

The scene is well fitted into the center of the plate; Hercules' raised arms and his stick curve into the gold scale decoration of the well border. The floral decoration, too, fills the background well; it is present but does not overwhelm. The pictorial center and the floral wreath border complement each other perfectly, not only in design but also in color. The harmony of these various elements gives an unusual beauty to this plate. We can safely say that while the previous plates show only paintings on maiolica, this is a maiolica painting *par excellence*.

Between the Hercules plates are two tall, cylindrical vessels (147) Called an *albarello* in the terminology of maiolica, such a jar was used to store drugs or syrups in pharmacies. This use is reflected in its form: the body is usually drawn in at the waist to provide a good grasp for the hand, while the short neck is flanged at the rim in order to hold the string that held the parchment cover in place. The body is decorated in horizontal bands of flowers and foliage and of stylized peacock feather tips in blue, green, and orange. These ornaments are characteristic of the potters of Faenza around 1480. The peacock feathers are said to allude also to Cassandra Pavone (*pavone* meaning peacock in Italian), mistress of the ruler of Faenza at that time.

While the Hercules plates reproduced well-known works of art, the design on a roundel (157) might have been inspired by an actual happening. The scene on this flat object is a satyrical *Triumph of Love*. It is quite possible that for this design the maiolica painter drew from actual scenes or representations of the colorful processions, entries, or burlesque feasts that celebrated important occasions and provided entertainment in the days of the Renaissance. The costumes, sets, decorations, and other paraphernalia of these elaborate processions and plays were designed by the best artists and they in turn influenced others. Here the captives of Love are displayed on a chariot; a stylishly dressed young woman sits in back while her suitor, a young warrior in armor, rides on a pedestal. That they are captives of the blindfolded Cupid standing in front is indicated

Second Room

by the fact that their hands are tied behind their backs. The chariot is drawn by winged putti and surrounded by lesser but no less colorful participants, a satyr with long, pointed ears and a stylishly dressed dwarf, probably a jester. The stylized background is decorated with strings of pearls hanging from cornucopias. In contrast, the foreground is populated by naturalistic renderings of inhabitants of earth and water: a snail, toad, shell, turtle, snake, and a duck or swan. There are few clues to the exact meaning of this mock-triumphal cortege. The symbolism of the figures seems to be that of love and passion. A late medieval writer, for instance, says of Cupid that "painters cover his eyes with a bandage to emphasize the fact that people in love do not know where they drive, being without judgment or discrimination and guided by mere passion." The blindfolded Cupid further signifies a "lower, purely sensual and profane form of love." This meaning is underlined by the satyr, who represents uncontrolled passion. The meaning of the little amphibious creatures in the foreground is also uncertain, although all seem to have some symbolic relation with earthly, profane love. The turtle in some Renaissance emblem books signifies turgidity. The snake, among other things, symbolizes fertility, and the swan is the sacred bird of Venus, goddess of love. The unusual color scheme, of striking blues and yellows, and the linear, inventive style indicate that the roundel was made in Castel Durante about 1510. The talented painter, who might have been schooled as a book illuminator, must have worked under the influence of one of the finest masters of maiolica, Giovanni Maria (active during the first decades of the sixteenth century) of Castel Durante.

A brightly colored and brilliantly lustered plate (148) is one of the most important pieces of early sixteenth-century Italian maiolica and is decorated with the story of the *Prodigal Son amid the Swine*. The composition closely follows Albrecht Dürer's famous engraving of the same title, usually dated to 1496. In this celebrated print Dürer—the father of the Renaissance in the north of Europe—captured the essence of the Biblical parable: the final humiliation and desperate prayer of the prodigal son when forced to eat from the trough of the swine. Italian artists especially admired this print, probably because it successfully blends Biblical pathos and genre details, such as the hungry, snorting pigs and the quaint German farmyard. Vasari calls this print "most beautiful," and at least three early sixteenth-century Italian engravers copied it to some extent.

It was through these copies that the composition became popular among maiolica painters; at least four of them copied or adapted it during the first half of the sixteenth century. Comparison of our plate with the three others that survive (in Berlin, Cleveland, and Bologna) makes it clear that our painter

was the only one who subjected the use of color to the composition and actual lines of the print. This imaginative artist defined the main parts by using large masses of color and setting them against each other. But his mastery of color is shown best in the application of the lustre. The strong outlines of the figures in the central group and the long vertical and horizontal lines on the timbered buildings of the farmyard provided him with an almost unlimited opportunity to use his virtuosity. This excellent maiolica painter remains unidentified, although his style has been recognized on other objects. Sometimes he is called the Painter of the Three Graces, after a plate in the Victoria and Albert Museum, London; there are also scholars who think that he is identical with Maestro Giorgio Andreoli (active 1519–1553), the most famous lusterer in Gubbio, whose initials, with the date 1525, are painted on the back of this plate. This attribution is more likely because of the high degree of harmony between design, painting, and lustering on our piece. These artistic qualities and the importance of this plate in demonstrating Dürer's influence on Italian maiolica, have earned considerable fame for this piece.

Two plates are prominent representatives of one of the most celebrated groups of Italian maiolica, a service made for Isabella d'Este, Marchesa of Mantua. This extraordinary assemblage is the creation of one artist, Nicola Pellipario of Urbino (about 1480–1542). The first plate (151) is exquisitely decorated with a mythological scene composed of numerous figures, coats-of-arms, and various devices. All these elements are masterfully composed and enhanced by a deft harmony of colors, dominated by blues and yellows. The story illustrated is that of the musical contest between Apollo (Phoebus) and Pan, judged by King Midas and the mountain god Tmolus, as recounted in Book XI of the *Metamorphoses* of Ovid.

The setting is the mountain of Tmolus, and the painting on the plate almost exactly reproduces the story. From left to right Pellipario represented Midas, Tmolus with his bushy hair, Apollo with the crown of bay holding his precious violin, then Pan, Midas again, pointing to his favorite, Pan with the reed pipes. The artist seems to indicate the end of the story by the angry figure of Apollo peering around the tree and possibly by the overemphasized ears of Midas. The composition is divided into two well-balanced groups by the large escutcheon held by two putti and conspicuously painted into the well of the plate. The quartered coats-of-arms are those of Isabella d'Este and her husband, Gian Francesco Gonzaga, Marchese of Mantua. There are also two smaller escutcheons displaying *imprese* (personal devices) hung on the branches of trees: at the left, a candelabrum, which might refer to Isabella's recent widowhood, her husband having died in 1518; at the right, a bunch of lottery tickets, probably an allusion to unpredictable fortune.

The historical facts, the coats-of-arms, and the devices suggest a date between 1519 and 1522, or perhaps a little later. A period of two or more years would have been needed to complete the service, which must have been rather extensive. Twenty-five surviving pieces are known today, most of them plates, three of which are in the Robert Lehman Collection.

Another plate from his celebrated Este-Gonzaga service (152) provides further information about Isabella d'Este and Nicola Pellipario of Urbino. The whole surface of this flat plate is filled with a spirited representation of the *Triumph of Silenus*. In contrast to the previous plate, where the artist used his own imagination, here he relied almost completely on an engraving by Agostino Veneziano, made around 1516. He compressed it and added the coats-of-arms and one of the devices. This latter is augmented by two others: on the right, a little tablet on a tree branch is inscribed with the defiant Latin motto of Isabella, NEC SPE NEC METV (neither by hope nor by fear) ; underneath, a roundel bears her monogram, intertwined YS.

A dish decorated with the profile of a girl (161) displays another side of Nicola Pellipario of Urbino. Painted around 1525, this plate emanates a classical beauty, sureness of the artist's brush, and purity of line. The helmeted girl's name, CARENDINA, is inscribed on the scroll following the outlines of the plate. This precious object was probably presented by a lover to his beloved, since this type of footed dish was called a *coppa amatoria,* or love cup.

An ornate plate (149) demonstrates the influence both of Northern European artists and of ornamental designs by North Italian engravers. The surface of the plate is covered with a complex design, centered around an elaborate structure in the form of a candelabrum base. Putti, masks, trophies, and musical instruments surround this center; they are also intertwined with hanging strings of pearls, stylized fish, and animal motifs. Two curious figures flank the lower part: on the left, a satyr playing a reed pipe; on the right, a reclining woman with a baby in her lap. The composition, painted in blue, white, and yellow, is a curious combination of Albrecht Dürer's engraving of 1505 of a satyr and nymph and an engraving by Zoan Andrea (active 1475–1505) , an artist from Mantua. It is difficult to decide who did the actual painting. Although it reveals the strong influence of Giovanni Maria of Castel Durante, it could have been painted by some other master, whose initials might be the IR that appear on a small tablet near the satyr.

In the center of the room, on the long refectory table (sixteenth-century Italian) , is an imposing piece of maiolica (164) . This large, trilobate vessel is a wine cooler, and as such is a utilitarian rather than a decorative object. The lobes of the vessel are divided by three powerfully modeled satyr heads surrounded by volutes. The stand consists of three clustered lion paws.

In the center of the bowl the *Judgment of Paris* is depicted. The seated young man, "the handsomest of all mortal men," from Troy is shown facing the three alluring goddesses: Hera, Athena, and Aphrodite (Venus). Paris' decision to give the golden apple of Eris to Aphrodite started the Trojan War, and this representation introduces another favorite source for maiolica painters, Vergil's *Aeneid*. The remainder of the inside and the whole outside are decorated with an elegant, grotesque design of intertwined real and fantastic animals, putti, and scrollwork. It is painted in pale yellow, blue, and green on a white background. This linear, ornamental design imitates Raphael's famous frescoes in the Vatican painted between 1509 and 1514, which in turn are based on antique Roman fresco decorations. This style is characteristic of a large maiolica workshop in Urbino operated by successive members of the Fontana family during the middle and late sixteenth century. Judging from the quality of the design and the style of the grotesque figures, this piece may be attributed to the circle of Orazio Fontana (1510–1571) and dated around 1560.

Similar luxurious wine coolers are depicted in paintings of the period, and it is mainly from these representations that we know how they were used: the bowl was filled with crushed ice or cold water, and then long-necked, globular flasks filled with wine were placed into the lobes to cool. The furrows on each side of the satyr masks also served a practical purpose: drinking glasses were placed in these shallow furrows by their long stems so that the cups rested on the ice. (There are several sixteenth-century globular flasks and long-stemmed Venetian drinking glasses in the Collection.)

The chandelier above the table is a fifteenth-century Flemish bronze work. In its center stands a statue of the Virgin and Child; the branches are decorated with figures of hunters and wild animals.

A large bowl (150) is a world-famous object. For more than a century it has been acclaimed, published, and reproduced, and recently it was called "both technically and artistically one of the high points of Italian maiolica." The painted decoration is masterfully constructed from various elements. The center is occupied by the coat-of-arms of Pope Julius II (Pope 1503–1513), showing the oak tree of the Della Rovere family (*rovere* means oak). The arms are crowned by the papal tiara superimposed on two elaborate, crossed keys (symbols of papal authority). Above a square red hanging, the veil of Veronica with the Holy Face (*vera icon*) is displayed by a putto. Beneath the papal arms is another coat-of-arms surrounded by trophies: it has been identified as that of the Manzoli family of Bologna. This central part is surrounded by putti and satyrs in symmetrically arranged tiers. The upper pair of putti stand on cornucopias and hold rich festoons by means of ropes. Next to them a

pair of sitting satyrs blow on stylized horns. The lower pair of putti sit on dolphins; above their heads in two roundels is the monogram of Julius II.

An inscription on the well-decorated back states that the bowl was "made in Castel Durante by the potter Giovanni Maria on September 12, 1508" (*1508 adi 12 de sete[m]br[e] facta fu i[n] Castel dura[n]t[e] Zova[n] maria v[asa]ro*). In all probability, it was commissioned as a gift for Julius II by Melchiorre di Giorgio Manzoli on the occasion of his being appointed senator by the Pope. Such an imposing piece for the head of all Christianity must have been so important a commission that the artist felt compelled to sign his name. This is the only record we have of Giovanni Maria of Castel Durante, and therefore it is not certain whether he was in fact the painter as well as the potter (*vasaro*) of our bowl. More important, however, this signed and dated piece enabled Bernard Rackham to attribute a large number of maiolica objects to Giovanni Maria and to establish a relative chronology among them. It is mainly because of this bowl that his distinctive colors, the soft, grayish blue, the light amber brown, as well as the beautifully drawn dark blue contours of his style, are clearly recognizable and acclaimed as the highest achievements of maiolica. At least two other objects attributed to Giovanni Maria are in the Robert Lehman Collection, one already described (157).

A large dish (158) painted with a famous Renaissance subject, the *Death of Laocoön,* has an unusually lengthy inscription on the back: "Sea serpents killing Laocoön and his sons as it is told in the second book of the Aeneid by P. Vergilius Maro." The inscription further states that the plate was "made by Francesco Xanto Avelli of Rovigo in Urbino" (active about 1530–1542). The initials M.G. and the date on the back indicate that the plate was lustered by Maestro Giorgio Andreoli in 1532.

The story of Laocoön was well known to medieval and Renaissance artists from Vergil's *Aeneid,* and from illuminated manuscripts that preserved the text. Vergil describes in great detail how Laocoön, the priest of Apollo, and his sons tried to warn the Trojans not to take the tempting, enormous wooden horse built by their enemies the Greeks inside the walls. The gods supporting the Greeks sent two sea serpents to strangle Laocoön and his sons. Maiolica artists were also aware of the story of Laocoön from the fame of its most important ancient representation, an imposing Greek marble statue that was praised by Pliny in his *Naturalis historia.* This legendary sculptural group, after having been lost for almost a thousand years, was found by accident in an underground chamber on January 14, 1506, by a peasant who was working in his vineyard near the church of San Pietro in Vincoli, Rome. The news of the fabulous discovery spread throughout Rome, reaching Pope Julius II, who sent his architect Giuliano da Sangallo to investi-

gate and to secure the statue for his collection. Sangallo took along his houseguest Michelangelo, and, according to later accounts of the visit, both were awed by the beauty of the statue. Thus it is no wonder that on March 23 of the same year Julius II purchased it and after restoring the missing arms had it installed in the Belvedere court of the Vatican, where it still stands.

The story of Laocoön and the sculpture itself deeply impressed sixteenth-century Italian artists and art lovers. They admired it not only as a sculptural creation of exceptional beauty but also as an *exemplum doloris,* a perfectly formulated symbol of sorrow. Soon copies were made in marble and bronze, and its fame spread by means of drawings and engravings, which in turn were eagerly copied on frescoes, cameos, jewels, and maiolica plates.

This complex history of the Laocoön group is reflected on our plate. The composition in general follows an engraving made shortly after 1506 by Marco Dente, in which the struggling figures, instead of being nude (as in the original), are dressed in fantastic Roman armor and placed on a rectangular base. But the plate differs from the engraving in that the group is placed in a vaulted hall, probably an allusion to the underground chamber where the sculpture was found. The composition is forceful and well balanced: the extended arms and spread legs of Laocoön fill and unify the pictorial space. The figures of the sons are well spaced between the crossing diagonals formed by the arms and legs. The composition, the violence, and the grief shown on the faces were especially suitable for the painterly temperament and talents of Francesco Xanto Avelli, as Bernard Rackham sums it up: "His coloring is rich and strong almost to violence, with an abundance of bright orange and yellow—washing pale mauve over blue. His work is . . . that of vigorous temperament and . . . results in a splendid and highly decorative harmony of colors and rhythms."

The large plate to the right of the bowl (163) carries us down from the heights of humanist learning to a more popular level, that of the genre scene. The deep well of the plate, encircled by a strikingly decorated wide rim, shows a comic group: an ass seated in an armchair while his mouth is washed from a bowl held by a standing, aproned man. The anecdotal mien of the scene is underlined by the inscription on the side of the chair: CHI LAVA/ EL CH[A]PO/ AL ASEN/ SE PERDE/ERANNO E/ L[A]SAPONE. It sounds like a proverb and might be translated as: "He who washes the head of the ass will lose the soap." Although there is no signature or date on the back of this plate, by the style of its ornamental decoration it may be attributed to a workshop in Deruta. The pottery painters of this little Umbrian town were especially interested in this and other themes based on proverbs. At least five other existing plates show the seated ass and the man in similar manner and are dec-

orated with the same divided rim of acanthus leaves and fish-scale motifs. Since two of these plates bear the dates of 1552 and 1556, our plate may be assigned a date about 1550.

A bowl and its cover, in the center of the second shelf, are among those rare maiolica objects made to be used. These two pieces were once parts of a so-called confinement set. Such a set, given to a woman after the delivery of a child, consisted usually of five vessels made to fit into each other. The main part was the broth bowl (159), with a flat cover serving also as a plate for bread (160). On top of these were placed an inverted drinking cup, with a salt cellar fitted into the upturned foot, and a cover forming a finial to the whole assembly. As in the case of our two pieces, usually only the broth cup and its cover have survived.

Their elaborate decoration, according to Rackham, "shows that their donors were thinking less of their practical usefulness, than of their suitability to be kept as memorials of the occasion." Our pieces are richly decorated on both sides, and the pictorial representations are accompanied by appropriate inscriptions. The bowl is painted with the story of *Aeneas and Anchises,* another episode from the Trojan War. The scene depicts vividly how Aeneas, one of the survivors of the war, carried his father Anchises on his back out of the destroyed and burning Troy. The outside is embellished with an ornamental design surrounding a coat-of-arms. The cover bears on one side the story of *Pyramus and Thisbe,* the classical predecessors of Romeo and Juliet. On the other side *Hercules Slaying the Lion* is represented.

The muted yellow and blue color scheme, as well as the minute details, are indicative of the style of Baldassare Manara (active in Faenza in the first half of the sixteenth century, died in 1547). Our two pieces may be dated to around 1530, when the artist was strongly influenced by the style of the Urbino maiolica painters. The noble lady to whom the set was presented remains anonymous because the coat-of-arms on the bowl is still unidentified. But we have a fleeting glance at her from the poetic inscription around the rim of the bowl, which describes her: "God with his hand created you so fair that now to mortal eyes you appear more precious than any oriental precious stone."

A large plate with the profile portrait of a woman (162) introduces a type of decoration not observed on the previous examples. The inside of the plate, between the rim with the pleated ribbon and the portrait, is decorated with ornaments molded in relief, consisting of masks, dolphins, and other intertwined fantastic animals painted in lustre against a light blue background. This type of exquisite ornamentation appeared around 1520 in Deruta, and this is the date that might be assigned to our plate.

Five objects bear the same coat-of-arms: a blackamoor head,

prominently displayed,of the Pucci family of Florence. The service to which these colorful objects once belonged was commissioned by Piero Maria Pucci (born 1467), who in 1520 was appointed *gonfaloniere* by Pope Leo X. The large jug (153) is decorated with a boldly designed cornucopia surrounding the coat-of-arms. The colors and the simple decoration signal that it was made in Caffaggiolo in the 1530s. A closer dating is provided by a plate (154). This brilliantly lustered object carries an inscription on the back stating that it was made in 1532. The story on the front is that of Jupiter changing (on the right) the two sisters of Phaëton into poplars and (on the left) Phaëton's friend Cygnus into a swan (Ovid's *Metamorphoses,* Book II). The back also bears the signature of Francesco Xanto Avelli of Rovigo. It seems that Francesco Xanto decorated dozens of plates and other objects for this justly famous service. Another plate (155) is also signed by him and dated 1532. The scene on it represents Aeneas and his companions at the tomb of Polydorus (Vergil's *Aeneid,* Book III). This plate is distinguished by the masterful use of the Gubbio lustre, enhancing the effectiveness of the whole design.

Dining Room

The stately dining room was one of a succession of formal rooms occupying the second floor of the Lehman house. The beamed and coffered ceiling is painted in the manner of those still found in seventeenth-century Italian *palazzi.* The chandelier is seventeenth-century Dutch brasswork. The red and gray marble floor and the Gothic-style bay windows were designed by the architect of the house.

This somber but imposing room is dominated by a single work of art, a Flemish tapestry from around 1510 showing the story of *St. Veronica's Veil Curing the Emperor Vespasian* (140). It is made of wool and silk, interwoven with gold and silver threads. Although it bears no signature nor the mark of a tapestry weaver, it can safely be attributed on the basis of style and technique to one of the many workshops in Brussels.

In the center Veronica holds her veil with the image of Christ before the weak, half-kneeling Emperor, identified as VESSPEIANVS, inscribed below his feet. The story of how this miraculous veil came to be has two versions: according to one, Veronica, the pious woman of Jerusalem, was so moved by the suffering of Christ bearing the cross that she offered her veil to wipe off his face. After the Lord used the veil the likeness of his face was miraculously pressed upon it, thus producing his only true image, or *vera icon.* The other version, more medieval and romantic, is told in the *Golden Legend:* "Veronica said, 'As

Jesus was always travelling about to preach, and I could not always enjoy His presence, I once was on my way to a painter to have the Master's portrait drawn on a cloth which I bore with me. And the Lord met me in the way, and learning what I was about, pressed the cloth against His face, and left His image upon it. And if thy master but looks upon this image, he shall straightway be cured.' " Veronica was therefore summoned by an envoy to take the veil to Rome and cure the ailing Emperor Vespasian.

The story, with successive episodes, was very popular in the Middle Ages. It was known to almost everyone, mostly through a mystery play entitled *The Vengeance of Jesus Christ*. As we know from the first edition of this play, printed in 1491, or shortly before our tapestry was made, the mystery took four days to perform and employed 177 actors. This tapestry not only recites the story but, with its rich and complex composition (there are close to fifty figures), represents it in the manner of a mystery play. The artist who designed the cartoons for it must have seen these plays, and he imitated their stage settings and the groupings of actors in them.

The miracle is set in the Emperor's bedroom, dominated by a canopied and curtained bed. As on a stage the prominent persons are crowded into the center: Veronica, the Emperor, his son Titus, who gently supports his father. Five attendants holding long candles surround them and emphasize their importance. The supporting characters are arranged around them in well-defined groups. To the left of Veronica, the bare-headed young man is the envoy who brought her to the court. Behind him, a richly attired old man with arms crossed on his chest and another in a scholar's gown seem to be the councilors of the Emperor. In the upper right-hand corner of the tapestry, next to the head of the bed, an ornately dressed physician with a urine glass in his hand looks somewhat dismayed at the miracle.

There are many wonderfully characterized figures in the lesser groups. The young woman shown in complete profile (left side, between the envoy and the councilor) looks as if she had been cut from a fifteenth-century Florentine painting. The young courtiers and attendants are represented with individuality and they wear an almost unending succession of fabric patterns, pomegranate velvets, silks, brocades, embroidered edges, and furs. Behind the physician, the face of a middle-aged man is partly hidden by the open door. This might be a self-portrait of the weaver, or, more probably, that of the artist who designed the tapestry.

Since there are no marks or signatures, it is very difficult to connect the design with any particular Flemish artist of the period. Certain characteristics, such as the standing girl in complete profile, or the profuse use of silk and velvet patterns, indicate that the artist was influenced by Italian art. At the same

time he shows a strong inclination toward individual characterization and inventiveness in genre-like figures such as the physician. All these point toward the circle of Quentin Matsys (about 1465/66–1530), the eclectic painter from Louvain who had become the leading artist in Antwerp by 1510. His *Deposition* altarpiece (in the Musée Royal des Beaux-Arts, Antwerp), painted between 1508 and 1511, abounds in scenes arranged in the same theatrical manner and in figures strikingly similar in outline to those on our tapestry. The Italian influence in Matsys's art is probably due to a trip to Italy, and on both the *Deposition* and on our tapestry this is demonstrated by the variety of expressions, gestures, and textures.

On the dining room table precious objects from the sixteenth century are gathered. What they have in common is that most were used on courtly tables and were commissioned by French patrons of the arts; they were either made in France by local artists or created in the great centers of Italy.

The large, clear glass *tazza* (a footed dish) (167), with a ribbed bowl and enameled dot and gilt decoration, is probably a Venetian work. The coat-of-arms on its foot is that of Louis XII of France and Anne of Brittany, who were married from 1499 to 1514, the date of the queen's death. This dates the tazza generally to the first decades of the sixteenth century, but it is most likely that it belonged to a large set of Venetian tableware commissioned for the wedding of the royal couple in 1499. Judging from the surviving pieces (in the Cluny Museum, Paris; Toledo Museum, Ohio; Victoria and Albert Museum; and formerly in the Rothschild Collection), the set must have been extensive. The tazza reflects a change in fashionable table services: sets of gold and silver were replaced by less costly but equally artistic glass or ceramic vessels.

The pair of maiolica candlesticks (165) is probably the work of Guido Durantino, called Fontana (active 1520–1550s), of Urbino. The scenes on top of their bases represent the stories of *Vulcan Forging the Arrows of Cupid* and *The Birth of Castor and Pollux*. The lower parts are decorated with landscapes, and the stems with putti. The arms on both are those of the Constable of France, Anne de Montmorency (1492–1567). These candlesticks were part of an extensive service of maiolica, many pieces of which still exist in various collections. Some of these pieces, all with the same coat-of-arms, bear the date 1535 and the mark of the workshop of Guido Durantino. Thus our candlesticks may be assigned the same date.

The large maiolica plate (166) is highly decorative. In its center the nude figures of *Orpheus and Eurydice* are copied from a well-known engraving by the Venetian engraver Marcantonio Raimondi (about 1475–1534). The decoration of the wide rim consists of intertwined sea horses and putti, divided by trophies of arms and armor. The figures in the well and on

the rim are raised, painted, and lustered in light hues of blue and yellow on a deeper blue background. Because of this raised decoration and the lustre, this plate was long thought to be from a workshop in Deruta, where raised ornament was widely used. The figures after Marcantonio seemed to confirm this. However, scholars are now inclined toward an attribution to a French workshop that used Italian methods and prototypes; the light colors and the thin lustre also seem indicative of French origin.

The large oval plate with the representation of the *Crossing of the Red Sea* (170) is a French Renaissance work from the second half of the sixteenth century. Both sides of it are decorated with painted enamel, a technique developed to perfection in the city of Limoges, famous for its enamels and metalwork for almost a millennium. Sixteenth-century Limoges enamel differs from earlier types, such as *champlevé* or translucent enamels, in many ways. The artist used a thin copper plate fashioned into the shape of the desired object. On top of a foundation of neutral-colored enamel, into which silver foil was sometimes fused, the enameler painted and fired the decoration in stages, first using the color with the highest melting point.

The front of our plate is done in brilliant hues of blue, green, and reddish tan on a black and gray background. The foaming water of the Red Sea separates the composition, with Moses and his people on the left and Pharaoh's army on the right. The faces and beards of the people on the left are accentuated with pale ochre and white, echoed by the same colors on the drowning horses and army. The subdued but vibrant colors are embellished by the use of gold, emphasizing the folds of the robes, the spears in the background, and the rays emanating from the upper center representing God's command. The band encircling the center is decorated with scrollwork painted in gold. On the rim fantastic winged and human-headed animals and herms alternate, mostly in pearly white enamel.

The back of the plate is equally ornate and enameled in grisaille, that is, in hues of black, white, and pearly gray. The decoration consists of pairs of female and male herms, with harpies and strange, dog-like animals, all facing an oval escutcheon in the center. This contains the initials I.C., the maker's signature. These initials are found on several other objects, and for a long time the artist was thought to be a member of the Courteys family, enamelers of Limoges, probably Jean. Recently it has been proposed that the objects thus signed are probably products of a workshop directed by two Limoges artists, Jean de Court and Jean Court, called Vigier ("magistrate"). Since dated and signed works by both these latter artists exist (1555 and 1556), and since their style is similar to that of our plate (and half a dozen similar ones), it can be assumed that all were made at about the same time, by various members of the shop under the direction of the two masters.

The tazza with the representation of *Christ and the Woman of Samaria* (171) is also a Limoges enamel from the second half of the sixteenth century. The border is decorated with gold arabesques; the back of the bowl, the stem, and the foot are painted with masks, caryatids, and sphinxes. The painting is a symphony of blue, green, and purple enamel, punctuated with the white of the faces, arms, and legs. Powdered gold serves to emphasize the folds, the highlights on the buildings and on the hills of the background. Close to the upper rim, just above the right-hand bird, are the initials s.c. The high quality of the piece and stylistic comparisons suggest the signature may be that of Suzanne Court, the only known woman enameler of Limoges (There is a signed plate by her in the Sitting Room, 169.)

The triangular salt cellar (168) with three putti belongs to a rare group of French Renaissance ceramic art, so-called St.-Porchaire faïences These precious and delicate objects (only a few dozen are known today) were manufactured in the village of St.-Porchaire from about 1525 to about 1565, mostly during the reigns of Francis I (1515–1547) and Henry II (1547–1559) The method of making this type of faïence was as follows: The main body as well as the sculptural and ornamental parts were modeled from the same cream-colored fine clay. While still pliable, the linear patterns were impressed, probably with stamps. Then dark clay pastes were embedded in the tracery, glazes of various colors were painted on, and finally the object was fired. St.-Porchaire faïence, in spite of its relatively inexpensive material, has a strong resemblance to inlaid, enameled, and sculptured goldsmith's work.

This is clearly visible on our salt cellar. The putti, the bearded masks on the base, and the festoons on the top are carefully modeled. The decorative patterns are precise and are harmonious with the figures and architectural details. In the shallow bowl the embedded decoration represents the arms of France surrounded by the collar of the order of St. Michael. The interlaced crescents of the shields held by the putti are a reference to Diane of Poitiers (1499–1566), the mistress of Henry II. These dates, the technique, and the style of the decoration indicate that our salt cellar belongs to the middle period of the St.-Porchaire workshop, to the 1550s, and that it was probably part of a set made for the king or his mistress.

Red Velvet Room

This room most fully preserves the character of the original one in the Lehman townhouse. The entrance is through a late-sixteenth-century, richly carved and gilded doorway framed by two columns. The walls are covered with eighteenth-century

French red velvet, and the carved, gilded cornices are contemporary with the doorway. The luxurious character of the room is enhanced by late sixteenth-century gold-embroidered curtain headings, by red velvet chairs and their embroidered pillows, and by elaborately carved furniture with bronzes and maiolica placed on it. This was the ambience that both Lehmans considered right for the presentation and enjoyment of their most important masterpieces. The invalid Philip Lehman spent many hours sitting in his wheelchair before some of the paintings in this room, especially the Botticelli *Annunciation,* a birthday present from his son. Robert Lehman's favorite resting place during his visits to the house was one of the red chairs, where he sat in contemplation.

The paintings in this room represent the most important and influential masters and schools of fifteenth-century Italian painting, the artists of Siena, Florence, and Venice at their best. The room is dominated by an extraordinary painting, the *Expulsion from Paradise* (19) by Giovanni di Paolo (1403–1483). This panel is a fragment of a predella, which in turn once was part of an altar probably painted for the Guelfi chapel, church of San Domenico, Siena, around 1445. (Another panel from the same predella showing the *Paradise* is in the Metropolitan Museum.) In spite of its relatively small size and the fact that it is a fragment, this panel is generally regarded as one of the most important works of the artist, and it is widely admired for its brilliant colors, curious iconography, and mystical vitality.

The *Expulsion* of Adam and Eve from paradise and their banishment to earth is represented in a complicated manner. The figure of God, surrounded by angels, hovers in the upper left corner. His forcefully outstretched right arm and the penetrating rays of His halo signify that His will is directing the momentous action that will decide the fate of mankind. On the right side the angel is bodily pushing Adam and Eve out of paradise, abundant with trees bearing golden apples, colorful flowers, and meek little animals. God's finger points toward the place of their banishment: the arid, flat earth surrounded by the concentric circles of the universe and framed in the outermost circle with the twelve signs of the zodiac. This roundel dominates the composition, superimposing the horizontal line that divides the pictorial field into almost equal halves of ground and sky. The concentric circles with their pulsating colors seem to generate forces that draw the attention to the center. Here the earth is represented in the customary medieval manner in the form, roughly, of the letter т, with Europe and Asia forming the top bar and Africa the stem. Only mountains and rivers are indicated; it is as if the uninhabited place is waiting for the first couple to till the soil, make it fertile and populate it.

The semi-abstract form of the representation of the universe is in vivid contrast to the abundant details of the paradise on the

right. Under the golden apple trees, the flowers, fruits, and little animals flourish in a mystical symbiosis. The four rivers of paradise "course the world to the four geographic directions, symbolizing by extension the four virtues by which man will eventually be saved, and, thence the Four Gospels, announcing this salvation to Christendom" (John Pope-Hennessy). The strawberries are symbolic of the Virgin Mary (as the second Eve; see p. 16), as are the lilies so obviously placed between the angel and Adam and Eve. Lilies appear in almost every Annunciation scene symbolizing the message of salvation, whereas here they symbolize the message of banishment. Thus the composition and iconography represent a theological dogma: as a consequence of the first sin man was not only expelled from paradise and banished to earth, but also given the promise of salvation.

The *Expulsion* is a characteristic painting from the artist's best years, around 1445. The slender, nervous figures of the angel, Adam, and Eve betray his indebtedness to the International Gothic style prevalent around 1400, and especially to Gentile da Fabriano and to French miniature painting. The wondrous details of the flora and fauna, the refinement of the painting of the bodies, and the delicate coloring of the angels surrounding God reveal his talent as an illuminator. Many scholars have noted that the tight composition of the three figures was borrowed from a relief by Siena's greatest sculptor, Jacopo della Quercia. But besides his capacity for absorbing techniques, Giovanni di Paolo possessed an inventive talent. The hovering figure of God, with outstretched arms and pointing finger, seems to have been later utilized by Michelangelo for the *Creation of Adam* scene in the Sistine Chapel. Our painting also reveals that Giovanni di Paolo remained largely unaffected by Florentine art, and was called by John Pope-Hennessy "one of the most individual fifteenth-century Italian painters."

On the sixteenth-century table is a bronze *aquamanile* in the form of a mounted knight (123). (An aquamanile is a container for water in the shape of an animal, a human figure, or a group. The water is dispensed through the mouth, or through a spout or spigot.) This vessel is filled through a hinged opening on the horse's neck; the short tube on the forehead serves as spout. The somewhat stiffly modeled figures are embellished with engraved decoration characteristic of bronze-casting workshops in Lower Saxony during the thirteenth and fourteenth centuries. The helmet with the high crest, the chain-mail shirt, and the armor allow us to date this aquamanile toward the end of the thirteenth century. Since it has no apparent religious connotation, it can be assumed that it might have adorned the table of a secular lord or possibly have belonged to a ceremonial table service of a knightly order.

The *Annunciation* (15) has traditionally been attributed to

Stefano di Giovanni, known as Sassetta (1392–1450), another great Sienese artist and a contemporary of Giovanni di Paolo. The two figures standing in front of the gold ground are poetic in their simplicity. Their humility is expressed by the deeply bowing figure of the angel and the gesture of receptivity in the outstretched, delicate fingers of the Virgin. There are no distracting details; the colors are muted; and even the punched-in halos blend into the gold background. This great restraint and use of large, simple forms to express emotion seems to indicate that this panel is an autograph work of Sassetta. The date can be securely set between 1430 and 1440 by comparison with some of the master's dated altarpieces. Nevertheless, there are connoisseurs of Sienese painting who consider this panel to be by an assistant or a close follower of Sassetta, admitting that the master himself may have outlined the main parts.

There are many problems concerning Sassetta's oeuvre, but none so much debated as that connected with *The Temptation of St. Anthony Abbot* (16). This panel, with seven known others (four in the National Gallery of Art, Washington, D.C., two in the Jarves Collection, Yale University Art Gallery, one in Berlin) and probably a few more still missing, once surrounded a painting of *St. Anthony Abbot in Meditation* (in the Louvre), forming a large polyptych. For a long time all these panels were attributed to Sassetta and considered his chefs-d'oeuvre, painted between 1430 and 1440. After World War II, Italian scholars, on the basis of stylistic differences, attempted to detach the St. Anthony panels and other important works from the oeuvre of Sassetta and to attribute them to a contemporary but distinctly different artist. This painter was given the name of the Master of the Osservanza Altarpiece, after a triptych dated 1436, now in the basilica of San Bernardino all'Osservanza in Siena. This was opposed by many scholars, and the attribution of the St. Anthony panels is still hotly debated; however, the attribution of our painting to Sassetta has been reaffirmed but dated shortly after 1444.

St. Anthony (about 251–356) is considered the founder of monasticism. He gathered hermits into loose communities and exercised authority over them, hence he is called the Abbot. He passed most of his life in the Egyptian desert in solitude. During this time he underwent manifold temptations, both physical and spiritual, but overcame them by faith. The temptation depicted on our panel occurred to him in the desert; a golden porringer, held by the devil, who mocked and tempted him, vanished in a puff of smoke when the saint lifted his hands in prayer or blessing. Unfortunately, the devil and porringer have been scraped off our panel, but their position can be detected by the grayish spot halfway between the saint and the little rabbit on the left.

The desert, with its withered trees, a few hungry animals, and

a rocky road leading into the distance, is depicted by Sassetta in an almost surrealistic manner. The winding road first leads the eye to a strangely cubistic pink chapel, then toward the curving horizon where on a lake or bay surrounded by mountains a solitary sailboat floats. Beyond this eerie landscape looms the sky; its blue, gray, and red cloud ribbons interrupted by a gold streak above the chapel and by two ominous-looking black birds.

The style of the painting, its colors and technique, are strikingly different from those by contemporary Italian painters. John Pope-Hennessy thinks that "the skeletal trees," "the rolling landscape," and "the linear pattern" on our panel derive from Sassetta's acquaintance with early fifteenth-century French miniature painting. But Sassetta's innate artistic temperament, his sensitivity to nature, is also apparent, as Pope-Hennessy observed: "This was brought home to me very vividly last autumn when late one afternoon I went out from Siena to Lecceto. On the way back the sun began to set, and there above the wooden hills Sassetta must have had in mind when these panels were designed, there lay a flaming sky, patterned with pale grey lines of cloud, just as Sassetta shows it in the Lehman scene."

The large panel showing the *Coronation of the Virgin* (22) has been called "one of the most beautiful amongst the large-scale compositions of Giovanni di Paolo." Indeed, the well-composed, colorful painting, with the Virgin and Christ seated on a wide throne surrounded by angels, reveals him as a very successful painter of large-scale figures, of forms and textures. This panel also demonstrates how much the artist is still influenced by the Gothic style of the previous era. The symmetrical composition, with the two main figures seated on an elaborate, marble-inlaid throne, harks back to fourteenth-century examples. The elongated figure of the Virgin, in her gold-embroidered white robe, clearly shows the influence of the miniatures in the so-called International Gothic style. The preoccupation with textures, such as the Virgin's robe, the deep red, brocaded velvet cover of the throne, the richly embroidered edge of Christ's mantle, and the finely wrought crown, are also signs of this influence. The two angels at the base of the throne, one playing a portable organ, the other a harp, frame the composition.

Both composition and style indicate a date later than the *Expulsion from Paradise.* A large painting by Giovanni di Paolo of the same subject, in a church in Siena, is securely dated 1445. The elegant figures, their pleasing faces and colors, do not show the mannered repetitiousness characteristic of Giovanni di Paolo's last works, and therefore we may conclude that our panel was painted around 1445.

With the addition of the Lehman Collection, The Metropolitan Museum of Art has become probably the greatest depository

of works by Giovanni di Paolo. Almost every period and facet, almost every important altarpiece by this important Sienese artist, are represented, and, along with works by other Sienese artists, make the Museum one of the world centers for the study of Sienese art.

The carved and gilded cassone (136) is a masterpiece of North Italian woodcarving from around 1550. The three visible sides are carved with exquisite high reliefs. In the center of the front two putti support an oval escutcheon bearing on the left the arms of the Doria family (above) and those of the Gagliardi family (below). On the right, a crescent indicates that a son of the head of the Doria family married a daughter of the Gagliardi. On the left of the front panel a group of pagans brings offerings to a statue of Apollo; the right side probably depicts Christians bringing gifts to the enthroned Emperor Constantine. The front corners bear a nymph and a warrior carved in the round; the side panels show Apollo pursuing Daphne and Diana fleeing from Orion.

The *Madonna and Child* (49) by Giovanni Bellini (about 1430–1516) is an important early work of this Venetian master, who became popularly known as the "painter of Madonnas." The brooding calmness of the Mother and the Child, whose hand is raised in blessing, and the serene landscape forecast the later success of the artist. His influence spread far and wide in Italy and northern Europe; echoes of this composition can be detected even in the Madonnas of Albrecht Dürer.

The almost hieratic composition is coupled with a feeling of intense stillness. The former is mostly due to the Byzantine inheritance of Venetian painting; the latter comes mostly from the classical, sculptural modeling of the figures. The dignified joining of the two figures, with the Child clasping his Mother's right hand, and the uninterrupted fall of drapery from the Madonna's headdress and the Child's tunic, contribute to the serenity of the painting. The landscape shows a town on the left, a river and castled hill on the right, quiet and undisturbed by human or animal figures. The only seemingly intrusive element in this idyll is the garland of fruits and leaves behind the Madonna's head. The fruits may have a symbolic meaning, and the town may also be a specific place, perhaps indicating for whom the painting was made. (Before its acquisition by the Lehmans, the painting was in the collection of the princes of Potenziani, hence sometimes called the Potenziani Madonna.)

The dramatic intensity and the strong plastic qualities of the figures reveal the influence of the great Paduan painter Andrea Mantegna, Bellini's brother-in-law. Although there is neither signature nor date on the painting, we can place it on the basis of style in the early years of the master, around 1460. (Another early *Madonna and Child* by Bellini is in the Metropolitan Museum.)

The *Annunciation* (36) by Sandro Botticelli (his real name was Alessandro Filipepi, 1444/45–1510) is one of the jewels of fifteenth-century Italian art. Placed here on a sixteenth-century French lectern, this intimate view of the panel not only promotes its enjoyment but is appropriate because the painting was in all probability meant for private devotion in a small chapel or chamber.

This *Annunciation* embodies the achievements that made the art of Florence so famous and influential in the second half of the fifteenth century. The classical architectural setting is rendered in perspective, one of the great discoveries of Florentine artists. The receding rows of pillars and the coffered ceiling, the glimpse of the Virgin's bedroom through the doorway and of the outside through the arched windows, imbue the small painting with a feeling of depth. The Virgin's oratory is sparsely furnished, and its privacy is emphasized by the half-drawn curtain. The tranquility of the setting contrasts with the colorful and vibrant figures of the Madonna and the angel. They are self-contained, exquisitely drawn and painted figures, seemingly separated by the center row of pillars, but subtle artistic devices draw them into a unified composition. For instance, their outlines are almost mirror-images of each other; the rays of light coming through the doorway, which carry God's message from heaven through the angel to the Virgin, also tie the figures together with their diagonals. These diagonals, along with the angel's wings, cut the vertical and horizontal lines of the painting and create an interplay of triangular patterns. This complex composition, the quality of the drawing, and the transparent colors are indicative of Botticelli's late style, developed about 1490. He painted several small Annunciations during this period, but critics agree that this is probably the most appealing.

The appreciation of the little *Annunciation* is reflected in its history. Early in the nineteenth century it was among the treasures of the Barberini Palace in Rome; later it became a prized painting in the collection of Oskar Huldschinsky in Berlin. While there, its attribution to Botticelli was questioned, but neither the collector nor the connoisseur Wilhelm Bode were shaken by this opinion. Their admiration was shared by Robert Lehman, who acquired the painting in 1928. Knowing of the doubts about it, he sent a cable to Bernard Berenson: "Do you consider Annunciation from Huldschinsky Sale entirely by Botticelli. Have bought it from Steinmeyer. . . ." The laconic answer was "Yes. Berenson." The great connoisseur elaborated in the following letter, of interest for the history of the Lehman Collection:

Hotel Grande Bretagne Lampsa Anthenes. Nov. 14, 1928.
Dear Lehman. As I have been knocking about some days on my way from Constantinople letter with cable reaches me today only. I answer "Yes. Berenson."

The little Huldschinsky Ann[unciation] is in my opinion an autograph Botticelli.

I have not taken in the fact that you were making a collection of your own distinct from your father's.

Please let me know what you have already and keep me informed. My lists will not be closed till next summer I suppose. And let me know about your drawings. As soon as I get my lists cleared off my desk, I shall begin the revision of my Florentine Drawing.

Please remember me to your parents. Sincerely, B. Berenson.

Robert Lehman acquired the painting to honor and please his father, and it remained one of the favorites of both. At the Metropolitan it joins Botticelli's *The Last Communion of St. Jerome* and *Three Miracles of St. Zenobius*.

The *Madonna and Child* (17) in the elaborately carved and gilded frame is by the Sienese painter Benvenuto di Giovanni (about 1436–about 1518?). This late master of the Sienese school developed a pleasing style using Florentine and Venetian elements in his compositions. The sweet, oval face of the Madonna recalls Botticelli, while the sculptural qualities of the Christ Child are reminiscent of Giovanni Bellini. The painting bears no date, but comparison with dated works points to around 1490.

The curious fruit held by the Madonna and Child is a pomegranate, which is symbolic in many ways. Because it contains countless seeds in one fruit it alludes to the unity of the Church. Since antiquity it has also been a symbol of fertility, and thus is an attribute of the Madonna. Finally, since the fruit gives life to many others through its seeds, it is also a symbol of resurrection and immortality: the reason that the Child is shown holding it.

The painting is in its original wooden frame and, according to experts, in its original state, never having been varnished. The delicate carving of the angel's head and columns, covered with gesso and gilding, is the work of a professional carver. By the fifteenth century, in contrast with earlier periods (compare the frame of Paolo di Giovanni Fei's Madonna [13]) painters no longer prepared frames; this activity was carried out by a separate group of artisans, the frame-makers.

The two small portraits framed together are attributed to Jacometto Veneziano, a Venetian miniature painter active from about 1472 until a short time before 1498. The man is sometimes called *Alvise Contarini* (53), while the female portrait is supposed to represent a *Nun of San Secondo* (54). The uncertainty about dates and identifications stems mainly from the fact that no signed work of Jacometto has survived, although he enjoyed an almost legendary fame among his contemporaries. What little we know is culled from sixteenth-century descriptions and inventories. In these he is called "the best miniaturist of the

world," who illuminates manuscripts in "the most sophisticated manner," and one who was commissioned to paint portraits of many famous Venetians.

The chronicler Marcantonio Michiel in 1543 reported seeing in the house of Michiel Contarini in Venice "a small portrait of Messer Alvise Contarini, who died some years ago; and in the same picture there is opposite the portrait of a nun of San Secondo. On the cover of these portraits is represented a hind and a landscape. . . . It is a perfect work by Jacometto." Almost a century ago our two little paintings were identified with those seen by Marcantonio while they were part of the collection of the princes of Liechtenstein in Vienna. They are considered among the earliest and most famous examples of portrait painting, an art characteristic of Venetian artists of the sixteenth century. Scholars have used these portraits to define Jacometto's style and on this basis to attribute other paintings to him. (One, a *Portrait of a Young Man,* is in the Metropolitan Museum.)

The portrait of the man successfully captures a wealthy Venetian merchant, a member of one of the prominent families who ruled the city. Against the clear blue sky, power, self-consciousness, and culture emanate from his slightly pampered but energetic face. The modest hat and the unadorned, dark robe further accentuate this feeling of authority. The small ship shown beyond his right shoulder may indicate that his wealth comes from shipping.

Although the portrait is small and the technique close to that of manuscript illumination, it is as monumental as if it were life-size. This is partly due to the composition, with the sitter represented in three-quarter view and with most of his upper body shown. This is a marked contrast to the then standard profile view used by Florentine and other Italian artists. The three-quarter formula came to Venice through the influence of Flemish painters, such as Hans Memling (a typical portrait by him may be seen in the Flemish Room, 59). Monumentality was achieved also by the summary treatment of the face, also a Flemish trait, although in this case transmitted by Antonello da Messina, a Sicilian painter trained in the North and later active in Venice.

On the verso, a hind, or female deer (55) lies on a grassy rock, chained to a roundel. The background imitates red porphyry, and the roundel attached to it bears an inscription in Greek: ΑΙΕΙ ("forever"). The significance of the tethered hind is mysterious, but the meaning of the inscription is clearer. "Forever" implies that the image of the man is preserved by this painting forever. This theory is supported by the inscriptions on two other portraits in this room (41, 42).

Jacometto used the same formula on the portrait of the *Nun of San Secondo*. The figure, clad in the dark but revealing habit

of her order, is shown in three-quarter view. Her pensive mood is echoed by the gently rolling hills and quiet waters of the background. The island with a walled building may allude to her convent. There are no clues to her identity; she might have been a member of the Contarini family. Her headdress is that of the Benedictine nuns of San Secondo; the bare shoulders and plunging neckline are surprising at first sight, but, apparently, life at San Secondo was so worldly and compromising to the order that in 1515 the convent was subjected to reform and reorganization by the patriarch of Venice.

The secular character of the sitter is even more evident on the verso (56). Although it is badly rubbed, the representation, executed in gold drawn on a dark olive background, is still discernible. A female figure in a robe with rich folds sits on an island in front of a mountain. On the left an empty boat floats on the water, the other side of which is lined with wooded hills. As with the portraits, the landscape is related to the figure: both are viewed from the same perspective.

The precious little paintings of Jacometto were not meant to be framed and hung as they are seen now. Marcantonio described them as kept in the Contarini house in a leather case stamped with gold, and it is also evident from his description that the two were assembled in a box-like structure, where the female portrait served as a kind of sliding cover for the other. This probably accounts for its badly worn verso, which must have been on the top. Such little portrait boxes were very much in vogue in sixteenth-century Italy, but very few of them have survived. They were created to preserve personal images; according to Jacob Burckhardt, they served as "the monuments of hidden, gentle feelings."

Robert Lehman acquired these two portraits to give to the Metropolitan Museum, before he gave his entire collection, with one proviso: "that they go into the Wing, when it is finished." With these somewhat cryptic words, Robert Lehman told the Director, Thomas Hoving, that the Metropolitan was indeed to receive his collection.

The large, ornately framed *Madonna and Child* (51) is by Carlo Crivelli (1430–1495). This Venetian master is well known for his elaborate, colorfully painted altarpieces and other devotional paintings, many of which he painted for churches in the cities of the Marches. Crivelli was so successful that in 1490 he was knighted by Ferdinand, Prince of Capua, after which he always signed his name as *miles,* or knight. His style pleasingly fuses naturalistic and decorative motifs, the reminiscences of the International Gothic style with the newly discovered elements of the classical. His colors are bright, and the subjects are painted with an almost finicky minuteness.

The Madonna's throne imitates an antique niche, its framework decorated with classical balusters, urns, and scallop motifs.

The seat rests on fluted pilasters, and the base resembles the checkered marble floors of antique buildings. This demonstrates that Crivelli was aware of the trends emanating from Florence. The *Madonna and Child* still shows some influence of the Gothic masters: the elaborate, raised halos and the richly tooled gold background also hark back to earlier Venetian paintings. The naturalistic garland of apples, and fruit garlands in general, are the hallmark of Crivelli's work, and here they offer a pleasant contrast to the highly decorative patterns of the Madonna's robe and of the gold background. These characteristics clearly assign this painting to Crivelli, although it is neither signed nor dated. (Possibly, a signature or date was painted on the lowermost part, which at some time in the nineteenth century was cut off.) Comparisons with securely dated works, such as the so-called Demidoff altarpiece in the National Gallery, London (signed and dated 1476) or the *Madonna* from the Bache Collection in the Metropolitan (from around 1482) , suggest a date for our painting close to 1480.

The frame was probably made in the nineteenth century, closely imitating the surviving original frames on Crivelli's paintings, or possibly even the badly damaged original frame itself. The large size, the rich Gothic traceries and pinnacles, strongly suggest that our painting could have been the central panel of a large altarpiece, surrounded by smaller panels and predella paintings such as the *Apostle* exhibited in the Second Room (52) .

The carved and gilded cassone (137) matches the other one in this room (136) . It bears the same coat-of-arms, and the style and theme are also similar. The mythological story on the front is that of Niobe, Queen of Thebes, who incurred the wrath of Latona, the mother of Apollo and Diana, by boasting of her own offspring of seven sons and seven daughters and comparing them with those of Latona. This led to the tragic consequence of the slaying of all her children. On the left, Apollo is shown with bow and arrow, slaying the seven sons, while on the right the huntress Diana, equipped also with bow and arrow, kills the seven daughters. The deeply carved figures are arranged in dramatic groups: the fallen son with his outstretched arms, or the daughter crawling before Diana clutching her head with desperate hands, approximate the quality of the best contemporary small bronzes.

Two portraits are among the great rarities of Renaissance art. They depict a married couple, *Alessandro di Bernardo Gozzadini* (41) and his wife *Donna Canonici* (42) , both of Ferrara. The portraits are a pair, or a double portrait: they are exactly the same size and bear the same coat-of-arms. They are tied together also by the mirror-image poses of the couple and most of all by the inscription, which starts on the frieze of the building in the man's portrait and continues in the woman's. Only

a handful of Renaissance double portraits exist today (one by Filippo Lippi is in the Metropolitan).

The two noble persons are represented in strict profile. Their bodies are shown to upper-arm height, and their raised left hands hold a carnation and an apple, respectively. The immediate background on both pictures is a continuous building of classical style with quadrated walls, an elaborate cornice, and frieze. The dark opening of the rectangular window accentuates the sharp features of the young woman. The ceremonial pose of the fashionably dressed figures, their identity and social standing emphasized by the escutcheons, is a clear indication that these are portraits commissioned to preserve the images of the couple. This is explicitly stated in the Latin inscription that runs through the frieze: VT SIT NOSTRA FORMA SVPERSTES ("So that our images may survive"). We have seen a similar intention on the verso of the portrait of Alvise Contarini (55), phrased as a poetic allusion.

The two portraits are also bound together by the use of symbols. Behind Donna Canonici a reluctant unicorn is wooed by a young woman holding a mirror. Is this a suggestion that the noble animal (Gozzadini) was captured by a virgin, according to the legend of the unicorn? In the same place behind Gozzadini's shoulder a hunter on horseback carefully holds his trained falcon. Does this suggest his patience and skill in taming the noble bird, the bride? The falcon is a symbol of obedience. The chastity of the bride is symbolized by an ermine on her portrait. Next to it, a pair of rabbits, symbols of fertility, play around a tree stump. Here they probably express hopes for the future of the couple; and the cut-off tree trunk with a new sprig growing out of it may also be an allusion to coming offspring, the rejuvenation of the old family tree.

On Gozzadini's portrait, in the lower left-hand corner, a stork perches on a tree stump, next to a pelican feeding her young with blood spurting from the self-inflicted wound on her breast. Since the dead tree and the pelican are symbols, respectively, of death and immortality, we may assume that these are references to the couple's wish that their image may be immortal—on the dead wood of the panels that bear it. The stork may be here as the enemy of serpents, which since Adam and Eve have been symbolic of marital discord. Or perhaps the bird hints of the coming of a child.

The landscapes behind the two figures are continuous. On Gozzadini's portrait, behind the wooded hills with hunters, the towers and cupolas of a distant city are seen. On Donna Canonici's, a river with a solitary boatman leads to a busy port city, its waterfront filled with ships. There is a masterful illusion of distance in both paintings.

The conception and execution of two such extraordinary portraits required the skill of an excellent painter. Since the por-

traits are not signed, this artist's identity must be determined by internal evidence. The sitters were of the nobility of Ferrara, where their descendants were still alive in the middle of the nineteenth century. The portraits were purchased by the Italian collector Bardini directly from Countess Gozzadini. This fact has directed scholars to the artists of Ferrara, where, in the second half of the fifteenth century, a school of portrait painters was active. Therefore Robert Lehman, following Bode and Venturi, attributed the portraits to Francesco Cossa (about 1435–1477), the famed painter of the frescoes in the Palazzo Schifanoia in Ferrara. Berenson regarded them as among the finest portraits of fifteenth-century Italian art, "not by Cossa, but not unworthy of him." More recently, another Ferrarese artist, Lorenzo Costa (1460–1535), has been suggested, and was given Robert Lehman's approval. From the research on Ferrarese art, mostly that of Roberto Longhi, it appears that the treatment of the profile, the use of the architectural background, and of the far-reaching landscape behind the figures, correspond to the work of Costa around 1490. The symbolism also indicates the last decade of the century, as do the costumes and jewelry. Attribution is made more difficult because important parts of the paintings have suffered from ancient restorations and repainting.

Alongside the paintings are many notable pieces of Renaissance furniture. The cassoni, the lectern, and some of the frames have been already mentioned. The center of the room is occupied by an imposing sixteenth-century hexagonal table (131). Carved of walnut, it is composed of three richly decorated and gilded caryatid leg elements attached to a vase-like core. Each caryatid stands on a lion's paw foot, and the mid-part is accentuated by wreaths that merge with deeply carved festoons of fruit and flowers. The expressive faces and classicizing headdresses are carved with sensitivity in the manner of Roman sculpture. The style strongly suggests that the table is from Tuscany; according to an old tradition, it is from a palazzo in Siena.

On the table is an incense burner (126) by the Paduan sculptor Andrea Briosco, who because of his curly hair was nicknamed Il Riccio (1470–1532). This bronze, with its black patina and decoration composed with masterful technique, is one of the most important late works by this famous creator of Renaissance bronzes. Philip Lehman purchased it from a royal collection in England through the dealer Joseph Duveen.

The cylindrical body, supported by three half-figures, is decorated with standing nude figures, horned masks, and eagles with spread wings. Around the base, between the masks and festoons, are arch-shaped holes. These supplied air for the burning of the incense, which was placed inside on a bed of hot charcoal. The incense smoke rose up to the cover, where it escaped through

the open mouths of the three masks. The elaborate cover is supported by three putti and three rams' heads, and is also decorated with festoons, shells, and masks. The whole structure is topped by the seated figure of a faun holding Panpipes in his left hand and a bunch of grapes in his right. The rich decoration and the vigorous modeling reflect the influence of Jacopo Sansovino, and date this piece around 1530.

This type of incense burner is rare in the oeuvre of Il Riccio, although many of his other compositions have survived in numerous examples and casts. A simplified version, probably by a collaborator of Il Riccio, is also in this collection. This provides a rare opportunity to compare the original with its contemporary copy.

Staircase Landing

This room, a staircase landing in the old Lehman house, is dominated by a large tapestry representing the *Last Supper* (141). This masterpiece of early sixteenth-century Flemish tapestry weaving measures close to twelve feet on each side and was woven of woolen and silk yarns of various colors. A red border of intertwined leaves, vines, and flowers frames the composition: Christ seated at a table before a columned niche surrounded by the twelve apostles arranged in animated groups. Judas is on the right without a halo; a money bag tucked into his belt refers to his betrayal. A servant in the foreground pours wine.

Bold reds, blues, and golden tans dominate the color scheme, but the real beauty of this tapestry lies in the skill with which different textures are captured on it. The lozenge pattern of the tablecloth, the varicolored marble squares of the floor, and the architectural details are all masterfully woven. Especially outstanding are the renderings of Italian velvet, brocade, and silk patterns, such as those on both sides above the heads of the apostles. The colors, textures, and patterns are further embellished by the use of gold thread, evident not only in the velvet and brocade patterns and halos but also in highlights on the drapery of the figures, for instance on the apostle in a red robe who prominently occupies the center front. The thread is not gold wire or even woolen thread wound with gold leaf, but is gold tinsel, consisting of yellow silk thread wound with gilded silver ribbon. Since some of the gilded silver ribbon has worn away, the yellow thread gleams with the remaining gold and silver and softens the metallic effect. This glow, blended with the warm colors of the wool yarns, lends an unusual effect of soft light to early sixteenth-century tapestries such as this.

Our *Last Supper* tapestry was probably designed in the workshop of Bernard van Orley (1485–1542) of Brussels, the court painter and designer of Margaret of Austria, Regent of the Netherlands. The large cartoons must have been prepared there too, and the actual weaving probably was done in the workshop of Pierre van Pannemaker, a famous tapestry weaver, also of Brussels. The workmanship of this master can be recognized by the use of certain colors and of techniques such as the deep slit chains. Thus the tapestry is completely a product of Brussels, in the early sixteenth century the most important center of Flemish tapestry weaving. This industry was so important to the city that in 1528 an ordinance was passed requiring tapestry weavers to mark their products with a small red shield flanked by two B's standing for Brussels and Brabant. Since this shield and letters are absent from our tapestry, it must have been made before 1528, and we can give a closer date from our knowledge of other activity in Pannemaker's workshop. It is known that early in 1528 Emperor Charles V purchased a Last Supper tapestry (now in the Escorial, Madrid); Margaret of Austria commissioned from Pannemaker a set of Passion tapestries with scenes of the Road to Calvary, the Crucifixion, and the Deposition, after 1526 but before her death in 1528, when she willed them to her nephew Charles V. On this basis a date between about 1525 and 1528 can be assigned to our tapestry, and by comparison with the tapestries mentioned above we can assume that our *Last Supper* belonged to a similar set of Passion tapestries (the other parts are now in the Widener Collection, National Gallery of Art, Washington, D.C., and in the Jacquemart-André Museum, Paris).

The richly carved cassone (135) is an Italian piece made around 1540 in Rome. This impressive piece of furniture, of walnut, is decorated with scenes of Roman soldiers. The groups are separated in the center by an escutcheon held up by two winged putti and by a recumbent nude man holding a horn of plenty between his entwined legs. On the two front corners statues of men wearing togas stand on rams' heads. The sides are carved with putti riding tritons. The feet are in the shape of a lion's claws.

The deep, rich, dark brown tone of the waxed wood enhances the sculptural quality of the figures, which are reminiscent of contemporary small bronzes, as a quick glance at the andirons (130) shows. As on some Renaissance bronzes, the carving on the cassone was embellished with gilding, traces of which are still visible in the background. The military scenes on the front hark back to reliefs on Roman monuments, and the two corner figures are copied from the Arch of Constantine in Rome. These affinities are the main reasons for attributing this piece to a workshop in Rome. The coat-of-arms is still undeciphered, thus giving no clues to the first owners of the cassone. In more

recent years it was in the collections of the counts of Gosselin and of William Randolph Hearst.

On top of the cassone the aquamanile representing *Aristotle and Phyllis* (122) is an object of exceptional importance. As a strikingly bold composition, which narrates a well-known medieval tale, it is an exceptional piece of secular sculpture from the beginning of the fifteenth century.

The story of Aristotle and Phyllis first: while Alexander the Great was conquering Asia, he became so infatuated with Phyllis, an Indian girl whom he had taken as a wife, that he totally neglected the affairs of state. The alarmed dignitaries of the court sent his former tutor, Aristotle, the great philosopher, to plead for his return to his duties. The philosopher apparently did so to such purpose that the king turned his mind once more to the business of state. Naturally, this did not please the queen, who, having found that Aristotle was at the bottom of her husband's coolness, resolved to revenge herself. She made advances to him, and in no time the old goateed philosopher was in love. As he was pressing her to requite his love, she said he must prove it by allowing her to ride upon his back. Aristotle, blinded by love, consented. Phyllis, in the meantime, had tipped off her husband so that he might observe the performance. It took place in a secluded garden where, after placing a saddle on Aristotle's back and a bit in his mouth, Phyllis rode upon him, the old philosopher crawling upon all fours. After witnessing the scene Alexander summoned Aristotle and demanded that he explain how his conduct could be so contrary to his advice. Whereupon the philosopher replied, "If a woman can make such a fool of a man of my age and wisdom, how much more dangerous must she be for younger ones? I added an example to my precept, it is your privilege to benefit by both." This fable is not of classical but of Indian origin, and had appeared in Islamic literature by the ninth century. It is impossible to tell how it reached the West; the Crusaders may have brought it back in the twelfth century. It was used by clerics to discredit the popular Aristotelian philosophy; lay scholars were greatly amused by the frivolous details. Hundreds of representations attest to the popularity of the tale in medieval art; the religious ones emphasizing the moral aspect, the secular ones the comic side. But few succeeded so well in conveying all the meanings of the story as does this aquamanile.

The cunning damsel, attired in a modish dress with scalloped sleeves and a deep decolletage, triumphantly sits on the back of the philosopher and firmly grasps a tuft of his hair. His face expresses humiliation tinged with delight. The large hands and stretched limbs not only emphasize his ridiculous position, but firmly support the whole sculptural composition. The sculptural qualities are also outstanding: there are no superfluous details of drapery or decoration. Parts of the bodies are defined by

large, uninterrupted volumes, such as the joined conical shapes of the upper torso and the thigh of the girl, the cylindrical limbs of Aristotle, and the unbroken, massive form of the sleeves. The ornamental decoration is sparing and never interferes with the main sculptural ideas of the composition; dotted circles mark the edges of her dress and the rosettes of his belt.

Who was the artist and in what circle did he work? The aquamanile bears no signature nor any other kind of mark. The dress of the two figures loosely dates it to the beginning of the fifteenth century. There is only one similar piece among the several hundred aquamanilia existing today, but that one (in the Musée Dobrée, Nantes) is, like ours, without signature or mark. Fortunately, the material and sculptural style of our aquamanile offer some help. The light yellow bronze points toward the famous bronze-working cities in the southeastern Netherlands, centered on the town of Dinant on the river Meuse. In the ateliers of these cities large-scale bronzes such as lecterns, candelabra, and baptismal fonts were produced in great variety during the fourteenth and fifteenth centuries. Some of these so-called *dinanderie* objects are well dated, and they are also stylistically related to the Burgundian sculpture of the time, especially to sculptures commissioned by the Burgundian dukes (in whose realm were these Mosan bronze-working cities). Several of the dated dinanderie works and Burgundian sculptures possess the refined sculptural qualities as well as the jocose secular spirit of our aquamanile, and therefore it seems appropriate to attribute it to a Flemish master working in the Mosan region around 1400.

Two Italian bronze andirons (130) from around 1600 are decorated with ornamental and figural sculptures. The base is formed of a mask enclosed in scrollwork and held by a pair of putti. The second stage of the front is triangular; the voluted corners are occupied by three seated women each holding a basket of fruit. On the left-hand andiron, this pedestal is topped by the figure of Mars loading a gun. The attire of the Roman god of war is a fancy mixture of the imaginary "antique" costume and contemporary hunting accessories, such as the gunpowder horn. The andiron on the right is topped with the figure of Minerva, the Roman goddess of civic and military virtues. On her left arm is an oval shield; a spear is probably missing from her right.

Although these andirons are not signed, the style of some of the figures provides some leads. Several versions of Mars and Minerva exist and have been attributed to various Venetian and Paduan artists of the late sixteenth century, among them Tiziano Aspetti (1565–1607). Recent research has brought to light the strong resemblance between the seated woman on the second stage of our andirons and the great statues of Temperance and Charity executed and signed by Aspetti for the

Staircase Landing

Santo of Padua between 1593 and 1603. This discovery firmly establishes the Paduan sculptor as the artist responsible for the andirons.

Two small panels represent scenes from the *Life of Santa Francesca Romana* (43, 44). The saint was born in 1384 into a family of Roman nobility, and her husband, one of the Ponziani, belonged to an even more prominent family connected with the papal court. Like St. Catherine of Siena (see p. 13), she found perfection in pious activity, tended the sick in several hospitals, and was famous for her charity to the poor. Also like St. Catherine, she championed the papacy against the warring factions of her time to promote the unity of the Church. As a widow, she led a life of religious devotion and charity, shared with a few companions called *oblatae*. She became a miracle worker, and, although she was not canonized until 1608, she was regarded a saint when she died in 1440. Her life is described in several accounts of her visions, the proceedings of her canonization, and other legends, as well as depicted on frescoes painted by Antoniazzo Romano in 1468 for the Tor de' Specchi convent of her oblatae in Rome. The scenes on the two Lehman panels were identified with the help of these frescoes and legends.

One panel shows Santa Francesca holding the infant Christ in her arms (43), a miracle reported to have taken place many times. The vision takes place in heaven; the saint is kneeling on an arch underneath which the sky is strewn with stars and other celestial bodies. The scrolls held by the Virgin, Mary Magdalen, and the angel in front of the saint refer in the legends of Santa Francesca to messages sent to her by these heavenly persons. On this panel, however, the pasted-on vellum strips contain not pious texts but lines from Canto 33 of Dante's *Paradiso*. Whether these quotations are substitutes for the original inscriptions or fit into the iconographic program of the picture is still an unsolved problem.

The other panel (44) represents a vision from 1439: the saint kneels before the Virgin; on the right her oblatae, dressed in white, look up in adoration, while on the left an angel is holding warps (for weaving) before a pair of warp beams. The text of the vision explains the scene: "Almighty God, desiring to increase His favors towards this Saint, willed that this Angel should change his former work, which he had been doing with skeins and balls; and he set up a warp-beam for the laying of a warp; and he spoke solemnly into the aforesaid Saint, and said: 'I will begin and lay the warp for a web of a hundred ties; and I will make another thirty ties.' . . . But in the warp which the said Angel had laid, certain dogs and cats did hinder the ordering of the threads of the cloth."

The vision and our panel have a symbolic meaning. The congregation of the Oblates of Santa Francesca Romana was formed [woven] by means of hundreds of threads of heavenly visions.

It was also assailed by evil spirits [cats and dogs] who tried to interfere with the congregation's work by fomenting doubt about the visions [disturbing the threads], but who could not destroy the pious work of the saint and her oblates [could not destroy the cloth woven by the angel]. Thus the vision is told in a manner easily understandable by the poor, many of them textile workers, among whom the saint did her work.

The visions of Santa Francesca Romana are depicted on these panels in a genre manner, delightful details of everyday life mixed with heavenly happenings. The charming naïveté of the visions is echoed by the brilliant colors, and by the strange attributes such as the elaborate crowns of the Virgin on both panels. Composed of wreaths, rays, flowers, and precious stones, they are not the inventions of the artist but are based on another vision of the saint.

The panels bear no signature, and their style is not related to the work of any artist known in this period. Some clues, however, are provided by the manner in which the scenes and visions are depicted. The figures are grouped in a somewhat unrealistic fashion on a neutral, mostly gold background, embellished with a punched in decorative design. This is very similar to the method of manuscript painters. The care exercised in the elaboration of the minutest details, such as the crowns, and the use of inscribed vellum strips, may also indicate that the painter was a manuscript illuminator. His definitely naïve, sometimes archaic style suggests that he came from North Italy to Rome—where the panels must have been painted, since they could have been made only for a community of oblates and these did not exist outside Rome. The panels must also have been painted after the saint's death in 1440. The abundance of details suggests that they might have been commissioned in connection with her canonization. Since the first depositions to start this process were made in 1443 and 1445, it is likely that the panels were painted between 1445 and 1468 (the latter is the date of the Tor de' Specchi frescoes, which, painted in a later style, imitate the composition of our panels).

The large *Crucifixion* (28) with a cuspidal top was attributed by Robert Lehman to the Florentine artist Andrea Orcagna (1344–1368) and his assistants. Dating the painting about 1360, he carefully noted in his catalogue that "the design of this noble and dramatic scene has evidently been the inspiration of Orcagna himself; and it must have been upon his design that some unidentified pupil completed this picture." One of Orcagna's assistants was his brother, known under the name of Jacopo Cione; Berenson assigned our painting to this master, while others have attributed it to artists among the followers of Orcagna.

The many opinions have been elicited by the outstanding artistic qualities of the painting. The groups at the foot of the

cross are tightly organized, the facial expressions of the figures individualistic. The colors of the robes complement the bright, tooled gold background of the upper part. The solitary suffering of Christ is underlined by the small angels fluttering around the cross. His sacrifice is emphasized by the "pelican in her piety" on top of the cross; according to legend, this pure white bird wounds her own breast to feed her hungry offspring with her blood, and is a well-known symbol of Christ and the Church.

This panel was recently identified as the uppermost part of a large polyptych (reconstructed from panels in museums in London, Rome, Luxembourg, and Denver). It has been suggested that this altarpiece might have been on the main altar in the inner church reserved for the use of the monks, in a Florentine monastery called Convento degli Angeli. Since this altar was consecrated in 1372, the paintings must have been done shortly before that date. As to the painter of the altarpiece, the Florentine Don Silvestro dei Gherarducci has been proposed. He was born in 1335, and as a young painter could have worked in the studio of Orcagna. This would explain the influence of both brothers on the painting as well as those stylistic peculiarities that point toward a different artistic personality.

The polyptych with the enthroned *Madonna and Child* in the center (50) is by the Venetian master Bartolommeo Vivarini (about 1432–about 1491). It is a wholly preserved altarpiece with five panels, in contrast to most of the panels seen in previous rooms, which are parts of dismantled altarpieces and cassoni. Although the richly carved and gilded architectural framework was probably made in the nineteenth century, it very successfully imitates the style of known Venetian frames of the Quattrocento; it is even possible that it was copied from the original frame. The two small upper panels show the Annunciation, with the archangel on the left and the Virgin in her chamber on the right. The lower left-hand painting is a Nativity, the right a Pietà. Together they represent a full cycle of the life of the Virgin, who is enthroned in the center.

Bartolommeo Vivarini belonged to a family of painters from Murano (an island in the Venetian lagoon) active during the fifteenth century. The most talented and influential member of the family was his brother Antonio Vivarini, who introduced the earliest Renaissance style to Venetian painting. This altarpiece clearly demonstrates his impact on the younger Bartolommeo. The classical modeling of the heads in the central panel, the use of perspective in the Annunciation and Nativity scenes, and, finally, the strong colors all echo the principles of Renaissance art in Florence as it was transmitted to Venice. But the Venetian tradition emphasizing decorative elements is also evident: it is enough to point out the richly brocaded velvet mantle of the Madonna and compare it with the one on the earlier *Madonna* by Lorenzo Veneziano (46) in the First Room. The

rich vegetation behind the Madonna's throne, the delight in details such as the maiolica vase filled with lilies and the carved side of the Virgin's prayer stool, are also distinctly Venetian.

The elements showing Florentine influence and comparison with dated works by Bartolommeo Vivarini place our altarpiece in the important mature years of the artist, shortly after 1465. The kneeling figure of an as yet unidentified nun in the central panel strongly suggests that the altarpiece was commissioned for the chapel of a convent, possibly one named after the Virgin.

Two colorful panels (33, 35) are from the late fifteenth century. Originally, they probably were the long sides of a cassone; we know of the existence of one of the short sides only from an engraving published in 1843 in the catalogue of the collection of Artaud de Montor. The well-preserved panels tell the story of Lucretia, a heroine of early Roman history. She lived during the reign of Tarquinius Superbus, the last tyrant of Rome. Her husband, a relative of Tarquinius, invited his royal companion to his house, and while they were being feasted there, as Boccaccio tells us in *Concerning Famous Women:* "Sextus, the son of Tarquinius, cast shameless eyes on the beauty and virtue of this chaste woman, and burning with evil love, decided to have her through force if he could not enjoy her charms in any other way." (This feast was depicted on the panel known from the engraving.)

The next episode is represented on our first panel (33). According to Boccaccio, "Spurred on by his madness, Sextus secretly went to Lucretia. Since he was her husband's relative, she received him hospitably and welcomed him. But when he saw the whole house was silent, thinking that everyone was asleep, Sextus entered Lucretia's bedroom with drawn sword. He . . . threatened to kill her if she cried out or did not give in to his desire. Because she refused his wishes and did not fear death, he stooped to a damnable trick. He said he would slay one of her manservants next to her and tell everybody that he killed them after having found them together in adultery. When she heard this, the trembling woman stood still, frightened by such a wicked disgrace. Fearing that if she died there would be no one to avenge her innocence, she unwillingly gave her body to the adulterer. Sextus satisfied his wicked desire and left like a conqueror."

On the right side of the panel Sextus is seen on a white horse approaching Lucretia, standing on the threshold of her house. On the left he is invited into the house by Lucretia, then feasted by her as can be seen through the window on the edge of the panel. Sextus's "wicked disgrace" is shown in the upper center of the panel, through the barred and half-curtained window of Lucretia's bedroom. (The inscriptions accompanying the figures on these panels are later, probably seventeenth-century additions.)

The next episode (which would have been shown on the short side of the cassone, now lost) must have represented Lucretia's suicide, which took place after she had told her husband and relatives what Sextus had done. The second panel (35) represents the finale. On the left, her shrouded body reposes on a bier surrounded by mourning relatives. On the right, in the columned portico of a round temple, an oath of revenge is taken by her relative, Junius Brutus. The fate of Lucretia so angered the Romans that shortly afterward they expelled Tarquinius and his family and established the Republic. Thus in the eyes of the independence-loving Florentines, she was not only an example of chastity and virtue but a heroine whose action brought down tyranny and returned freedom and civic virtue. In the conspiracy-ridden Florentine republic, for a while under the tyrannical rule of the Medici, she was elevated to the rank of a Biblical or classical hero such as David, Judith, or Hercules. It is mostly for this reason that Lucretia's story is depicted on so many fifteenth-century works of art, especially on cassoni, or marriage chests, where faithfulness and chastity had special meaning. Our two panels are probably the earliest examples of such representations on cassoni.

Especially noteworthy on these panels are the buildings, most of which imitate ancient Roman architecture, and the role they play in supporting the narrative. On the first panel, the street behind Sextus is shown in deep perspective and is lined with buildings that resemble contemporary palaces. This is very much in accord with the character of the episode: a drama in the private life of Lucretia. On the second panel there is a definite feeling of a public square; thus the scene is elevated to the sphere of a civic occasion. A Roman arch, a column decorated with spiral reliefs, and a round temple with a columned portico create a dignified and more classical atmosphere. This follows the fifteenth-century convention in Florentine painting and theatrical performances, where tragic scenes are always represented in pseudo-classical surroundings. These observations as well as the style of the richly dressed figures indicate that the unknown painter must have been Florentine.

A solemn and poetic *Annunciation* (34) is generally attributed to Amadeo da Pistoia, a lesser Florentine artist. His work, at the end of the fifteenth century, is not well known, and his artistic character is still vaguely defined. Because of this uncertainty our painting has sometimes been attributed to artists with such names as "Alunno di Benozzo" (a student of Benozzo Gozzoli), the "Maestro Esiguo" (because of his slender figures), or the "Master of the Goodhart Annunciation" (after the name of a previous owner of our painting). Whatever his name, this *Annunciation* reveals him as a sensitive artist. The composition, the structure, and the colors of the painting are as pure,

clearly conceived, and strictly measured as a Renaissance sonnet.

Attention is focused on the Virgin and the angel of the Annunciation kneeling in the sombre, columned enclosure of a churchyard. God's hand in the upper left-hand corner and the dove of the Holy Spirit seem to affirm the message delivered by the angel. The delicately patterned tiled ground, the severely bare columns, and the gray walls do not distract from the figures, who, by contrast, wear colorful robes—purples and greens with golden highlights accentuating the elegant folds. The arches of the vaulted corridor in the background echo the slight halos.

This *Annunciation* was formerly in the collection of Mrs. Albert E. Goodhart of New York. She was Robert Lehman's aunt, and with the help of both Lehmans she gathered a small but choice collection of paintings, bronzes, and other works of art. Other members of the family also benefited from Robert Lehman's connoisseurship, and with his assistance assembled considerable collections. While some of these have already been given to museums, Mrs. Goodhart's works of art were acquired by Robert Lehman and incorporated into his collection. Bartolo di Fredi's *Adoration*, Lorenzo Veneziano's *Madonna*, Cranach's *Venus and Cupid,* and some fifteenth-century bronze figures belong to this group.

Sitting Room

This impressive room, its walls covered with red velvet, with a simple cornice and wainscoting, is the last room of those formerly on the second floor of the Lehman house. The carved marble mantelpiece (sixteenth-century Italian), the large bronze candlesticks, the seventeenth-century Dutch chandelier, and the wooden shutters command attention. But most imposing are the paintings: four by Spanish masters of the sixteenth to eighteenth centuries; five by Dutch painters of the seventeenth.

Christ Carrying the Cross (74) is by El Greco (1541–1614; born Domenikos Theotokopoulos on the Greek island of Crete, hence called "the Greek"). After receiving his early training on Crete (probably in the Byzantine tradition), he went to Venice, where he was a pupil of Titian. After a short stay in Rome, he migrated to Spain; he settled in Toledo around 1577 and remained in that city until his death. His temperament matched the fervent mysticism of Spain in those turbulent times of Counter-Reformation and religious renewal. His method of painting was vividly described by one of his contemporaries after visiting his studio in Rome: "When I went into his studio I was astonished; the shades were so completely over the windows that you could hardly distinguish the objects in the room. Greco was seated in a chair—neither working nor asleep. He would

not go out with me as he said the daylight blinded the light within."

This painting is from his late period, when he created a new iconographical oeuvre, including figures of saints and scenes from the Passion of Christ. It is a great devotional image, painted with tenderness and superb technique. According to Harold E. Wethey, our painting is a "superb example of the subject . . . one of the best and possibly the earliest version from c. 1585–1590. . . . The gentleness and humility of the Christ, His beseeching attitude, the sensitively expressive hands which rest upon the Cross, the rich color in the red tunic and deep blue mantle make this canvas a pictorial masterpiece." Following Venetian tradition, the signature is on the cross itself, above the left hand in partly defaced cursive Greek letters: *domenikos theotokopoulos e' poiei* ("Domenikos Theotokopoulos created it").

Above the fireplace is another great painting by El Greco, *St. Jerome as a Cardinal* (75). The canvas is sumptuous in color, the brilliant red robe of the cardinal dramatic against the greenish black background. The green tablecloth, white sleeves, and open Scripture reflect these colors and contrast with them. The most striking feature is the elongated head, further emphasized by the long white beard. The frontality of the figure, the long head and beard, demonstrate how strongly his Byzantine heritage influenced El Greco, even in this late painting. St. Jerome is presented as an ascetic scholar and visionary, lost in thought. There is an absence of distracting detail: the background is flat; St. Jerome's face, beard, and hands are painted with flowing, summary brush strokes; even the pages of Scripture under his pointing thumb are indicated in this manner. The painting looks as if it had been painted by El Greco with "the light within him."

Several identifications have been proposed for the subject of this painting: a member of the Venetian Cornaro family, or the archbishop of Toledo, Gaspar de Quiroga, in the guise of St. Jerome. There is now general agreement that the painting is an idealized representation of St. Jerome. There are five known versions of the composition. According to Wethey, "the finest are those in the Frick and Lehman Collections." None of the versions is dated, and on the basis of style the Frick painting has been dated to about 1600, while our St. Jerome is dated between 1600 and 1610.

The portrait of *Maria Teresa* (76) is by Diego Rodríguez de Silva y Velázquez (1599–1660), painter of the Spanish court. Mastering a brilliant technique and style, he painted the well-known portraits of Philip IV and his family. He was invested by the king with the order of Santiago and was knighted in 1659. With his understanding of Philip IV's taste, his intimate knowledge of the royal family and of the inner life of the court,

Velázquez created spectacular historical paintings, ceremonial equestrian compositions as well as intimate portraits such as this Infanta.

Maria Teresa, daughter of Philip IV and Isabella, was born September 20, 1638. After her mother and brother died, she was the king's only child for some years until his second marriage produced a successor to the throne. She was betrothed to Louis XIV of France and married to him in 1660. During the negotiations preceding the marriage, the French king saw her incognito and is said to have been "appalled by her costume" and yet "he thought that she possessed much beauty and that he would find it easy to fall in love with her." An Italian ambassador described her as "small but well proportioned" and added "I do not believe that at present Christendom has another princess as gracious and as beautiful." The most revealing description comes from Mme de Motteville, of the French court: "She has a wide forehead; hair of silvery gold, her eyes although not large enchant by their brilliance and sweetness; her cheeks are somewhat fat, but her skin is of luminous whiteness and her mouth is small and red."

These characteristics are well captured by Velázquez. The melancholy mood of the little princess is enlivened by the glitter of the pearly gray dress, the strands of pearls, and the flower-like jewel affixed to the front of her dress. The large, dark mass of her hair and of the gray background is broken up by the elaborate, gay bow, painted with a spontaneity that will not be encountered again for two hundred years, until the paintings of the French impressionists. The high forehead and the somewhat large lower lip (a typical Hapsburg feature) are faithfully painted but their impact is lessened due to the "luminous whiteness" of the whole.

There is a good reason to believe that the portrait was commissioned to introduce Maria Teresa to Louis XIV, probably at the beginning of the marriage negotiations. Judging from the portrait, she was about ten years old, and Velázquez painted it in his mature style, before November 1648 when he left for his second trip to Italy. (There is a later portrait of Maria Teresa at the Metropolitan, showing her at fourteen wearing a wig adorned with ribbons.) The occasion that drew sitter and painter together had somewhat tragic consequences for both: the marriage arranged for Maria Teresa was a very unhappy one; after bearing several children for the Sun King, she died in 1683. As for Velázquez, after accompanying the court to the wedding and returning to Madrid exhausted, he took to bed and died in August of 1660.

A double portrait of *The Countess of Altamira and Her Daughter* (77) is by Francisco de Goya y Lucientes (1746–1828). It bears a long inscription, translated as: "Her Excellency the Lady Maria Ygnacia Alvarez of Toledo, Marchioness of

Astorga and Countess of Altamira and the Lady Maria Augustina Osoria Alvarez of Toledo, Her Daughter born on 21st of February 1787." Since the little girl appears to be about a year old, the painting must have been done in 1788, a year before the artist was appointed court painter. Intensive study of the works of Velázquez and those of the Venetian G. B. Tiepolo imbued Goya's art with a brilliant technique and breadth of style. His understanding of human nature shows in his portraits (he admired eighteenth-century English portraits), and his free-flowing brushwork had an impact on the French impressionists.

This early portrait is a masterpiece both as a characterization and in its virtuoso use of color. The countess, sitting stiffly in the middle of a blue sofa, is both a symbol of Spanish aristocracy and a woman who bore three children and ruled the household of her wealthy and influential husband. The dark eyes in the pale face, seemingly expressionless, convey the impression of a commanding personality. (Very little is known about her; she married in 1774 and died in 1795.) The golden-haired little girl timidly touches the stem of a purple flower taken from the bouquet held by her mother. The countess's gown and the little girl's dress are a tour de force of painting: the pale pink satin dress with its border of blue, red, and green embroidered flowers contrasts with the airy gray tulle fichu and the pearly gray of the baby's dress. The silvery gray background is in harmony with the colors on the figures and with the blue of the sofa, and gives the picture a feeling of aristocratic remoteness. The painting enriches the tradition of Spanish portraiture with the exquisite color tones of late eighteenth-century French painters.

The double portrait belongs to a group of four portraits Goya painted of the Altamiras. The earliest are those of Count Altamira, commissioned for the Bank of Spain in 1787 and still there, and of his older son, now in a private collection in Spain. These were followed by the Lehman painting, in which the artist's talents are beginning to show. The fourth Altamira portrait is one of the most popular paintings in the Metropolitan, the little boy in the red suit, Don Manuel Osorio Manrique de Zúñiga, probably finished in 1789; this is the first portrait in which Goya's distinctive personality clearly emerges.

The two portraits by Rembrandt Harmensz. van Rijn (1606–1669) represent important periods in his life and art. Both reflect his artistic achievements, in the words of a Dutch scholar, "his understanding of and sympathy for the complex world of feelings and emotions . . . his ability to represent these in all types of subjects . . . and his use of the media, exhausting their possibilities for expressing these emotions."

The *Portrait of an Elderly Man* (78) is signed and dated 1638 in its upper right-hand corner. It is from the period in Rembrandt's life when he was in demand as a portrait painter for

the rich burghers of Amsterdam and was himself well-to-do. This elegant and precise portrait of a well-dressed elderly man is typical. The details are subordinated to the composition, despite the meticulous representation of the collar and cuffs, the mustache, beard, and skin. The portrait emanates contentment.

Judging from his attire, the sitter must have been well off and influential. Presumably, he was the first owner of the painting, but its early history is unknown. In 1818 it was purchased by Lord Mansfield at an auction in London; later it passed into the collection of David William, third Earl of Mansfield, and was kept at Scone Palace in Perth, Scotland. This portrait, purchased in 1911, was one of the first important acquisitions Philip Lehman made.

The other Rembrandt painting, the portrait of *Gérard de Lairesse* (79), is signed and dated 1665 in the lower left-hand corner and dates from the artist's last years. The sitter, de Lairesse (1641–1711), was a painter from Liège who settled in Amsterdam in 1665. He earned a reputation and a great deal of money by producing pleasing historical and mythological paintings and drawings (a drawing by him is in the Lehman Collection). He was notorious for his expensive tastes and even more because of his repulsive face. The almost destroyed saddle nose, swollen lips, and sullen expression were the consequences of congenital syphilis.

Rembrandt, when he painted this portrait in 1665, was beset by personal and artistic problems. Just two years before, his faithful companion, Hendrickje Stoffels, had died. He had to move from his large house and settle in a smaller one, his commissions decreased, and his fame was in decline. In spite of all this he painted the young, brash, and unpleasant Lairesse with compassion. In the words of Wilhelm von Bode, the great German connoisseur: "the ugliness of the man . . . strikes one forcefully. The rich and mat colored costume, a doublet interwoven with gold and the thick golden locks of hair framing the head cause the irregularity and distortion of the face to stand out even more; at least at the first glance. For the repulsive impression disappears when we penetrate further into the features of this sick man . . . with the hollow eyes that show a strong melancholic expression. . . . In a certain sense we become sympathetic to this personality and are able to enjoy the work."

Rembrandt composed the portrait to de-emphasize the ugliness of the face. The right hand is tucked into the folds of the robe, not only because it was a fashionable pose, but also probably to hide it so that the sores covering it would not show. The left hand, with the white cuffs and sheet of paper, is brought forward, probably to counterbalance the ghost-like face. Rembrandt's understanding was not reciprocated by Lairesse. At the time of Rembrandt's death the young artist was enjoying a great

reputation, and he commented: "In his efforts to attain a mellow manner Rembrandt merely achieved an effect of rottenness. The vulgar and prosaic aspects of a subject were the only ones he was capable of noting. . . ." History's judgment turned out to be quite the opposite, and if it were not for the portrait, Lairesse would be remembered only as an obscure painter and theorist. (Rembrandt is well represented in the Metropolitan Museum by paintings and drawings. The Robert Lehman Collection also possesses sixteen drawings; 187, 188, 189.)

A pair of portraits by the Dutch artist Gerard TerBorch (1617–1681) represent the *Burgomaster Jan van Duren* (81) and *Margaretha van Haexbergen* (82), his wife. The husband's portrait is signed in the lower left-hand corner G.T.B.; on the verso it bears the inscription JAN VAN DUREN BURGEMEESTER EN CAMERAAR VAN DEVENTER ("Jan van Duren, burgomaster and treasurer of Deventer").

The slightly overfed and self-conscious subjects, the solemn composition, and the sober color scheme are the epitome of life and art in a Dutch town such as Deventer, where the couple and the artist lived around the middle of the seventeenth century. Jan van Duren (1613–1687) was a wealthy burgher. His social standing and office are shown not only by the inscription but also by the fact that he is represented in a group portrait of the magistrates of Deventer painted by TerBorch in 1667 and still in the city hall. His wife, Margaretha van Haexbergen (1614–1676), also from a well-to-do family, was distantly related to the artist.

TerBorch portrayed them in dignified compositions without flattery. The faces mirror well-being and quiet contentment as do the dark clothes, brightened only by the whites of the collars and cuffs. The few pieces of small jewelry worn by the wife do not sufficiently indicate their wealth; we perceive this from the rich wine-red velvet and gold fringes of the table covering and the chair. At the same time this subdued but vibrant color adds life to the paintings, which otherwise would be totally composed in black, gray, and white. The use of such devices characterizes the paintings and helps us to arrive at an approximate date. Shortly before 1650 TerBorch traveled to Spain and probably came into contact with Velázquez. These solitary figures, represented with cool objectivity and on a monotone gray background, reflect the influence of the Spanish painter. The paintings may be roughly dated between 1650 and 1667, the date of the group portrait already mentioned. Dutch scholars think that our canvases were painted about five or six years earlier than the group of magistrates, or around 1660.

As portraits representing a married couple, they do not seem to follow the seventeenth-century convention in which the man is shown as an active, and the wife as a passive, personality. Van Duren and his wife are equal in pose and stature, though the

man is grasping his gloves, whereas the woman lets her right hand hang limply down the back of the chair.

The portraits have an unbroken provenance. From the original sitters they passed to their son and in turn to his daughter, who in 1738 married a Martinus van Doornich. They remained in this family until 1911; they then passed through separate collections until they were reunited by Philip Lehman in the 1920s.

The delightful *Interior with Figures* (80) is by the Dutch painter Pieter de Hooch (1629–after 1684). Hooch lived an industrious, tranquil life, never going beyond the boundaries of his native land or of its artistic heritage. Born in Rotterdam, he studied there with the local masters. After marrying a woman from Delft, he settled in that city and probably worked there until the early 1660s, when he moved to Amsterdam.

The painting is composed of three interrelated spaces. The foremost is the windowed corner of a well appointed room; through an open door this space extends into another room occupied by a standing servant. His turned figure leads to the third area, an open courtyard in which stands a haggard, bare-headed old man. This traditional composition originated in the middle of the fifteenth century and was invented by Flemish painters. The largest part of the painting's surface consists of the wall of the room, covered with gilded Spanish leather panels. These panels, made in Cordova, were very much favored by the wealthy in the Netherlands at this time. Their glimmering is a wonderful backdrop for the inlaid ebony cabinet, the mythological painting, and the four persons gathered around the table covered with an Oriental rug.

A subtle play of color and light characterizes these persons. The standing young woman receives the full impact of the light streaming through the window to emphasize her blue dress and her curly blonde hair. The seated man, smoking a pipe, is in shadow, underlining his apparently thoughtful mood. The smaller objects, such as the flute glass held by the seated young woman or the glass goblet and china bowls on top of the cabinet, suggest well-being and security. This is markedly in contrast with the forbidding pose of the servant and the humility of the begging old man, who is not even admitted to the house. These seem to be more than mere genre elements, and suggest the intention to present a moral, perhaps a reference to a Biblical parable about the rich and the poor.

The painting is signed P. D. HOOCH on the stretcher of the chair, but it bears no date. Most scholars of Dutch painting believe that Hooch painted it while living in Delft, in the restrained, sombre manner that characterizes his work of the late 1650s. This style resembles that of his contemporaries, the most famous of whom is Vermeer, but Hooch's is more intimate, captivating, and sentimental.

An aquamanile representing *Samson and the Lion* (125) is the creation of a North German sculptor and bronze-caster about 1400. The Biblical story is presented in the manner of a medieval tale, or *fabliau:* the heroic struggle of Samson is changed into almost playful wrestling. The meaning of the story, the struggle between Samson (Christ) and the lion (evil) is almost forgotten; both Samson and the lion seem to be enjoying themselves. This frolicsome mood gives the artist the freedom to model Samson disproportionately small compared to the lion, whose body had to be ample to hold enough water. The lion's paws have become stylized leaves, just as in medieval tales creatures metamorphose into something entirely different.

This vivid group is distantly related to the contemporary Flemish aquamanile *Aristotle and Phyllis* (122) . The figure of Samson has the same summary treatment as that of Aristotle, and a somewhat similar face. This relationship may be explained by the close commercial and artistic connections that existed between the Flemish and North German Hanseatic cities at this time.

The pair of bronze candelabra (129) is probably Venetian from about 1600. Their stems are in the shape of urns decorated with sitting putti and half-female, half-animal creatures. Each three-legged base, supported by putti, bears escutcheons; one with the image of St. Nicholas of Tolentino, two with unidentified coats-of-arms. When deciphered these may identify the person who commissioned the candelabra (perhaps for an altar dedicated to St. Nicholas) and probably the artist who made them. Otherwise their style gives the only clues for attribution; they are usually compared to the great altar candlestick made by Niccolo Roccatagliata in 1598 for the church of San Giorgio Maggiore in Venice.

A large maiolica plate (156) on a late sixteenth-century French–Burgundian chest represents the *Magdalen Anointing the Feet of Christ at the House of Simon the Pharisee*. It is signed on the back by Maestro Giorgio (Giorgio Andreoli of Gubbio, active 1519–1553) and dated 1528. The source of the composition is an engraving by the Italian artist Marcantonio Raimondi. The maiolica painter transferred the design using luminous colors, also demonstrating a virtuoso talent in his use of lustre and in his ornamental border of interlaced fantastic figures, horns of plenty, and putti. The border incorporates two escutcheons with the coat-of-arms of the Della Rovere (the oak) . It is probably that of Guidobaldo II della Rovere, Duke of Urbino, and indicates that the plate was made for his court.

By the late eighteenth century the plate was in the possession of the Brancaleoni family in Gubbio, and in 1857 the Marchese Francesco Ranghiasci Brancaleoni described it, accompanied by an engraving, in a printed letter. The plate may have been purchased from the Brancaleonis by J. Pierpont Morgan, whose

collector's number, PM 7058, is visible on the back. Robert Lehman purchased it from the sale of the Hearst collection.

Two chairs (139), long thought to be Italian of the second half of the sixteenth century, have been recently revealed to be probably French, rare products of the school of Fontainebleau. There is a group of six nude male figures carved on the back-rest of each chair. These figures, with their intertwined muscular bodies, resemble groups of acrobats common in engravings around the middle of the sixteenth century. These decorative graphic works are generally attributed to various Italian and French artists, members of that influential group gathered to decorate the palace of Francis I at Fontainebleau. The artist who carved our chairs must have been influenced especially by engravings attributed to the Florentine Giusto Betti, or Juste de Juste (active at Fontainebleau 1530–1540). Whether the carver was French or Italian is difficult to decide at the present. The date of these chairs could be set around 1550.

The large oval plate (169) of Limoges enamel, illustrating the *Conversion of St. Paul*, is a signed work by Suzanne Court (see 171 for another work possibly by her). Her signature, SVSANNE COVRT in gold, is placed at the lower edge in the middle. She is the only known woman enameler of Limoges, and she poses many problems for art historians despite the fact that many of her signed works have survived. Since there are no documents mentioning her, the only information about her comes from these pieces. According to one theory, she may have been the daughter of Jean Court (the artist of another Limoges plate, 170), but her style is very different from that of Jean. Another proposal is that she married a member of the large Court family and acquired her knowledge of enameling in their workshop. The period of her activity can be dated only very loosely, to a few decades before 1600, and that is the date assigned to our plate.

The front and back of the plate are painted with the same virtuosity although in an entirely different manner. The front sparkles with the whites of arms, legs, and horses, as well as with the gold on the trappings and in the heavenly rays. The decoration of the wide rim resembles a jeweled collar, with centauresses, herms, and sphinxes painted with the precision of goldsmiths' work. On the verso masks and herms are interwoven with a lattice-work of decoration in grisaille on a background of gold scrollwork. Touches of light colors break up the monotony of the gray.

The small bronzes placed on a table are by Andrea Briosco (1470–1532; see also 126). The figure of the *Kneeling Satyr* (127) is noteworthy because of the richly modeled surface of the bronze and its dark brown patina. It probably served as a candleholder. The *Satyress with Her Child* (128) is remarkable as a group composition.

Flemish Room

The last of the reconstructed rooms is the Flemish Room, so called because here are gathered the Flemish paintings and most of the fifteenth-century northern European works of art. This room, a successful blending of paintings with objects of Flemish and Italian origin, is also a monument to the selective eye and far-sighted collecting of Philip and Robert Lehman. In it the two Lehmans assembled, with shrewd judgment and a willingness to acquire highly priced masterworks, paintings and objects that richly illustrate northern European art and culture of the fifteenth century. That culture echoes in almost every object, opening up vistas of Bruges, Antwerp, Brussels. The visitor is confronted with kings and queens, powerful prelates, Italian bankers and merchants, as well as with humanists, creative artists, and craftsmen.

The carved and gilded ceiling is a late fifteenth-century Italian work; its main beams are original, the panels reconstructed. The bronze chandelier hanging in the middle is a rare fifteenth-century Flemish work, its decoration unusually rich and well preserved. Cast in several pieces, it was put together with the help of assembly marks incised on each component and still preserved. The curved branches are embellished with leaf motifs, and the central shaft is in the form of a spire-topped canopy, housing a small statue of the Madonna. The hexagonal lower part terminates in a lion's-head mask, and its sides are decorated with engraved leaf and floral friezes. Centuries of cleaning have obliterated such delicate designs from most similar chandeliers. Judging from the size and decoration, the chandelier must have graced a church or chapel rather than an ordinary room.

The carved stone mantelpiece is late fifteenth-century Italian, as are the built-in cupboards flanking it (formerly in the Davanzati Palace, Florence) . The prayer stools (*prie-dieus*) and the armchairs alongside the walls are also Italian, but somewhat later, from the early sixteenth century. The seats of the chairs are covered with Italian velvet in various colors, some contemporary with the velvets of the robes and draperies represented in some of the paintings.

Three larger pieces of furniture are somewhat later in date. The long refectory table is late sixteenth century. The walnut credenza is a rare example of early sixteenth-century Tuscan furniture-making: the classical columns set into the corners, the sparse decoration of carved palmettes, and the lion's-paw feet complement the elaborate details of the painting hanging above it. The sumptuously carved high chest (138) might have been made for a French king, around 1550. Its profuse decoration, the caryatids on the upper part and accentuating the corners, and the masks on the doors show a relationship with

the works of the school of Fontainebleau. As on the carved chairs in the Sitting Room (see 139), decorative elements from the Italian Renaissance were transplanted and adopted. Italian maiolica is placed in the lower part of the chest; it was highly esteemed in northern European courts and cities, and is often shown in Flemish paintings.

The four bronze apostle statues are products of two bronze-casting workshops in Flanders. *St. Adrian* (124), the soldier saint, holding his attribute, an anvil, and *St. Stephen,* showing the stones by which he was martyred, may have been cast in Maastricht. The other two, *St. Peter* and *St. John the Evangelist,* with somewhat different proportions, are definitely by another master. The backs of these statues show that they were originally attached to larger objects: they might have been parts of tall Paschal candlesticks similar to those still in the churches of Flanders, or they might have been attached to large, elaborate lecterns (as was a great bronze eagle now in the Cloisters Collection of this Museum).

The aquamanile in the shape of a crouching lion (121) is an early thirteenth-century North German bronze. There is only one known similar lion, in the Museum für Kunstgewerbe, Hamburg. The composition is highly original: the ears serve for filling, the nostrils for pouring; the handle is in the shape of an elegantly curving dragon; and two wild geese being trampled underfoot ensure proper balance. The crisp details of the head and mane contrast with the smooth, uninterrupted surfaces on the hindquarters. The naturalism of the lion's head is balanced by the palmette motif on the tail and by the stylized dragon and wild geese. These decorative elements date the lion to the first decades of the thirteenth century.

The rotund head with curling hair, the square jaw with the open mouth set with large teeth and the tufts of hair around it, have no parallel in contemporary Western European or Islamic art, where lions were very popular. Our aquamanile shows the undeniable influence of earlier Chinese lion statuettes of the T'ang (618–907 A.D.) and later periods. These Chinese lions could have been carried to eastern Europe by the caravan routes across Asia and then transmitted to the great commercial centers of the West such as the cities of the Hanseatic league. Most recent scholarly opinion is that our aquamanile was made in Lübeck, and was for a long time in the possession of a family in Hamburg (both cities belonged to the Hanseatic league).

St. Eligius (57) by Petrus Christus (active in Bruges 1444–1473) commands instant attention. It is unusually large for a Flemish painting of this period. The three almost life-size figures dominate the picture, but upon closer inspection one's gaze is captured by colorful and intricate details. The eye is finally led to the artist's signature and date at the bottom: *m petrvs xpi me fecit aº 1449* ("Master Petrus Christus made me in the year of

1449") and to his emblem, which could be described as the escapement of a clock combined with a heart shape.

The painting represents a goldsmith sitting at his counter in the open street window of his shop, holding a balance and a gold ring. A young couple stands before a leaded window. The young woman wears a green-gold brocaded velvet gown decorated with a pomegranate pattern; on her head is an elaborate beaded headdress with two horns from which a thin white veil is hanging. Her left hand points to the balance. The young man tenderly embraces her, while his left hand grasps the enameled grip of a sword or dagger. His cloak is embellished with a gold pendant of two facing lions and a hat brooch of pearls and a ruby.

To the right are shelves filled with the precious products and raw materials of the goldsmith's trade. The upper shelf displays two silver cruets with gold finials and gilt inscriptions on their feet; a gadrooned ciborium on small gilded lions; another, partly hidden vessel, possibly of a glass or porcelain. A filigreed gold belt buckle hangs on a nail, and a string of beads is also strung on nails. On the lower shelf is a rock-crystal cup mounted in gold, ending in a finial of rubies and amethysts and surmounted by a "pelican in her piety." A red-lined jeweler's display box shows thirteen rings on three rolls of parchment. Unmounted rubies and other precious stones are in a rectangular black folder, and a cluster of seed pearls is in an open, circular leather pouch. Against the wall is a branch of red coral, slabs of porphyry, and of rock crystal. Above, on a piece of cloth, are two gold brooches and a pendant embellished with rubies, emeralds, and pearls. A pair of gold-mounted devil's teeth (fossilized shark's teeth) hangs next to these jewels. In the back a coconut cup with gilded mount and foot is partly hidden by the curtain.

On the goldsmith's counter are various weights: two flat, fractional ones and an opened nest of stacked brass weights in front. There are three groups of coins: ducats, or "riders" of Philip the Good, Duke of Burgundy; "angels" struck by Henry VI, King of England, for his French dominions; "guldens" minted in Mainz, probably around 1430. The round, convex mirror reflects a young squire and his servant (holding a falcon) who are walking on the street outside.

Because of the more than thirty detailed depictions of jewels and other precious objects, this painting is one of the most important sources of our knowledge of fifteenth-century goldsmiths' work. Its iconography is even more interesting. The subject has been traditionally described as St. Eligius, Bishop of Noyon (and the patron saint of goldsmiths) and St. Godeberta, whom the bishop affianced to Christ in the presence of King Clothaire II of France. Tradition also holds that the painting was commissioned from Petrus Christus by the gold-

smiths' guild of Antwerp, who indeed owned it until the middle of the nineteenth century. The official form of the legend does not agree with the interpretation on the painting. According to it, the event took place in the royal palace, and the bishop placed his episcopal ring on the finger of the pious maiden, who became a nun and was later canonized. In contrast, the painting represents St. Eligius as an ordinary goldsmith, not a bishop but a craftsman selling a wedding ring to a noble couple. Thus the painting cannot be considered the depiction of the legend, unless it illustrates a version that has not survived. (The halo around the goldsmith's head could also be a later, pious addition, an attempt to give a religious character to the painting.)

The presence of the goldsmith's work gives credibility to the tradition that the painting was commissioned by a goldsmiths' guild, though not necessarily that of Antwerp, to promote their trade under the protection of St. Eligius. The almost total absence of representations of St. Eligius or of goldsmiths prior to this painting indicates that the subject and the composition were entirely new. As the representation of an everyday event, a genre scene, it might be called his invention; and as such it is the first of a long line of paintings showing goldsmiths and moneychangers.

Petrus Christus was the artistic heir and only follower of Jan van Eyck in Bruges, and many of his dated and signed works show the direct influence of that great Flemish master. But Petrus Christus was more than an imitator. He made use of the new science of perspective and created new compositions (such as portraits arranged in corners of rooms, as on our painting). He used bold, large surfaces of color, carefully contrasting them, as on the robes of the goldsmith and the young couple. Petrus Christus introduced into Flemish art such important Italian elements as the summarizing portrait and in turn exerted considerable influence on Italian masters of the late Quattrocento, such as Antonello da Messina.

The *Portrait of a Young Princess* (67) is a late fifteenth-century French painting. The identity of sitter and painter have always been uncertain, and they are still being debated. The young girl, about ten years old, was for a long time supposed to be Suzanne de Bourbon (born 1490, daughter of Pierre de Beaujeu and Anne of France, married to Charles de Bourbon in 1504). This identification was supported mainly by the fact that in the twentieth century the painting still belonged to her descendants, the princes of Bourbon. But even half a century ago it was recognized that neither the age of the girl represented nor the costume could be reconciled with the birth date of Suzanne de Bourbon and with the general date of the painting. The features also bear no resemblance to the known portraits of Suzanne de Bourbon. Another identification, which has gained strength recently, is that of Margaret of Austria (1480–

1530), daughter of Emperor Maximilian I and Mary of Burgundy. Our portrait is believed to show Margaret at the age of ten or eleven, when she was betrothed to Charles VIII, King of France, and lived with the French royal family at the Château of Amboise. The pendant in the form of a gold fleur-de-lys (royal arms of France) embellished with a large ruby and an enameled dove might refer to this time. Her marriage to Charles VIII was dissolved in 1491, thus dating our painting to 1490–1491.

The somewhat sullen, pale face expresses the dignity and social standing of the unhappy child bride and her sorrowful life, and contrasts strongly with the royal crimson of the velvet robe and the jewels of her elaborate headdress. She is placed before a pillar dividing an open window, through which a peaceful vista, probably the Loire valley, and part of a moated castle open up.

Who was the painter who could concentrate all these elements in this well-composed panel? He seems to have fused the Flemish and French traditions of definition of form and clear precision. But as an artist of a new generation he enlarged the scope of the portrait by means of the deep landscape, thus loosening its strict organization. The painting has long been attributed to a French master whose name is not known but who is called the Master of Moulins after a triptych in the cathedral of Moulins. He is known to have been active in the last quarter of the fifteenth century and into the first years of the sixteenth. Since the donors of the Moulins triptych were Pierre de Beaujeu and Anne of France, it is evident that he was associated with the Bourbon family and thus could have painted our portrait of Margaret of Austria.

Many attempts have been made to identify the Master of Moulins. He has been thought to be Jean Perréal (about 1455–1530), a traditional French follower of Jean Fouquet, as well as Jean Prévost, a stained-glass painter who worked for the Bourbon family in Moulins. He has also been identified with Jean Hay (active about 1494), a painter of Flemish origin, which would explain the northern characteristics of this portrait.

Whoever the painter was, he not only captured the likeness of the little princess but with unexplainable intuition summarized her present unhappy state and projected into it a future full of sorrow. After her second husband, John of Spain, died, she was married a third time to Philibert of Savoy. This marriage was happy but lasted only three years until Philibert's death in 1504. The widowed Margaret became Regent of the Netherlands, and in her palace at Mechelen became one of the most sensitive collectors of the arts, as well as an accomplished musician and poet. She was the patron of the painter Quentin Matsys, the poet Jean Lemaire, and the composer Pierre de la Rue.

Flemish Room

The *Annunciation* (58) by Hans Memling (active 1465–1494) is one of the artist's masterworks. The serenity of the picture derives not only from the calm faces and quiet poses of the Virgin Mary and the archangel Gabriel but also from the cool, transparent colors. The room, with its beamed ceiling, curtained bed, and carved wooden cupboard, might have been an ordinary bedroom in a wealthy burgher's house in Bruges. But the ordinary household objects have a special significance. The wicker candle is a symbol of the heavenly light sent for salvation, referring to Christ. The shiny brass candlestick and the half-filled glass bottle represent the shining glory and clarity of the Virgin Mary, while the bouquet of lilies in the vase on her left is a symbol of her purity.

The original frame (now lost) bore the date 1482, indicating that Memling painted this intimate devotional painting at the height of his activity. By using everyday objects as symbols, he followed the example of earlier Flemish painters such as Jan van Eyck or the so called Master of Flémalle (whose Mérode altarpiece is in the Cloisters Collection of this Museum). The colors and the quiet drama of the composition reflect the influence of another Flemish predecessor, Rogier van der Weyden.

Hans Memling was born in Germany but spent most of his life in Bruges, where he was a prolific and very popular artist. Some of his greatest works are still there, many in the museum of St. John's hospital. He also excelled in portraits, continuing the tradition of Jan van Eyck and Petrus Christus. The *Portrait of a Young Man* (59) is one of Memling's finest male portraits. Neither the identity of the sitter nor the date of the painting are known. The features and the dress suggest that he could have been a member of the large Italian colony in Bruges. Max J. Friedländer suggested a date for the painting between 1470 and 1475; this seems to be in accord with the style of the artist's dated paintings from this period.

The Metropolitan Museum is remarkably rich in the works of Memling, among them a famous double portrait of Tommaso Portinari and his wife, Maria Baroncelli, and the *Betrothal of St. Catherine,* a version of the central panel of his altarpiece of the two St. Johns in St. John's hospital in Bruges.

The *Portrait of a Lady* (60) is surrounded with mystery. It has been attributed to Petrus Christus and, more recently, to an anonymous French master between 1450 and 1460. The sharp, linear outlines of the face and the geometrization of the volumes are French characteristics, whereas the placing of the figure in an open window and the precision of the painting are Flemish. But the costume points toward a later date, to some time around 1480.

The identification of the sitter is the key to the dating and attribution of this portrait. Latest scholarly opinion identifies her with Margaret of York, wife of Charles the Bold, the last of

the Burgundian dukes. She was born the sixth child of Richard Plantagenet of York in 1446, and to further the political alliance between England and Burgundy she was married to Charles the Bold in 1468 in Bruges amid colorful ceremonies lasting nine days. There are many well-documented and dated portraits of Margaret, especially in illuminated manuscripts painted for her; and the sharp, aristocratic features of our portrait seem to correspond with them. Her husband died in 1477, and since she is not wearing a widow's veil here, the portrait must have been painted shortly before that year.

Interestingly enough, the next panel is connected with both Margaret of York and Charles the Bold. It represents the *Lamentation of Christ* (66) and is attributed to Simon Marmion, a Franco-Flemish painter active between 1449 and 1489. Both an illuminator and a panel painter, he worked mostly in the cities of northwestern France and southern Flanders. He illuminated manuscripts for Charles the Bold; and the coat-of-arms of Charles and of Margaret of York is painted on the back of this panel, surrounded by the entwined initials c and m. The panel must therefore be dated after 1468, the year the ducal couple was married.

A date around 1470 is well in harmony with the style of this painting. The composition is a deeply moving scene, but the tragic happening is expressed by the sorrowful faces rather than by dramatic movements or gestures. In the French tradition, Mary does not touch her son's body, which is held by Joseph of Arimathea and another male figure. The clearly drawn outlines of Christ, the beautiful pattern of the folds of the Virgin's robe, and the minute details in the background clearly demonstrate Marmion's training as a miniature painter.

The portrait of *Erasmus of Rotterdam, 1476–1536* (73) is by Hans Holbein the Younger (1497/98–1543). There exist many portraits of the famous humanist by the Swiss painter, done at various times and for various purposes. This small likeness, with the arms resting on a parapet and the hands crossed, was probably painted after 1523. The "king of humanists" is represented in a dignified pose wearing a simple, furred robe. The strong facial features have been somewhat softened, but they still transmit Erasmus' determined, unbending character. The likeness must have had his approval: when Albrecht Dürer portrayed Erasmus in a drawing, he expressed displeasure, and the artist toned down certain parts in the engraving that followed.

The little *cartellino* in the upper left-hand corner is a seventeenth-century addition. Its inscription is illegible, but it might be the painted sign that was the mark of the collection of the Earl of Arundel. There is a legible inscription on the verso of the painting: HAUNCE HOLBEIN ME FECIT, JOHANNE[S] NORYCE ME DEDIT, EDWARDUS BANYSTER ME POSSEDIT ("Hans Holbein made

me, John Norris [or Norreys] gave me, Edward Bannister possesses me") . Thus the portrait, painted by Holbein,the court painter, was given by John Norris to Edward Bannister, both of whom were high officials at the court of Henry VIII. Later owners were John, Lord of Lumley, Thomas Howard, Earl of Arundel, the Howards of Greystoke, and, finally, J. Pierpont Morgan.

A profile portrait representing *Mary of Burgundy* (70) is attributed to the Tyrolean painter Hans Maler of Schwaz (active 1500–1529) and was apparently copied around 1510 from an earlier painting, on the order of Emperor Maximilian. Mary of Burgundy (1458–1482) , the only child of Charles the Bold, was married to the Hapsburg Maximilian in 1477. After a few years of marriage, during which Margaret of Austria and Philippe were born, she died in a hunting accident. Her inheritance in the Low Countries passed to Maximilian and began the long rule of the Hapsburg dynasty over the Netherlands. This portrait probably represents her shortly before her death, as it is the likeness of a highly born, mature woman.

Since the painter could never have seen Mary of Burgundy alive, he must have copied an earlier painting, probably by a French artist. The strict profile, the smooth, sensuous roundness of the face, mouth, and neck, are French traits as is the high, shaved forehead. The painter was even successful in imitating the pale, ivory color of earlier French portraits. Her costume is a curious mixture. On the one hand, the artist faithfully copied details fashionable about 1480: the hennin, its veil, and especially the jewelry. On the other hand, the sleeve of the velvet dress is slit and laced in a manner typical of the decades around 1500. The portrait gives us a glance at the jewelry fashions of the Burgundian court. The jewel pinned on her headdress is composed of a rectangular ruby set in gold, surrounded by pearls and completed with a large, pendent pearl. This must have been her most-loved piece of jewelry, since it appears on almost every known portrait of her. The gold necklace studded with precious stones and pearls must have been a favorite, too; it is present on a portrait of her in the museum in Vienna and even on her statue, standing among the figures of Maximilian's tomb in Innsbruck.

The next panel (61) is a commemorative picture and a portrait, by an unknown painter of Bruges called the Master of the St. Ursula Legend (active during the last quarter of the fifteenth century) . The painting represents the *Virgin and Child with St. Anne Presenting a Woman.* Her name and date of death are elaborated in the inscription: *De nieuwenhove co[n]iunx Domicella Johannis et Michaelis Obit de blasere nata Johanne Anna sub M.C. quater. X octo. sed escipe totum octobris qui[n]ta. Pace quiescat. Amen.* ("The lady wife of John Nieuwenhove, and died wife of Michael de Blasere, born Anna

daughter of Johanna in MC four times, X eight times, but take the total on the fifth of October. May she rest in peace. Amen.").

Anna apparently first was married to Jan Nieuwenhove, member of a prominent family in Bruges, was remarried to Michael de Blasere, also a patrician, and died in 1480. She was probably in her late twenties, judging from the painting, where she is shown kneeling in a garden enclosure and introduced by the Virgin and her patron saint, Anne. This charming little picture commemorating her death could have been placed to the right of a crucifix on the wall of a chapel. The frame is probably the original; if not, it closely imitates it. The coat-of-arms on the left side shows the shell of the Nieuwenhove family, and probably is that of John, the first husband. The coat-of-arms on the right, although not yet entirely identifiable, seems to belong to Michael de Blasere; it was probably he who commissioned the painting, a precious document combining piety and marital devotion.

The beautiful German panel representing the *Madonna and Child with a Donor Presented by St. Jerome* (69) is a masterwork about which very little is known. It may be dated by its style and by the particular details of the costumes to around 1450. The facial types, the intense feeling emanating from the faces, and the linearity of the design point toward a region including southern Germany and Switzerland as its place of origin. Although the painting has a distinct character, it still cannot be connected with the oeuvre of any known fifteenth-century German artist. It has been attributed to the Munich Master of the Life of the Virgin (after two panels of scenes from the life of Mary, now in Zurich), but this identification has not gained wide acceptance. The provenance of the panel is unknown; there are no clues to the identity of the donor; and its only known previous owner, the French collector Sequestre Wedland, acquired it in 1913 under unknown circumstances.

The Madonna, holding the Child in her lap, and St. Jerome clearly hark back to earlier decades of German art, particularly to Conrad Witz and to Stephan Lochner, the leading master of the Cologne school. The device of placing the group in an enclosed garden (*hortus conclusus*, a symbol of the Madonna's purity) is also deeply rooted in German art. But the sculptured seat of the Madonna and the carved stone wall surrounding the enclosure show the influence of earlier Flemish painters such as the Master of Flémalle. The small prophets carved in the side of the stone bench show some similarities in style to Burgundian sculpture from about 1440. The delicate figures of God the Father and the two flanking angels, and the technique by which they are punched and engraved in the gold background, are direct borrowings from Flemish and Burgundian goldsmiths' works of the first decades of the fifteenth century. The vegetation is more naturalistic than on most similar German paintings;

the three trees planted on the grassy bank strongly resemble those on our *Expulsion from Paradise* (19) painted by Giovanni di Paolo around 1445.

From these characteristics there emerges a south German artist who had his beginnings and basic training in the Upper Rhenish area, spent some of his wandering, learning years in Flanders and probably in Italy, and finally settled in his native region, probably in Munich around 1450, where he became an influential artist. He retained his basic German character, tinted with Flemish and Italian influences. As an artist his place is assured among those who are already well known, such as Conrad Witz, Hans Multscher, and Conrad Laib. He even influenced manuscript illustrators as late as the 1460s, and we will learn more about him when the donor is identified or when the mysterious inscription in the Madonna's halo is deciphered.

The framed, illuminated page (65) is from a Book of Hours (a book with prayers for the canonical hours of the day) that belonged to Etienne Chevalier, by the French painter Jean Fouquet (1415/20–1480). The large miniature, which occupies most of the page, represents the *Descent of the Holy Ghost upon the Faithful*. The text in capital letters on the bottom of the page is the beginning of the Vespers of the Holy Spirit. On the verso, another text from the Vespers begins with an initial incorporating the letters *e.c.* in Gothic minuscules, standing for Etienne Chevalier.

Fouquet, the greatest and most influential figure in fifteenth-century French art, illuminated the Book of Hours to which this page once belonged after his return from Italy in 1448 and before 1456, most probably in 1452. The man who commissioned it and whose portrait, name, or initials are painted on many of its leaves, was the treasurer of France, a rich court official of Charles VII. His Book of Hours is a monument of French art —illustrated in luminous colors, its compositions enriched by the subtle use of gold, it unites the achievements of French and Italian art. In spite of their small size, the scenes rival the grandeur and monumentality of the best and largest panel paintings of the period.

Our miniature is one of the best among them. It represents the descent of the Holy Ghost upon the faithful, who are transplanted into the middle of medieval Paris, leaving for us the earliest representation of that great city. As Claude Schaefer describes it: "On the terrace of the Hôtel de Nesle the faithful kneel in prayer, their gaze lifted toward the supernatural events taking place in the sky above Paris, 'the city of God.' Most of the miniature is occupied with the earliest known topographical view of the capital—an unusual setting for this scene. Among the most famous monuments shown are the façades of Notre-Dame Cathedral, the Pont Saint-Michel—a covered bridge at this time—and, beyond it, the Petit Châtelet. On the Ile de la Cité

are many houses no longer in existence, including the large tower to the south of Notre-Dame. Of the fifteen churches then on the Cité, almost none of which has survived, the one to the northwest of Notre-Dame, crowned with a little arrow, is probably the Church of the Madeleine, attended by the school children of the Left Bank on their name day to ask for indulgences."

The summer landscape and peaceful river are showered with gold and enlivened by small figures of boatmen, watering horses, and passing peasants on the tree-lined river bank. There is a delightful variety of roofs and spires in the background, all in a manner close to Flemish genre painting. Unfortunately, the beauty of the miniature is marred by the deterioration of the faces caused by oxidation of the white paint. This condition is mainly the result of the fate suffered by the Book of Hours. It seems to have remained in the Chevalier family until 1630; it passed through several collections until the eighteenth century, when the miniatures were cut out and pasted on oak panels. Following this act of vandalism, each miniature had its own journey; forty ended up in the Château de Chantilly and now belong to the Musée Condé there. Two pages are in the Louvre; single leaves are in the Bibliothèque Nationale, Paris, the British Museum, and two private collections. Other pages are still missing, unrecognized, or already destroyed. It caused a great sensation when our page was discovered in 1946 in a private collection in England, and its acquisition by Robert Lehman was widely acclaimed, because thus he brought the second authentic work of Fouquet to the United States. (The first was the drawing *Portrait of an Ecclesiastic,* purchased by the Metropolitan Museum in 1949.)

Gerard David, the last of the fifteenth-century painters of Bruges (active 1484–1523) , is represented here by four paintings (actually two wings of an altarpiece) . The painting with *Christ Bearing the Cross and the Crucifixion* (62) was on the inside of the right wing, the *Archangel Gabriel of the Annunciation* (64) in grisaille on the outside. The *Resurrection with the Pilgrims of Emmaus* (63) constituted the inside of the left wing, the outside grisaille showing the *Virgin of the Annunciation* (64) . The wings were split in the early nineteenth century; it is not known when they were separated from the central panel, nor whether it has survived. It has been suggested that the central panel may be the *Pietà* by David now in the Johnson Collection, Philadelphia Museum of Art. If this were the case, the complete triptych would have shown scenes from the Passion of Christ when open, and the Annunciation in grisaille (the colors of mourning) when closed, especially during the Lenten period.

The four panels are in excellent condition and reveal the fine details and careful brushwork characteristic of this late medieval painter. The Passion scenes are enlivened by genre figures, such

as the running little dog or the three pilgrims. The gray of the grisaille is lightened with touches of pale flesh tones, these spots of color seeming to underline the theme that during the time of mourning for Christ there is the glimpse of salvation in the Annunciation. The use of color, and the style as compared to that of dated works by Gerard David, indicate that the paintings were executed around 1500.

The *Madonna and Child* (68), by an unknown French painter, is a small, devotional panel of a kind that was very popular at the threshold of the sixteenth century. The artist is given the name of the Master of the St. Aegidius Legend (active about 1500) after two panels (now in London) representing the life of that saint, which are considered his most important works. The painter attempted to imitate some earlier Flemish Madonnas, especially those of Rogier van der Weyden. Instead of the dramatic monumentality of the Flemish master, there is an elegant intimacy and a virtuoso display of textures and the effects of light on the reds and greens of the Madonna's mantle and robe.

Lucas Cranach, the German Renaissance painter (1472–1553), is represented in the Lehman Collection by two paintings. This prolific artist spent most of his life in Wittenberg as court painter of three successive Elector-Princes of Saxony. He reflected the ideas of the German Reformation in intense religious paintings and in penetrating portraits of its leaders, Martin Luther and Philip Melanchthon. He also absorbed the artistic ideas of the Italian Renaissance in the humanist atmosphere of the court; this is apparent in the portraits of the dukes and their families and most of all in his innumerable paintings of mythological subjects. Both our Cranachs belong to this latter group.

The miniature-like *Nymph of the Spring* (72) is signed (on the tree trunk above the head of the nude) with a winged serpent, a mark adopted by Cranach and his workshop after 1509. In the upper right-hand corner the inscription FONTIS NYMPHA SACRI SOMNVM NE RVMPE QUIESCO may be translated as "I am the nymph of the sacred spring, do not disturb my sleep, I am resting." According to Otto Kurz, this is an abbreviation of a pseudo-classical poem composed in the late fifteenth century. It was rumored among humanists of the time that the poem was on a statue of a sleeping nymph found in a grotto along the Danube. The poem inspired many representations of the nymph on Italian fountains, and she also appears in a drawing by Albrecht Dürer. Cranach probably used as his source paintings or engravings by Venetian artists, most likely those of Giorgione, and created a very popular composition. It was repeated by him and by his workshop many times; the earliest version is dated 1518, and judging by the style ours may have been painted as late as 1540.

The success of the painting lies in Cranach's skillful mixture of classical myth and Christian morality. The recumbent nude, clad only in her jewelry and in revealing veils, is the embodiment of temptation, surrounded by symbols of Venus such as the rabbits and the partridges in the lush vegetation. But her placement in a remote grotto, from which the spring issues, and the bow and quiver hanging above her head, are attributes of Diana, the virgin goddess of the hunt. Thus the classical subject has been transformed into a warning against the temptations of sensual desire.

The other Cranach painting, *Venus and Cupid the Honey Thief* (71), is based on the same successful recipe. The mythological subject is accompanied by the Christian admonition of the inscription: DVM PUER ALVEOLO MELLA CVPIDO/FVRANTI DIGITVM SEDVLA PVNXIT APIS/SIC ETIAM NOBIS BREVIS ET MORITVA VOLVPTAS QUAM PETIMVS TRISTI MIXTA DOLORE NOCET ("As Cupid was stealing honey from the hive/A bee stung the thief on the finger/And so do we seek transitory and dangerous pleasures/That are mixed with sadness and bring us pain").

The subject and the inscription derive from *The Honeycomb Stealer* by Theocritus, a Greek poet of the third century B.C. A Latin translation was published in 1522 by a German humanist, and another in 1528 by Melanchthon himself, at that time a professor in Wittenberg. It is possible that he could have given the idea for the delightful and witty composition to Cranach. The lanky Venus represents the artist's ideal of the female nude in his later works, and comparison with other versions suggests a date in the 1530s.

Special Gallery

This gallery does not represent any room from the Lehman house. The selection of paintings and French furniture, however, endeavors to recreate the ambience of one sitting room in Robert Lehman's Park Avenue apartment, where he lived for thirty years.

Although all the paintings here are by French artists, there has been no attempt to arrange them in chronological order. Neither will the following remarks dwell too much on the biography or appraisal of these artists; their lives and works are well known. The paintings here and in the Grand Gallery will be explained in the spirit expressed by Auguste Renoir in a conversation he had with the American painter Walter Pach in 1908: "Nowadays, they want to explain everything. But if they could explain a picture it wouldn't be art. Shall I tell you what I think are the two qualities of art? It must be indescribable and it must be inimitable. . . . The work of art must seize

upon you, wrap you up in itself, carry you away. It is the means by which the artist conveys his passion; it is the current which he puts forth which sweeps you along in his passion."

In the center of the main wall, opposite the entrance of the Lehman Wing, hangs the superb portrait of the *Princesse de Broglie* (83) by Jean Auguste Dominique Ingres (1780–1867). The painting is signed and dated on the wall above the sitter's right shoulder: *J· INGRES Pit. 1853.* This calm young woman was born Pauline Eléonore de Galard de Brassac de Bearn (1825–1860) and married Jacques Victor Albert, Prince de Broglie. The short lived princess was a great beauty and a highly respected woman, embodiment of the best of the Second Empire's aristocracy. Among her descendants in the last hundred years have been some of the best French writers, critics, and scientists, and several members of the Académie Française.

Ingres began the portrait in 1851 at the height of his career. He was named president of the Ecole des Beaux-Arts for the year 1851, in 1852 Albert Maginel's book on his oeuvre was published, and in 1853 he was commissioned, along with Delacroix, to decorate the Hôtel de Ville. After accepting the commission for the portrait of the princess, he wrote to a friend that it would be his last except for that of his wife. Thus the painting completes Ingres's series of aristocratic portraits, and it incorporates his mastery, his bold use of color, and his understanding of female character. For it is the characterization that first strikes the beholder. The French poet Baudelaire noted that Ingres "depicts women as he sees them, for it would appear that he loves them too much to wish to change them; he fastens upon their slightest beauties with the keenness of a surgeon; he follows the gentlest sinuosity of their line with the humble devotion of a lover." There is beauty and sinuosity aplenty on this painting. We are drawn to the melancholy oval face, to the slightly troubled lips, and we try to catch the unfocused gaze of the almond-shaped eyes. The tranquility of the face, the resting arms, and the bluish gray of the background contrast with the shimmering, glistening blues, whites, and golds of the dress, the damask chair, and the still-life arrangement of the evening wrap, gloves, and fan. This juxtaposition of background and foreground create inner tensions that make the painting so much alive.

It is no wonder that Ingres constantly complained of difficulties while he worked on this painting for two years. It was finished in June 1853, as Ingres remarked, "to the applause of everybody." It remained in the possession of the de Broglie family until 1957, when Robert Lehman acquired it, making an important addition to the few comparable Ingres portraits in the United States (the best known of which is the *Comtesse d'Haussonville* in the Frick Collection).

Among the Impressionists Pierre Auguste Renoir (1841–

1919) was Robert Lehman's favorite. Beginning in the 1920s he steadily acquired his work: more than ten paintings and close to twenty drawings and watercolors. *Two Young Girls at the Piano* (93) is signed and dated in the lower left-hand corner: *Renoir, 92.* In the years around 1892 the achievements of the Impressionists began to be recognized: Renoir wrote to a friend, "The public seems to be getting accustomed to my art. . . . Why at this particular time . . . ?" This charming painting is partly the answer. The two figures in the comfortable and colorful interior are in the best tradition of French genre painting; the clarity of their presentation, the coordination of their movement, are worthy of Chardin. There is a formal solidity of the figures and a total harmony of the vibrant pinks, blues, and pearly whites. The captivating animation of the faces, the soft movements of the arms and hands, lend charm to the painting.

The identity of the two girls has not been established with certainty; they are most likely the Lerolle sisters, daughters of Henri Lerolle, a painter friend of Renoir's. Another version in the Louvre is known as the *Daughters of Catulle Mendès.* Five other versions exist on canvas or in pastel; ours seems to be the final one.

Another Renoir, the virtuoso *Young Girl Bathing* (92) is also from 1892, signed and dated in the lower left-hand corner: *Renoir 92.* In this year and the following the artist painted many similar nudes of young girls bathing, and this painting probably exemplifies Renoir's method as he described it to Pach in 1908: "I arrange my subject as I want it then I go ahead and paint it, like a child I want a red to be sonorous, to sound like a bell; if it doesn't turn out that way, I put more reds or other colors till I get it. I am no cleverer than that. I have no rules and no methods; anyone can look at my materials or watch how I paint—he will see that I have no secrets. I look at a nude; there are myriads of tiny tints. I must find the ones that will make the flesh on my canvas live and quiver." There is no difficulty in seeing the "sonorous reds" and "the myriads of tiny tints," the complete mastery of color in this painting. Perhaps this was recognized by Claude Monet, a fellow Impressionist, since the painting belonged first to his collection at Giverny.

House behind Trees on the Road to Tholonet (95) is a large canvas by Paul Cézanne (1839–1906). Although the painting is not signed, and is only roughly dated to 1885–1886, it is a true manifestation of Cézanne's art, an excellent example of his credo: "I try to render perspective solely by means of color . . . the main thing in a picture is to achieve distance. By that one recognizes a painter's talent."

This picture was painted in the outskirts of Aix, where Cézanne spent most of his life. Apparently the mountainous

landscape of Provence, with its tall trees and blue sky, provided the best surroundings for testing and perfecting his revolutionary method. The trees and the house behind them received the most summary treatment. The colors put on with bold strokes are basic; the ochre reds, in accord with his beliefs, have the same value in the right foreground as on the roofs of the houses. But despite this simplification, there is no attempt to arrange the forms into patterns, not even the intertwining boughs of the trees. The basic principle of Impressionism—the representation of nature—is adhered to but in a different manner. For instance, in Renoir's *Young Girl* the artist's impressions are broken up into "myriads of tiny tints," while here they are compressed into larger forms of basic colors. The former method eventually led to the Pointillists (who painted in minute dots), while Cézanne's very much influenced the Fauves.

Two small oil sketches are by Georges Seurat (1859–1891). *The Mower* (99), painted around 1879–1880, is a perfect example of the artist's mature style. His main achievement, that of using separate colors laid down in small, regular brush strokes, is evident, although somewhat muted. The artist seems to be preoccupied with the problems of composition as he sets the boldly moving diagonal lines of the working man against the three principal horizontals of the color fields. This sketch is part of a series of farm laborers and demonstrates Seurat's indebtedness to earlier French painters such as Millet.

The other small painting by Seurat is a *Study for "Sunday Afternoon on the Island of the Grande Jatte"* (98). The artist made about forty small studies in 1884 and 1885 for that famous painting, now in the Art Institute of Chicago. This one was probably done on the site, and only the general composition of the painting and the disposition of the figures are indicated. These figures are painted in the manner of the artist's drawings, several of which are also in the Lehman Collection.

The back of the canvas has been marked in blue pencil by Paul Signac: *Seurat #96;* this refers to the inventory of paintings made by Signac after Seurat's death. This little sketch later belonged to Félix Fénéon, the enthusiastic critic and collector of the Impressionists who especially admired Seurat's *Grande Jatte*.

A small picture painted on wood is entitled *Place Clichy* (106). Its painter, Paul Signac (1863–1935), was the most important proponent and the public leader of the Neo-Impressionists. He best summarizes the goals of the movement, to give "all the benefits of luminosity, color and harmony by the optical mixtures of pure pigments, all the colors of the prism and all their tones . . . by the separation of differing elements . . . by the balancing of these elements and their properties." Signac's first paintings done according to this theory date from 1886, and by 1889, when this panel was painted, he used it to

perfection. The colorful little square is a well-known landmark in Paris. The statue of Marshal Moncey, who in 1814 with his soldiers defended the barricades against the attacking Cossacks, stands in the background. The buildings, tents, and the large expanse of paving are depicted with divided colors put on with vigorous, square strokes. In his later paintings these become smaller, denser, and rounder, close to true Pointillism.

Robert Lehman was very fond of Signac's art, and there are several larger paintings by him in the Grand Gallery (104, 105). He also gathered many drawings by this artist, and an extraordinarily varied selection of his vibrant watercolors (195).

Promenade among the Olive Trees (113) is by Henri Matisse (1869–1954). As the signature and date of 1905 in the lower left indicate, it was painted during the so-called Fauve period. The name has an interesting origin. At the Paris Salon d'Automne of 1905, the works of Matisse, Marquet, Derain, Vlaminck, and Rouault were hung together in one room. The violent colors, flat patterns, and bold distortion of forms and perspective created a furor among the visitors. A critic dubbed them *Les Fauves* ("the wild beasts"). This name really denotes the period between 1905 and 1910 in the work of these artists, since they never constituted a coherent group. They are all represented in this collection, testifying to Robert Lehman's special attention to the Fauves at a time when they were hardly known in the United States.

Matisse was considered their leader, and this canvas, painted at Collioure in 1905, is one of his first Fauve landscapes. It is interesting to compare the strong, violent greens and reds, the deep turbulences of nature that emanate from this small picture, with the calm colors and clear organization of the large Cézanne (95). Although Matisse once said that Cézanne was "the father of us all," there is only a faint family resemblance. The *Olive Trees* was exhibited in March and April of 1906 in the Galerie Druet and was acquired soon afterward by Leo and Gertrude Stein. (A photograph of their studio at 27, Rue de Fleurus in Paris, made about 1913, shows it surrounded by other paintings by Matisse and by Picasso.)

Pierre Bonnard (1867–1947) and Edouard Vuillard (1868–1940) belonged to a small group of painters called *Les Nabis*. This name is taken from the Hebrew, meaning "prophet," and they assumed it to emphasize the prophetic nature of the advice of Gauguin to paint in pure and flat colors. In this spirit, one of them pronounced: "Remember that a picture, before being a horse, a nude, or some kind of anecdote, is essentially a flat surface covered with color, assembled in certain order." This implies a rejection of the naturalism inherent in Impressionism, and also emphasizes the importance of subject matter.

Bonnard remained true to this credo, although he modified it, especially in his later years, creating intimate, colorful in-

teriors somewhat in the manner of the Impressionists. *Before Dinner* (114), painted in 1924, is an excellent example of this change. The flatness of the pictorial field is emphasized by the large, rectangular color surfaces of the tablecloth, the floor, and the wall. The strength of these colors is balanced by the busy, shapeless figures of the two sitting women.

Vuillard's *Girl at the Piano* (102) is from around 1897. There is a delicate vibrancy in the lively pattern of the wall-paper and a feeling of intimacy in the profiled figure. She is probably Misia Godebska, wife of Thadée Natanson, publisher of the magazine *Revue Blanche,* which was often illustrated with lithographs by Vuillard. Her salon was famous; besides Vuillard and Bonnard, the poets Mallarmé and Verlaine were great admirers of this muse.

The other Vuillard panel, *Figure Seated by a Curtained Window* (103), is from about the same time. The pattern of the curtains dominates this painting, hardly offset by the dark mass of the reading man. It has often been said that the artist's interest in patterned fabrics is in part due to his mother, who came from a family of textile designers, and who, after her husband's death, operated a dressmaker's shop where there was always a great abundance of materials. About the time that these little panels were painted, Paul Signac paid a visit to Vuillard's studio, and his characterization of the artist is still valid: "They're the work of a fine painter, these many colored panels, predomi nantly dark in key, but always with an explosion of bright color that somewhere re-establishes the harmony of the whole pic-ture."

The House behind Trees (109) by Georges Braque (1882–1963) is from the Fauve period. Again we may compare it with Cézanne's canvas. The subject is the same: the landscape of the Midi, painted at L'Estaque in southern France in the autumn of 1906. But here the trees and their crossing branches form geometric compartments filled with strong colors. This fore-casts the future development of the artist; in 1907 he abandoned this style, "the short movement of his youth," and devoted him-self to Cubism.

Henri Matisse's *L'Espagnol; harmonie en bleu* (116), painted in Nice in 1923, is concerned with the same problem as Bonnard's large composition and Vuillard's small panels. Large surfaces covered with bold patterns surround the quiet, sitting woman in Spanish costume. But form and pattern are secondary here, be-cause the bright, pulsating colors dominate the little painting in an overwhelming manner. As a recent critic remarked, "Color, now being employed across its whole, more-than-Impres-sionist range, became owned by Matisse in the years after 1916, as it was never owned by any other artist. . . ."

The Houses of Parliament at Night (107) is by André Derain (1880–1954). It is signed in the lower right-hand corner but

bears no date. From the artist's recollections we know that he painted this strong Fauve canvas during his first visit to London in 1905. Derain was sent there by his dealer Ambroise Vollard, as he recalled: "M. Vollard . . . had sent me to London at that time so that I could make some painting for him. After a stay in London he was very enthusiastic and wanted paintings inspired by the London atmosphere. He sent me in the hope of renewing completely at that date the expression which Claude Monet had so strikingly achieved, which has made a very strong impression on Paris in the preceding years."

The painting is masterful in its composition, technique, and most of all in its colors. The pictorial field is divided into two equal sections by the diagonal of Parliament's shoreline. The upper half is split again by the use of differing brush strokes and colors: the short blue verticals and horizontals characterize the building; the wider, curving strokes the movement of the night sky. Derain repeated this pattern in the water of the Thames: the upper section, close to the shoreline, is done with parallel strokes, while the large expanse of the water with heavy barges is represented with long, flowing ones. This juxtaposition of rhythms and colors imbues the painting with an extraordinary sense of movement. Derain here followed in the footsteps of Claude Monet, who had painted the Houses of Parliament many times (one painting is in the Metropolitan Museum), but he also recorded the scene with a new artistic vocabulary.

The importance of this painting was recognized early; it was purchased from Vollard by the pioneer American collector John Quinn of New York. Since Robert Lehman acquired it in 1948, the painting has been shown in every important exhibition of the Fauves.

Pierre Bonnard's *Landscape in the South; Le Cannet* (115), a canvas of luminous colors, comes from the artist's last years, 1945–1946. Le Cannet is a village above Cannes. In 1925 Bonnard purchased a villa there called Le Bosquet; here he lived until his death. His nephew described it fondly: "It is a little house with pink walls, all white on the inside. The garden, where bushes and flowers grow at will, slants down to the street. At a distance one can see the red roofs of Le Cannet, the mountains, the sea." This painting was probably done outside the house; one of Bonnard's visitors from these last years remembers seeing canvases lined up against the wall as the artist put various colors on them one by one. The garden is in late spring bloom, and farther down the red roofs are also distinguishable. There is great freedom in this landscape, in the far-reaching vista and the brilliant colors. With hundreds of small brush strokes the innumerable color spots are arranged into horizontal layers representing the shoreline, the shallow, then the deeper waters, and finally the distant sky.

Grand Gallery

The Grand Gallery exhibits in depth and number the nineteenth- and twentieth-century paintings amassed by Robert Lehman. The continuous wall permits a chronological arrangement and grouping of paintings by the same artist.

The beginning is marked by a large canvas by Jean-Baptiste Camille Corot (1796–1875), an artist whose influence on French art was felt for almost a century. This *Diana and Actaeon* (84), signed and dated 1836, was painted after his second visit to Italy. The mythological story of the chaste goddess of the hunt, Diana, and her sudden discovery by Actaeon is set in a landscape of the Roman Campagna. This is the earliest landscape by Corot in which classical figures are introduced; the goddess and four bathing nymphs in various attitudes of abandon and surprise show clearly the influence of the seventeenth-century French painter Nicolas Poussin, who also spent time in Rome.

The landscape looks as if Corot had painted it on the scene; its deep, dense colors are naturalistic and somewhat different from the misty, silvery tones of his later, better-known paintings. That style may be recognized on the distant trees on the left side of the painting. This part was reworked by Corot almost forty years later, in 1874, when new owners of the painting asked him to do so.

Corot's landscapes had a great effect on a younger generation of painters, the so-called school of Barbizon. The name derives from the village of Barbizon in the forest of Fontainebleau, where they mostly worked. They aimed to depict nature and peasant life on the spot, exactly as it was, without making it prettier. This rendering of nature made them the direct predecessors of the Impressionists.

Théodore Rousseau (1812–1867), who settled in Barbizon in 1844, is represented by two small landscapes. One of these, *L'Etang* (87), with a little pond and a small herd of cows, is a sunny, light picture from his later years. The influence of seventeenth-century Dutch landscape painters is very strong.

The small *Landscape* (85) of a sunny road with two figures is by Henri Joseph Harpignies (1819–1916), signed and dated 1854. The treatment of the trees harks back to Corot, but it is closer to nature and more intimate. (In the archives of the Lehman Collection is a photograph of the painting, on which the artist wrote in November 1910: "I certify that this painting was painted by me in August of 1854; this work was painted solely after nature.")

The *Landscape with Ducks* (86) by Charles François Daubigny (1817–1878) has a different character. Instead of producing an idyllic landscape, the artist has introduced drama.

The oranges and reds of the sunset sky contrast with the darkness of the foreground, creating tension. The seemingly moving clouds are painted with such freedom that they are closer to the Impressionists than to Corot. This is not surprising, since the painting is dated 1872, only a few years before a critic exclaimed: "It is impossible not to recognize the exact hour at which M. Daubigny has been working, He is the painter of the moment, of an impression."

Landscape near Zaandam (88) by Claude Monet (1840–1926) was painted in Holland in 1871. The artist was forced to leave Paris during the Franco-Prussian war of 1870, and after a stay in London he went to Zaandam on the advice of Daubigny. The damp, dissolving atmosphere, the canals lined with colorful houses, apparently were very appealing to the artist. This light and airy painting conveys how this experience helped give his palette a greater subtlety. Monet's Dutch landscapes were greatly admired by his fellow artists; one of them was acquired by Daubigny.

The *Alley of Chestnut Trees* (89) by Alfred Sisley (1839–1899) is also a peaceful, sunny landscape. As it is signed and dated 1878, one would expect it to reflect the personal problems that beset the artist in that year. Sisley, born of English parents in Paris, was forced to change his lodgings several times that year because of financial difficulties. Finally, he and his family settled in Sèvres and were no sooner installed than he began to paint. The subject was of no importance to him, as long as it was landscape. With an unparalleled love of nature he created "the most restrained and harmonious landscapes, to the glory of the Ile-de-France." The charm of this canvas is reflected in its provenance: in 1900 it was purchased by Tadama Hayashi, the chief commissioner of the Japanese government at the Exhibition Universelle of Paris in 1900, and one of the first Japanese collectors of the Impressionists. Later the painting belonged to Mrs. H. O. Havemeyer (a large part of whose collection is now in the Metropolitan Museum).

Camille Pissarro (1831–1903), often called the "father of Impressionism," painted the *Potato Gatherers* (90) in the fall of 1881, in Pontoise. It is signed and dated in the lower left-hand corner. He settled in Pontoise in 1871 after returning from London and remained there for the rest of his life. In contrast to Sisley, Pissarro introduced human and animal figures as important components in his landscapes. The three potato gatherers occupy the center of the canvas, yet they do not dominate the painting. This is mostly due to the unsentimental, prosaic treatment of the figures. The landscape is a harmonious mixture of greens and yellows arranged in layers representing the potato beds, the trees, and the sunlit patches of the upturned field.

Renoir's *Sea and Cliffs* (91) is the product of his visit to the

Guernsey Islands in 1883. The flowing brush strokes show his total abandon to color and light; the yellows and blues follow each other quickly and relentlessly. But this technical mastery signals an impasse that occurred in the artist's career about this time. Renoir described it later: ". . . while painting directly from nature, the artist reaches the point where he looks only for the effects of light, where he no longer composes, and he quickly descends to monotony." Shortly after the summer of 1883 Renoir turned to figure painting again. The *Figures on the Beach* (94) from the 1890s is a happy combination of the genre like scene in the foreground with the great expanses of the water and sky.

Tahitian Women Bathing (97) by Paul Gauguin (1848–1903) is signed in the lower right-hand corner. Although there is no date on the painting, it is evident that the artist painted it in 1891 or 1892 on Tahiti. There are many comparable dated paintings by Gauguin done during these two years, the most important of which is in the Metropolitan Museum: *Ia Orana Maria—Ave Maria,* dated 1891, a gentle and colorful composition usually considered one of Gauguin's major Tahitian works.

Tahitian Women Bathing, in contrast, is a forceful, almost violent painting. The canvas is populated with massive, sculptural figures and densely covered with clashing fields of strong colors. The artist paid little attention to modeling; in fact, the arms of the standing woman are badly out of proportion. Despite its daring treatment of the human figures and its violent colors, this painting is part of the fabric of French art at the turn of the century. The whole composition, and especially the standing nude, is very close to Puvis de Chavannes's large canvas *Young Girls at the Seashore* (1879, in the Louvre). Gauguin's painting in turn probably played an important role in the creation of Matisse's series of bas-reliefs called the *Backs.* (The series is in the Museum of Modern Art, New York.) *Back* no. III especially recalls Gauguin's standing nude. A recent writer has noted: "Matisse must have known the painting; it belonged to Ambroise Vollard and then to Adolphe Kann (Paris), with both of whose collections he was quite familiar."

The portrait of *Madame Roulin and Her Baby* (96) by Vincent van Gogh (1853–1890) has neither signature nor date, but we know from the artist's letters to his brother that he painted it in November 1888 in Arles. Madame Roulin was the wife of the postman Roulin, who himself and whose family were portrayed by Van Gogh many times. The baby, called Marcelle, was three months old at the time, and both she and her mother must have been somewhat frightened by the artist.

The year 1888 was a difficult one for Van Gogh. He painted

feverishly in Arles, sustaining himself on small amounts received from his brother Theo. This was the time of Gauguin's visit to Arles, and its terrible consequences marked the beginning of the artist's end. Despite that, the painting is full of friendly yellows and hopeful greens. The baby's unpleasant grin is compensated for by the beautifully drawn profile of her mother. Tension may be observed in the nervous spread of her supporting fingers and abrupt modeling of the baby's thumb.

The *Landscape* (100) by Edgar Hilaire Germain Degas (1834–1917) is an unusual painting for this artist. Instead of the graceful ballet dancers or stylish ladies, here is the peaceful small town of Saint-Valéry-sur-Somme. It was painted around 1898, when Degas stayed there with his painter friend Braquaval. The colors are fresh and pastel-like, capturing the sunlit reds, ochres, and yellows of the houses. But the black contours of the houses and their roofs overlay a subtle network of geometric forms, perhaps an indication of the coming style of Fauve landscapes such as that by Braque in the Special Gallery (109).

Edouard Vuillard's *Interior with Figure Sewing* (101), signed and dated in the lower left-hand corner, is generally acclaimed as one of his best interiors. Stuart Preston has written "In very few of Vuillard's intimist interiors of his mother sitting in a room does he express so triumphantly the full density and complexity of real things. And few are as mutely or richly stated as this small oil, formed out of a multitude of tiny touches into an impressive whole. . . ."

The *Sergeant of the Colonial Regiment* (111) by Albert Marquet (1875–1947) was painted in 1907 and is one of the most significant Fauve portraits. The characterization and monumentality of the figure are in the best tradition of French portraiture; its economy of form reminds one of Manet, while the bold use of colors shows the influence of Gauguin. Yet the slightly bent figure, the almost unbroken black of his uniform, and the bold strokes defining the shape of the face are entirely different from earlier French portraits. The painting also has a special place in the artist's oeuvre; he painted only a few portraits after this one, and he is better known as a painter of nudes and landscapes.

Paul Signac's *View of Collioure* (104) from 1887 is signed and dated in the lower left-hand corner and marked *Op. 165*. (Signac began to use "opus" numbers on his paintings in 1887. This musical terminology hints at Signac's friendship with the Symbolist poets, who often employed musical symbols.) *View of Collioure* is an excellent example of the artist's Pointillist, or Divisional, style. It is painted entirely in small dots of primary colors; their concentration and combination decide the intensity of the color impression. The size of the dot usually indicates the distance; they are larger when

supposed to be closer to the onlooker, smaller when far away. Collioure is in the southernmost part of France, and its rocky bay with stark buildings had a special appeal to Signac: "Blue sky, blue sea, and all the rest burned orange;—thus a forced harmony. In that respect the 'Midi' is splendid."

Another Signac painting, *Fishing Boats, Concarneau* (105), signed and dated 1888, is marked *Op. 220* in the lower right-hand corner. It was painted in the north of France. Here Signac was fascinated by the calming, soothing effect of the sea, by the tranquility of hazy colors so evident in the painting.

Henri Edmond Cross (1856–1910) belonged to the circle of Seurat and Signac, but he was a latecomer to Neo-Impressionism. Only in 1891, when he settled in the south at Saint-Clair, did he first paint in this style. *Valley with Fir* (108) is dated 1909, thus it is a late work. There is a careful harmonization of the different color values; the hues of yellow, lavender, and blue are brought together with firm, even strokes.

Woman on the Seashore (112) by Louis Valtat (1869–1952) achieves a similar harmony, but instead of the staccato, regulated strokes, there are flowing veils of color. The canvas is not dated, but it is known that Valtat painted it around 1902. The scene is the famous red rocks, *roucas rou*, of the seashore near his house in Antheor on the French Riviera. The ragged diagonal of the rocks cuts through the whole composition: the reds, purples, and yellows in the turbulent lower part are perfectly set off by the calm bluish white and lavender of the sea and sky. The seated woman is hardly distinguishable from the surroundings; her undulating dress could be a piece of rock, her straw hat blends with the yellow sand. The bold colors and forms forecast the artist's future: he was one of the Fauves in the autumn Salon of 1905.

Three paintings by Maurice de Vlaminck (1876–1958) are from his famous Fauve period, between 1903 and 1907. At this time he was living and painting in the small community of Chatou, on the banks of the Seine not far from Paris. The landscape is the Seine and its surroundings, which fascinated the artist with their constantly changing colors. The two smaller paintings, *River Scene with Boat* (1905) and *Reflections of Sunlight* (1905–1906), are dominated by blues. The full force of Vlaminck's palette explodes, however, on the third, entitled *Sailboats on the Seine* (110), painted in 1906. This wonderful composition of pure colors needs no description, but to understand it better the artist's comments may be quoted: "I heightened all tones . . . I transposed into an orchestration of pure colors all the feelings of which I was conscious. I was a barbarian, tender and full of violence. I translated by instinct, without any method, not merely an artistic truth but above all a human one. I crushed and botched the ultramarines and the vermilions though they were expensive."

The *Reclining Nude* (119) by Suzanne Valadon (1867–1938) is a major work by an artist who has not received the recognition she deserves. Her life was almost entirely spent in and with painting. From the early 1880s on she was a favorite model of Puvis de Chavannes, Renoir, Degas, and Toulouse-Lautrec. The latter two discovered her talent for drawing and encouraged her to paint and engrave as well; she first exhibited at the Salon in 1895. This canvas, dated 1928, a mature work, reflects Suzanne Valadon's predilection for line; the contours are firmly and beautifully drawn without unnecessary details. The nude is positioned in the curve of the sofa; the delicate greens of the upholstery cast interesting lights on the flesh of the face; still it is the line that dominates.

Maurice Utrillo (1883–1955), Suzanne Valadon's son, was the painter *par excellence* of the Montmartre of Paris. With untiring eye and diligence he painted the stark colors of the small houses, cafés, and other haunts of artists lining the winding, steep streets. This painting represents *40, Rue Ravignan* (118), around 1913. The dominant whites and grays indicate that it is from the so-called "white period" of the artist. Eyewitnesses say that about 1910 Utrillo became fascinated with the white buildings of Montmartre, perhaps a reaction to Impressionist influences. In order to simulate the rough texture of their walls, he mixed some plaster of Paris into his paint and created whole ranges of whites and silky grays.

The *Avenue du Bois* (117), by Kees van Dongen (1877–1968), painted about 1925, is a delightfully colorful contrast to Utrillo's sombre painting. According to a penciled inscription on the stretcher, it represents a Sunday morning on the favorite strolling place of Parisians. Van Dongen's Fauve heritage is still in full force, although somewhat more sophisticated, as seen in the strong verticals and horizontals of the throng of automobiles and in the predominantly blue and gray color scheme. The canvas is also a precious document of contemporary costume and transportation.

It is not a coincidence that this panorama of French painting from the nineteenth and twentieth centuries closes with Balthus's *Figure in Front of a Mantel* (120). Painted in 1955, it is more than a century away from Corot's landscape with Diana and her nude nymphs (84). The concepts behind the two paintings are even farther apart than the six generations separating them. Yet this painting is connected to those generations and their artistic inheritance with a network of perceptible ties.

Balthus (born in 1908 in Paris as Count Balthasar Klossowsky de Rola) is a self-taught painter. But he, like almost every French artist of the previous centuries, made his pilgrimage to Italy, where he copied the frescoes of Masaccio and Piero della

Francesca. The nude figure of a girl before a mirror, the intimacy of a bedroom interior, are timeless themes from earlier French art. The classical figure and the pure contour of the profile are undeniable echoes of Piero della Francesca's standing females, but without their gravity. The figure is rather light, like those of Matisse, and pliant, like those by Ingres. But the whole is totally mid-twentieth century. Some of the details are decorative, such as the wallpaper, some almost neo-realistic, such as the carving on the mantelpiece. The figure is painted with a discreet eroticism; the painter suggests the feline feeling permeating the body rather than its structure. The simplicity of his means counterbalances the complexity of his meanings.

Drawings, Glass, and Jewelry

Several parts of the Collection, because of their fragile nature, cannot be on continual exhibition. The largest category of these comprises the more than one thousand drawings. All were acquired solely by Robert Lehman. His first purchases were made in the early 1920s, and the first large group consisted of Italian drawings from the sale of the collection of Luigi Grassi. After this auspicious start, Robert Lehman acquired drawings at auctions and from dealers both famous and small. The collection of Henry Oppenheimer was purchased in 1936, and a group of Dürer drawings came from the Lubomirski collection in the early 1950s. Two memorable events were the acquisition of sixteen Rembrandt drawings from the former Silver Collection, in the early 1960s, and shortly afterward the addition of the Venetian drawings of Paul Wallraf to the already extensive collection of Venetian drawings.

The largest section in this extraordinary collection is that of Italian drawings, dating from the fourteenth century to the beginning of the nineteenth. The drawings of the early Veronese masters, such as the *Wild Man* by Stefano da Verona (172), are considered great rarities. Fifteenth-century Florentine artists are represented by such important pieces as Leonardo da Vinci's *Study of a Walking Bear* (174), Pollaiuolo's design for the Sforza equestrian monument (173), and Francesco di Giorgio Martini's colorful project for the funeral monument of a humanist (175). Other schools of fifteenth-century art are also well represented; there are rare drawings by masters of Siena, Ferrara (Cossa's *Venus and Cupid*, 176), and Messina.

The absence of Mannerist paintings in the Collection is greatly compensated for by the drawings from the sixteenth

(178) and seventeenth centuries. But the most outstanding group of Italian drawings consists of those by the Venetian masters. Two important compositions are attributed to the fifteenth-century artist Giovanni Bellini. These are followed by sixteenth-century leaves by Titian, Tintoretto, and Veronese. More than one hundred exceptionally varied Venetian drawings are by the great eighteenth-century masters, the two Tiepolos (179), Canaletto (177), and Guardi.

The fifteenth-century Flemish drawings are among the great rarities of northern European art of that century. The large composition representing *Men Shoveling Chairs* (180) is attributed to Rogier van der Weyden, and was probably a design for a sculptural capital. Another delicate page, probably from a sketchbook, shows figures from this artist's famous St. John the Baptist altarpiece in Berlin. Another late fifteenth-century composition showing a bear hunt is probably a cartoon for a tapestry. From among the many important Flemish drawings from the end of the century, Hieronymus Bosch's little sketch of *Two Pharisees* (181) stands out. On its verso is another drawing by the same master showing Adam and Eve. (More than two hundred sheets in the Collection have drawings on both sides.) Of the later Flemish masters Rubens's celebrated *Bust of Seneca* (183) stands out.

The fifteenth- and sixteenth-century German masters are also spectacularly represented. Drawings such as a charming little Madonna (182) for a stained-glass window, or the *Flagellation* (184) by the Master of the Playing Cards, are considered among the earliest masterpieces of German drawings. The great master of the German Renaissance Albrecht Dürer is represented by five outstanding drawings. The *Self-Portrait* (185) from 1493 is one of his early self-images. The *Holy Family in a Trellis* (186), from his later years, is one of his lightest compositions. Among the works of Dürer's contemporaries and followers are such important drawings as the *Bust of a Man* by Martin Schongauer and a *Pietà* by Hans Baldung Grien.

From the seventeenth century a rich assembly of Dutch drawings shows the continuation of the northern tradition. Among the most outstanding are the drawings of Rembrandt van Rijn, especially his *Self-Portrait* (189), the great red chalk composition after Leonardo's *Last Supper* (187), an important, dated *Cottage near the Entrance to a Wood* (188) from 1644, and, finally, his amusing *Satire on Art Criticism*.

Robert Lehman's love of French art is reflected in the great assembly of French drawings from the sixteenth to the twentieth centuries. The *Running Nudes* by Primaticcio exudes the spirit of the French school of Fontainebleau, dating from the middle of the sixteenth century. Claude Lorrain's *View of the Villa Doria Pamphili* (190) is a perfect expression of what French artists saw and experienced during their trips to Italy.

Drawings, Glass, Jewelry

Of the many eighteenth-century French drawings and watercolors, those of Fragonard (191) and Hubert Robert stand out. The great French draftsman of the nineteenth century, Ingres, is represented by no less than four portraits and a sensitive study for his painting *Raphael and Fornarina* (192). From the first half of the nineteenth century other masters such as Chassériau and Prud'hon are well represented; there are many sensitive watercolors by the masters of the Barbizon school, especially Théodore Rousseau.

There are drawings or watercolors by almost every master of the Impressionist and Post Impressionist periods. The great Renoir paintings in the Collection are augmented by drawings such as the *Portrait of Madame Severine* (195). A colorful early drawing by Van Gogh shows a *Road at Nuenen* (193); a late pen and ink drawing represents a *Bridge over the Rhone*, in his better-known style. Amedeo Modigliani's two studies of the *Painter Benito* and the *Sculptor Gargallo* are not only delightful quick sketches but also precious documents of Parisian artistic life at the beginning of the twentieth century. An extraordinary group of watercolors by Paul Signac, landscapes (194) and still lifes, covers the entire career of the artist.

Important drawings represent other countries and schools. A rare *Self-Portrait* (196) by Goya and an early sketch by Picasso are examples of Spanish art. From the eighteenth-century English masters are drawings by Gainsborough, Rowlandson, and Romney, and watercolors such as a charming one by Crome. From nineteenth-century English art, drawings by Ruskin and by Pre-Raphaelites such as Burne-Jones deserve mention.

Nineteenth-century American art is colorfully represented by a whole sketchbook (197, 198) by Maurice Prendergast with watercolors showing scenes from Boston's Public Garden from 1895 to 1897.

Other parts of the Collection that are shown in special exhibitions are in the field of decorative art. The collection of fifteenth- through seventeenth-century European glass is interesting on many counts. It was acquired by Robert Lehman almost entirely through the late Leopold Blumka, a well-known Viennese-American dealer. It contains beautiful blown-glass objects bearing the coats-of-arms of popes, kings, and princes as well as those of patricians and burghers. Their provenances include collections such as those of Rothschild in Paris, Taylor and Eumorfopoulos in London, and Huldschinsky and Bondy in Vienna. The close to one hundred glass objects in this Collection together with those in the Metropolitan Museum probably constitute the largest group of glass from the fifteenth to seventeenth centuries in the Western hemisphere.

Among the Venetian glass, a blue ewer painted with enamel is considered one of the most important pieces from the middle of the fifteenth century. Another clear glass ewer and several

plates bear the coats-of-arms of Medici popes. There are drinking glasses with the coats-of-arms of Florence and of other Italian cities. Almost every technique of glass manufacture and decoration is represented; there are several plates of *latticinio,* or cracked and agate glass. A large goblet is painted with a gilded fish-scale pattern, and a traveling flask with intricate arabesques in enamel. Some still have their original gilded silver or pewter mounts.

An interesting double cup bears the date 1518 and the coats-of-arms of two German families: according to tradition, it was used in a marriage ceremony. Among the seventeenth-century glass, there are several pieces decorated with diamond-engraved patterns; others are in curious shapes such as German drinking glasses in the form of riding boots or hunting horns.

Robert Lehman gathered his exquisite collection of Renaissance jewelry and precious stone carvings with the same care as he did his drawings. Since in the early 1920s there were very few important medieval jewels available (ones similar to those represented on the *St. Eligius* [57] by Petrus Christus) , he decided to concentrate on Renaissance jewelry. With the help of his traveling parents, and of well-known connoisseurs of old jewelry such as John Hunt, he made spectacular purchases even in the beginning. A pendent jewel, with a cameo on one side and translucent enamel on the other, is a delicate, late fifteenth-century French piece that later belonged to Mary Stuart, Queen of Scots. The provenance of another outstanding piece, a gold round hat jewel, is not known, although it is probably early sixteenth-century French. The figures, a standing woman, an old man, and a young gallant, probably constitute the first genre scene in Renaissance jewelry.

There are many outstanding sixteenth-century Italian jewels in the Collection. An important group is that of those made from baroque pearls; a large, late sixteenth-century composition showing a lion attacking a horse was probably fashioned after a small Renaissance bronze. Several German jewels were made after the designs of Jost Amman. Robert Lehman's interest in jewelry didn't stop with pieces from well-known workshops. There are several Spanish devotional jewels, and many works by seventeenth-century Hungarian goldsmiths.

The collection of carved precious stone objects includes several late sixteenth-century Italian rock-crystal carvings. Outstanding among these is a cup in the form of a sea monster surmounted by the figure of an infant Bacchus, by a Milanese master from the circle of the Sarachi brothers. A rock-crystal ewer in the form of a sitting dog is seventeenth-century German and bears the arms of Bavaria. There is also a small but important group of enameled gold snuffboxes and watches, and a group of objects decorated with sixteenth-century Limoges enamel such as mirrors and mounts.

Plates

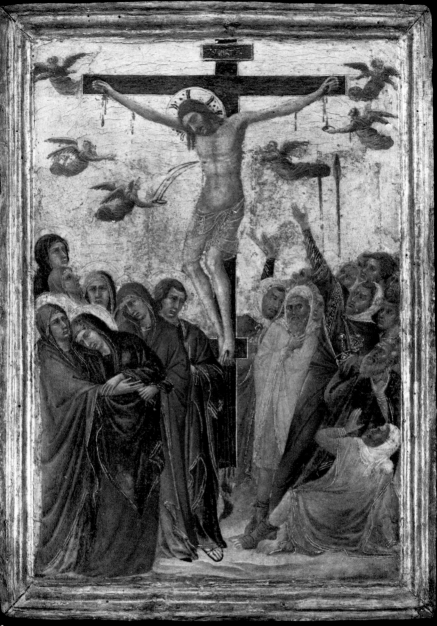

1

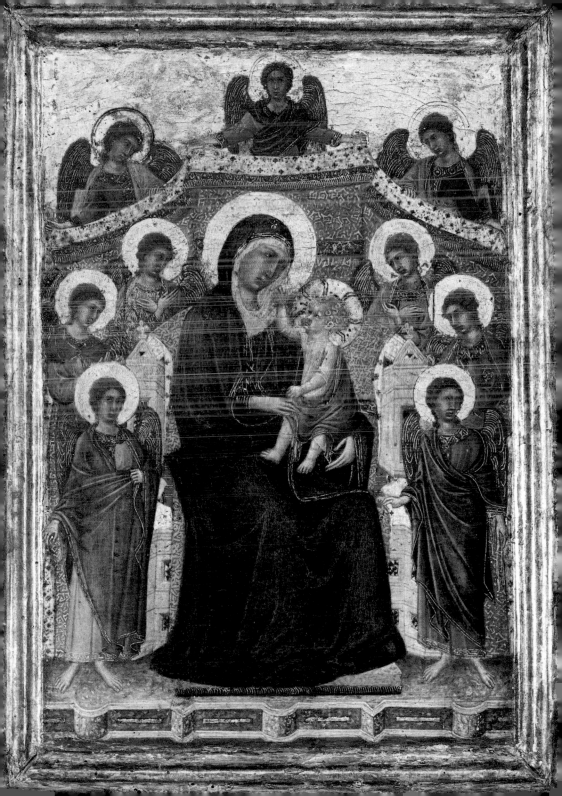

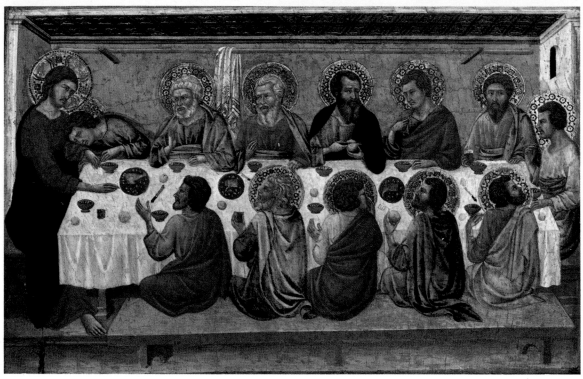

3

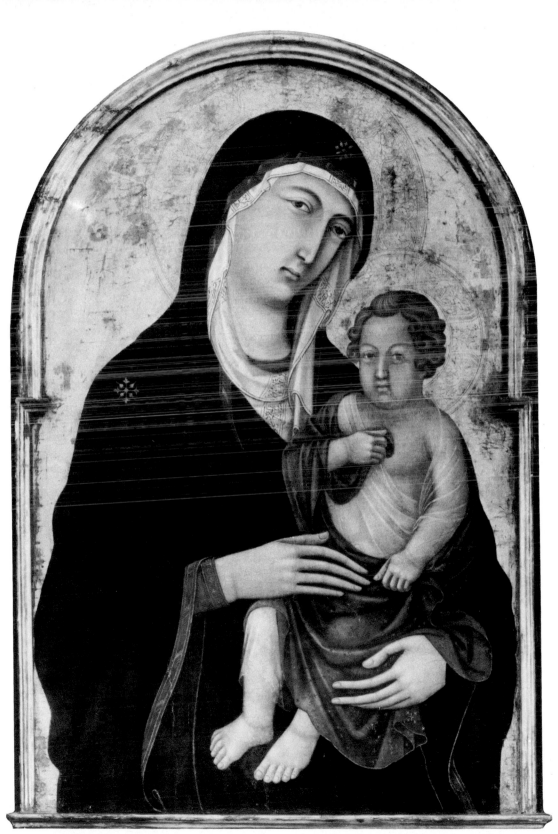

4

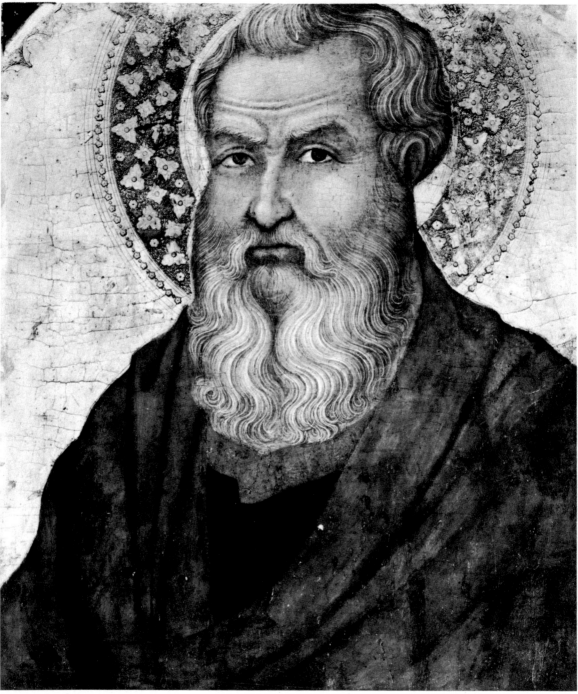

5

5. Ugolino da Nerio, Apostle.
Second Room, p. 29

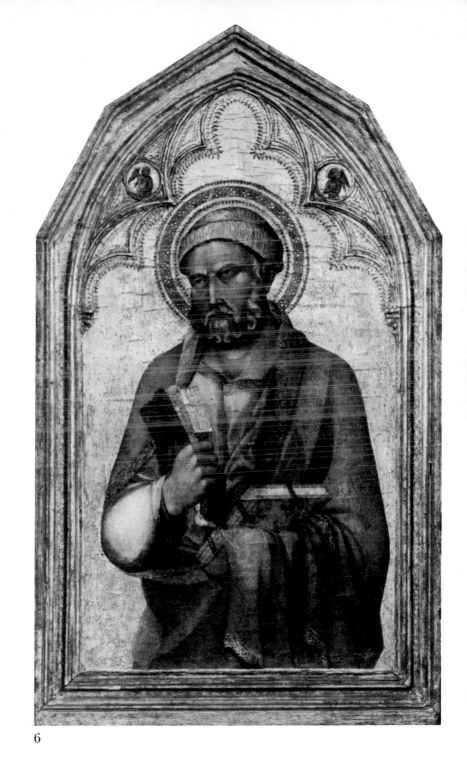

6

6. **Barna da Siena, St. Peter.**
First Room, p. 13

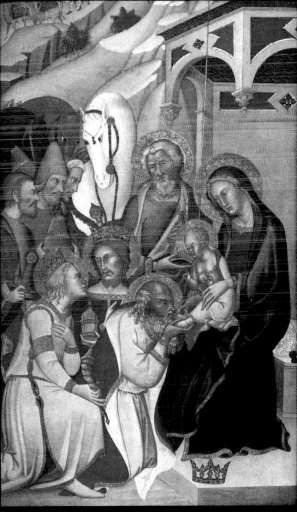

8

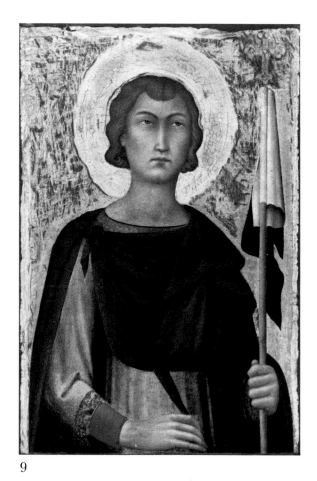

9

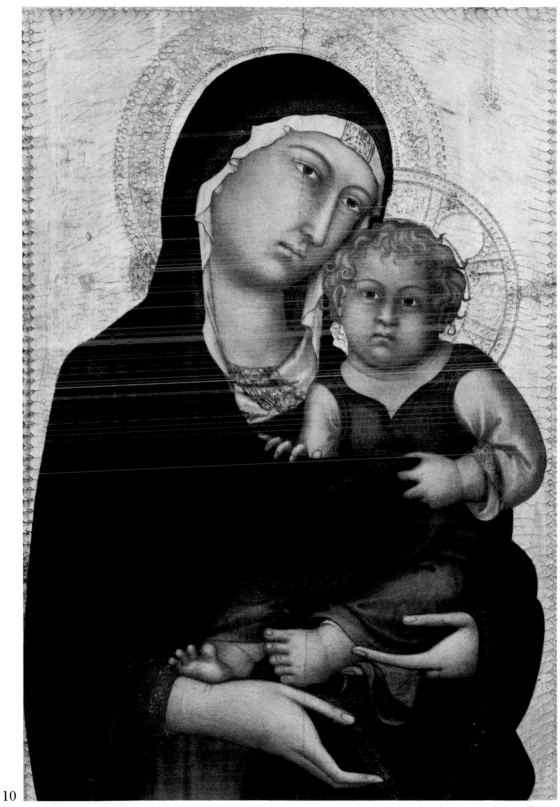

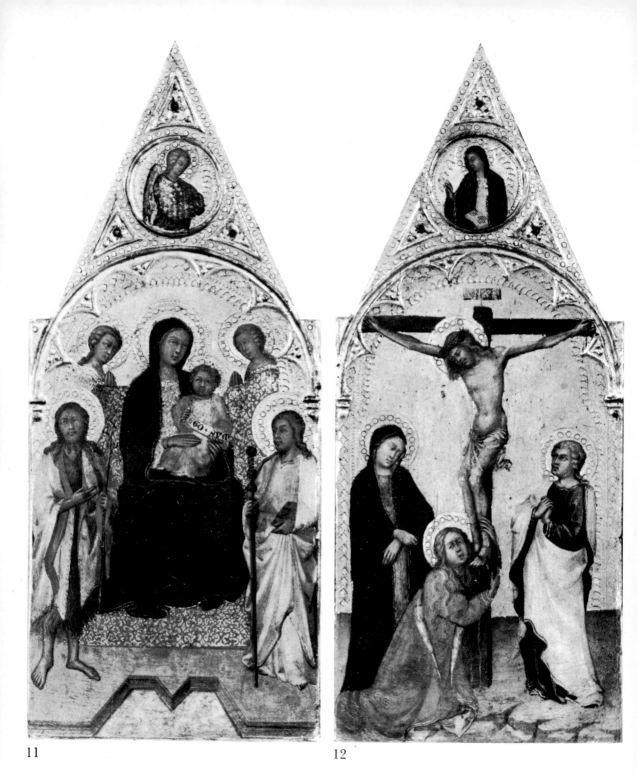

11

12

11. **Paolo di Giovanni Fei, Enthroned Madonna.**
Second Room, p. 30

12. **Paolo di Giovanni Fei, Crucifixion.**
Second Room, p. 30

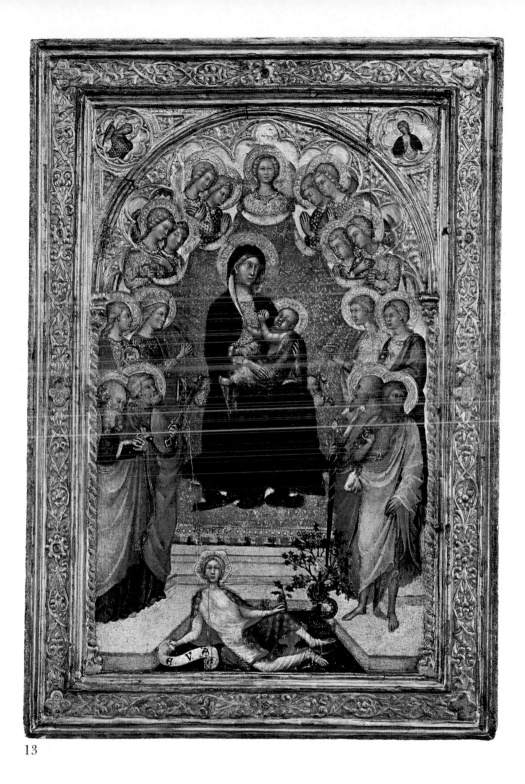

13

**13. Paolo di Giovanni Fei, Madonna and Child with Saints,
Angels, and Eve.**
First Room, p. 16

14

15

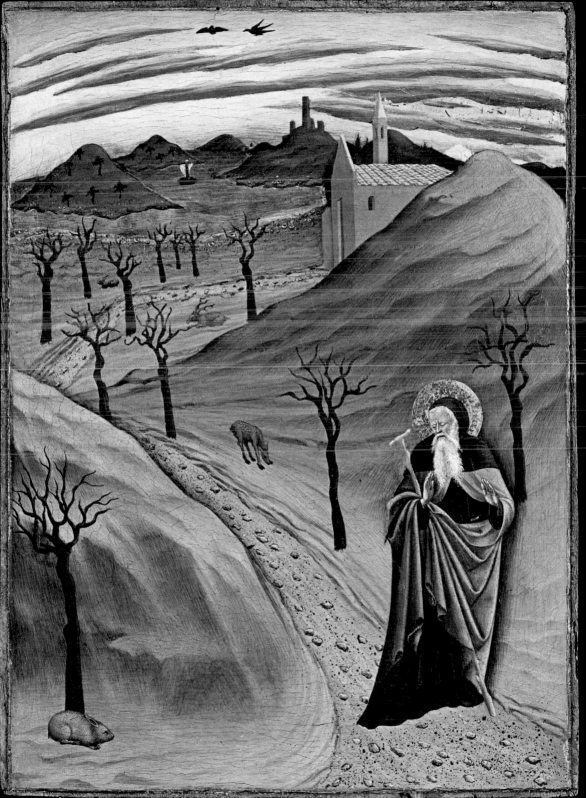

16

17

17. **Benvenuto di Giovanni, Madonna and Child.**
Red Velvet Room, p. 54
18. **Giovanni di Paolo, Annunciation to Zachariah.**
First Room, p. 15

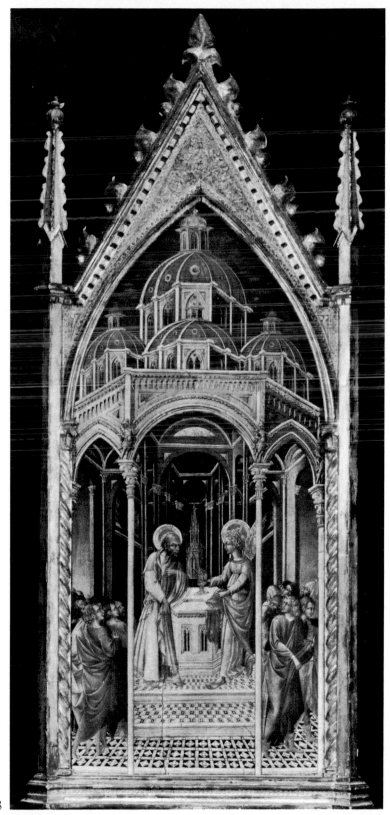

18

19. **Giovanni di Paolo, Expulsion from Paradi**
Red Velvet Room, p. 48

20

20. Giovanni di Paolo, St. Catherine Receiving the Stigmata.
First Room, p. 13

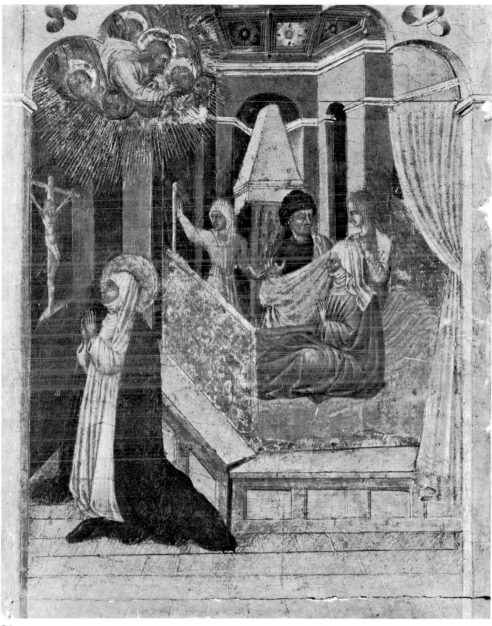

21

**21. Giovanni di Paolo, St. Catherine's Prayer and Christ
Resuscitating Her Mother.**
First Room, p. 13

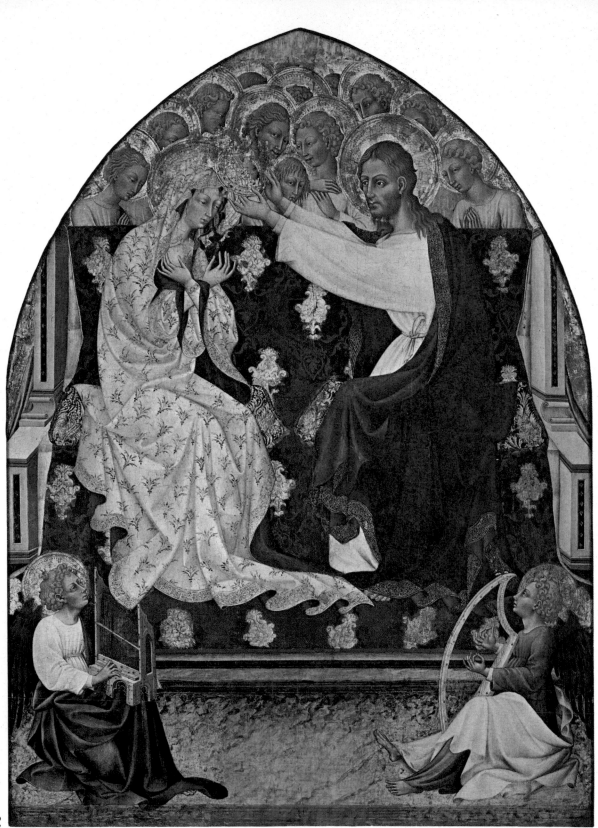

22

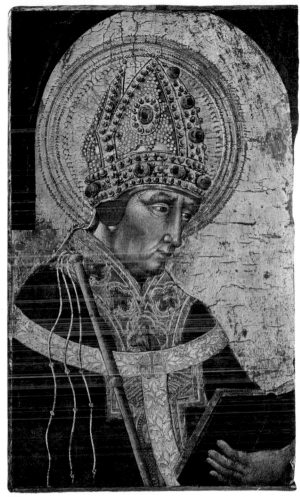

23

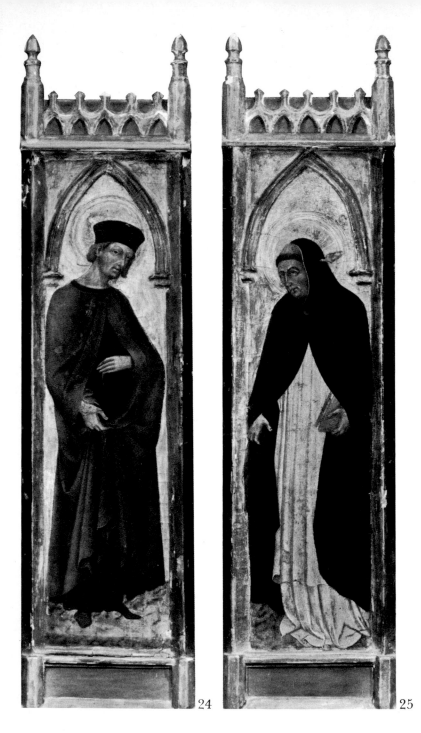

24. **Pellegrino di Mariano, Blessed Andrea Gallerani.**
First Room, p. 17
25. **Pellegrino di Mariano, Blessed Ambrogio Sansedoni.**
First Room, p. 17
26. **Bicci di Lorenzo, Two Standing Saints.**
Second Room, p. 28

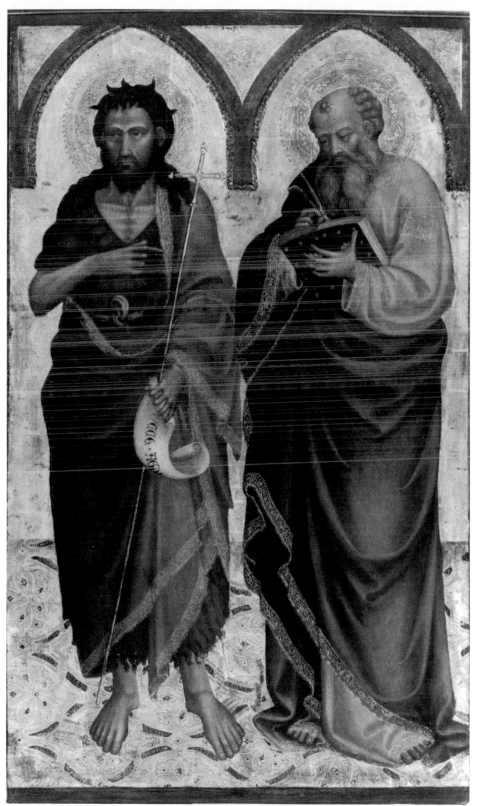

26

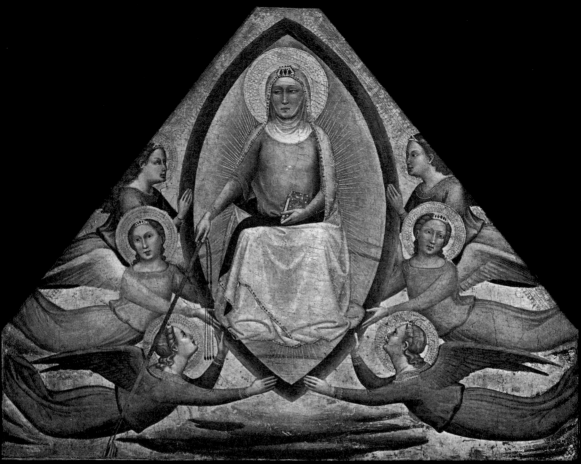

27

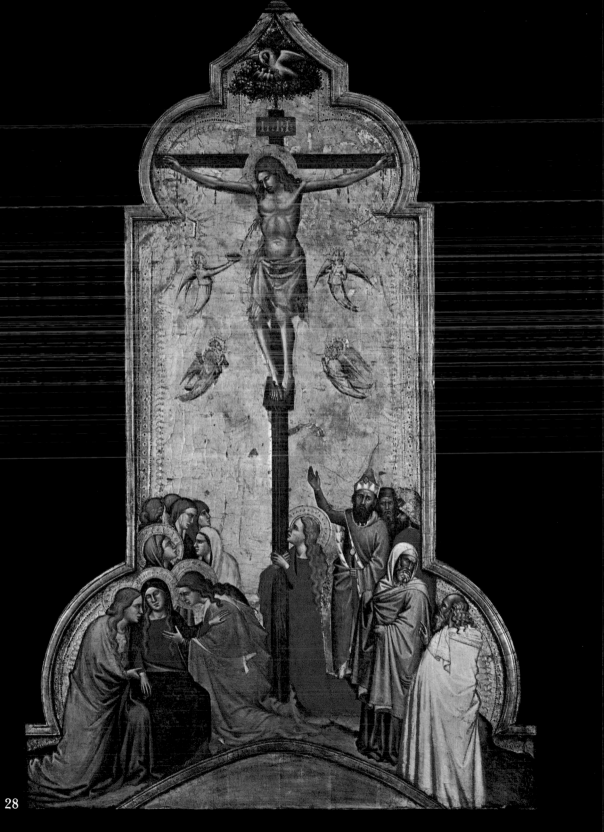

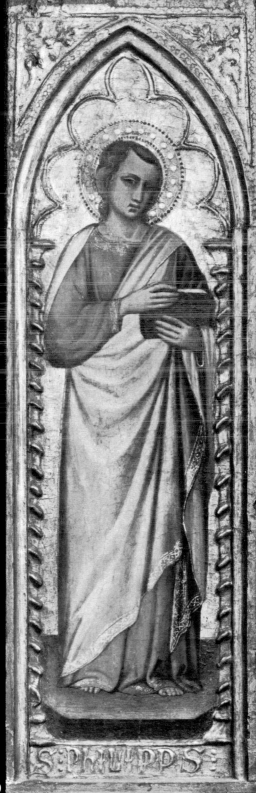

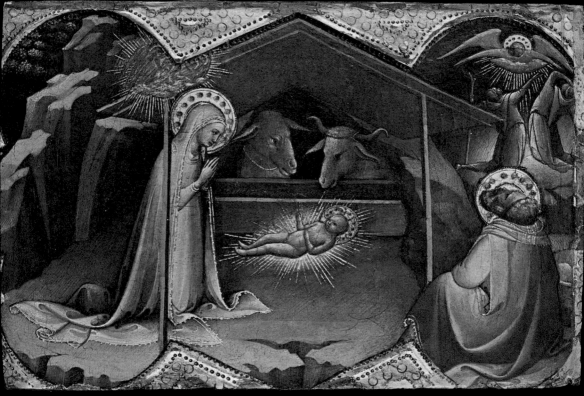

31

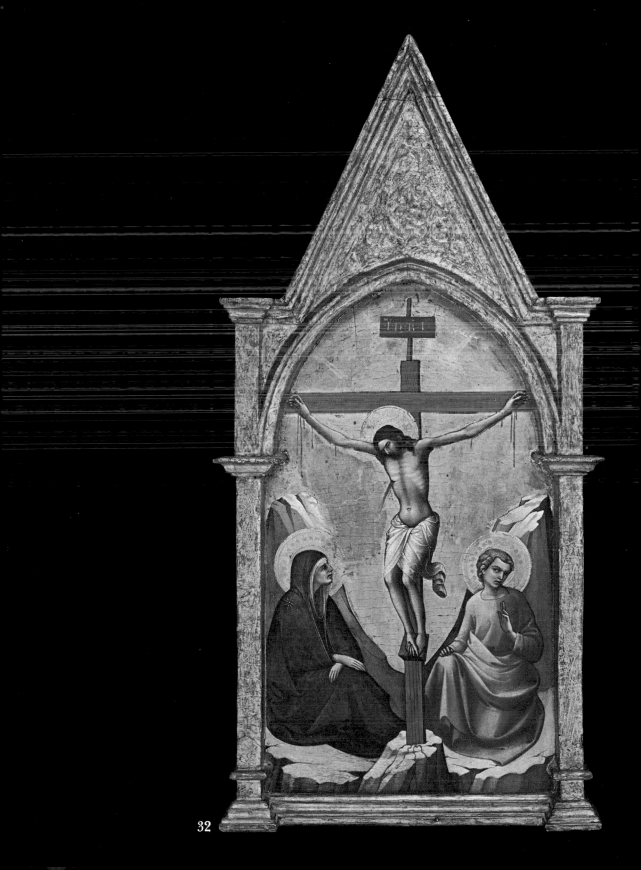

32

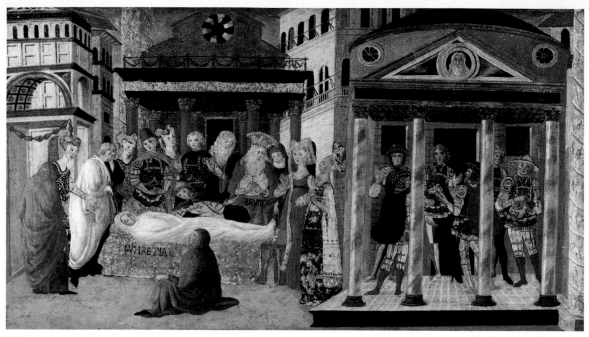

33

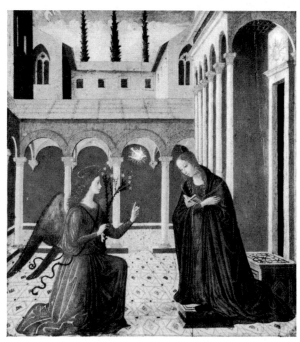

34

35

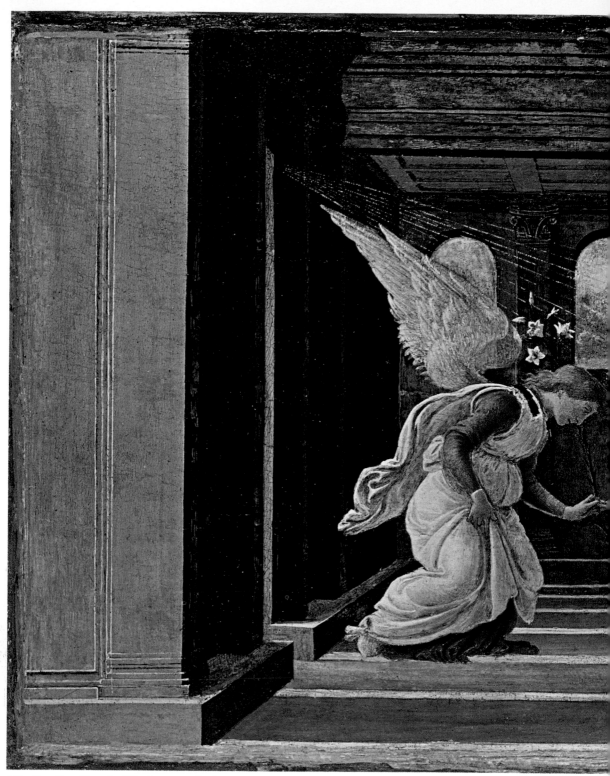

36. Sandro Botticelli, Annunciation.
Red Velvet Room, p. 53

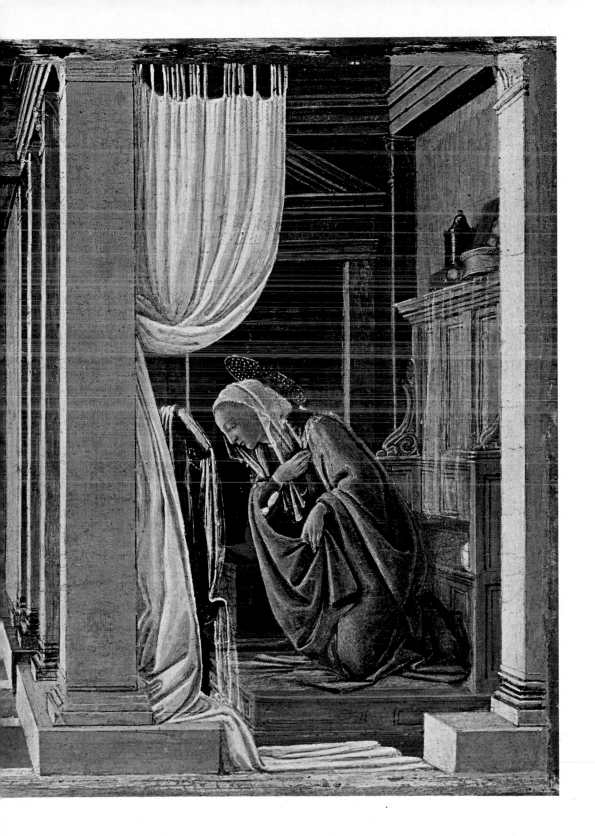

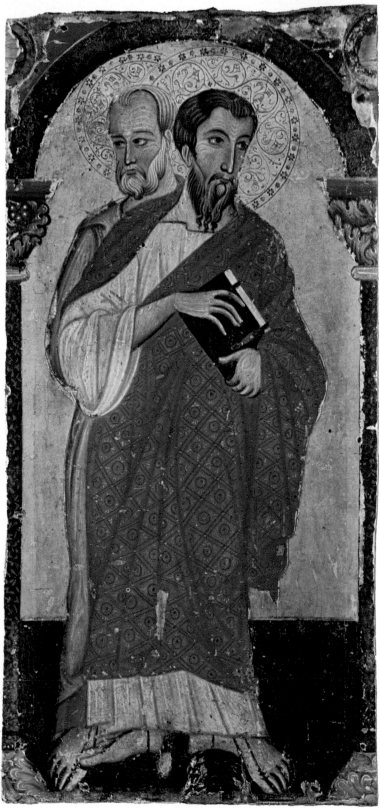

37

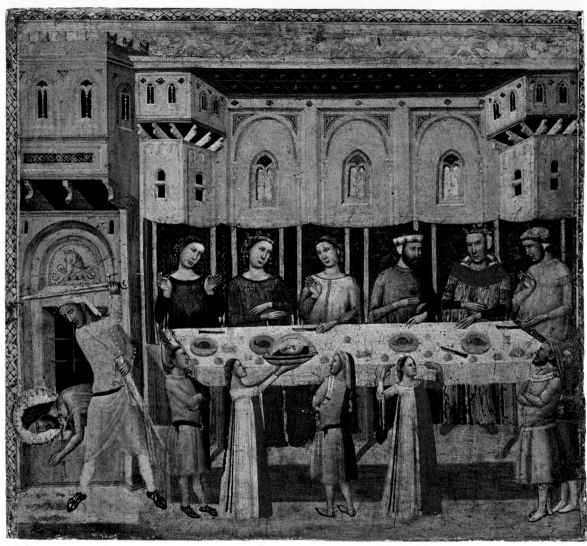

39

39. **Master of the Life of St. John the Baptist, Feast of Herod.**
Second Room, p. 24

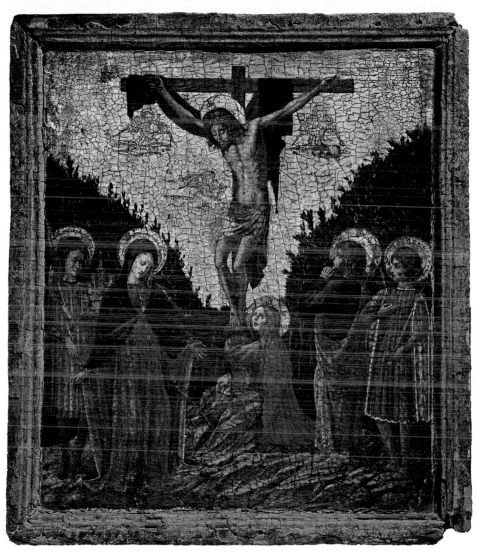

40

40. Giovanni Boccati, Crucifixion.
Second Room, p. 25

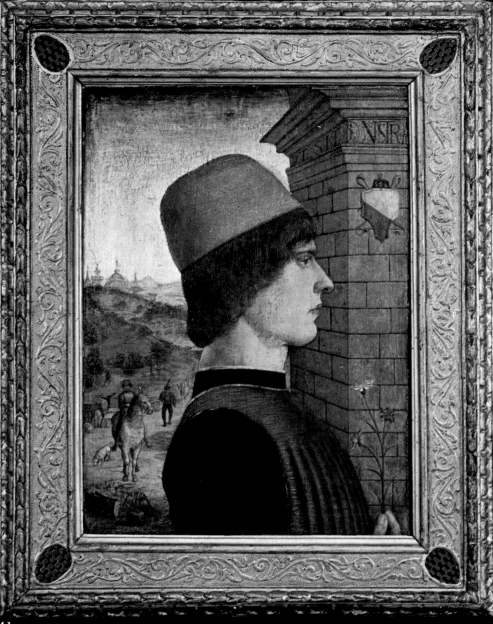

41

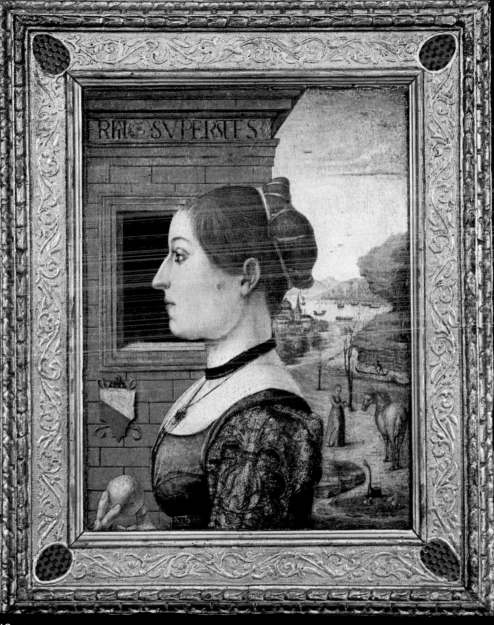

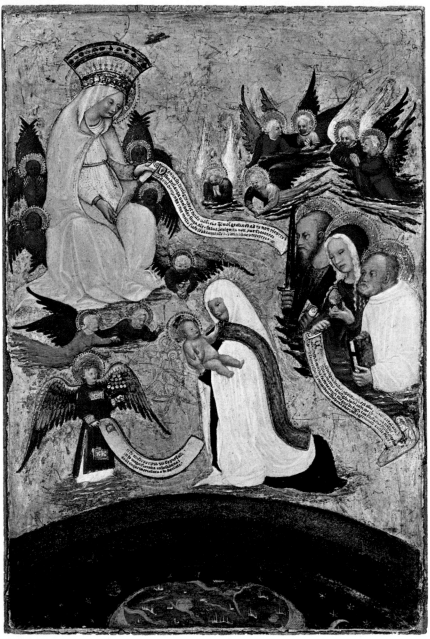

43

43. **Master of the Marches, Life of Santa Francesca Romana.**
Staircase Landing, p. 64
44. **Master of the Marches, Life of Santa Francesca Romana.**
Staircase Landing, p. 64

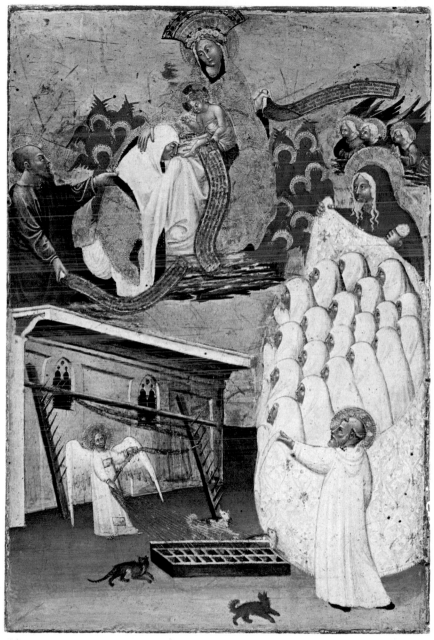

44

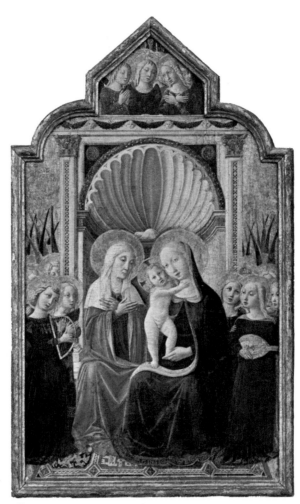

45

45. **Niccolo da Foligno, St. Anne and the Madonna and Child Surrounded by Angels.**
Second Room, p. 30
46. **Lorenzo Veneziano, Madonna and Child.**
First Room, p. 20

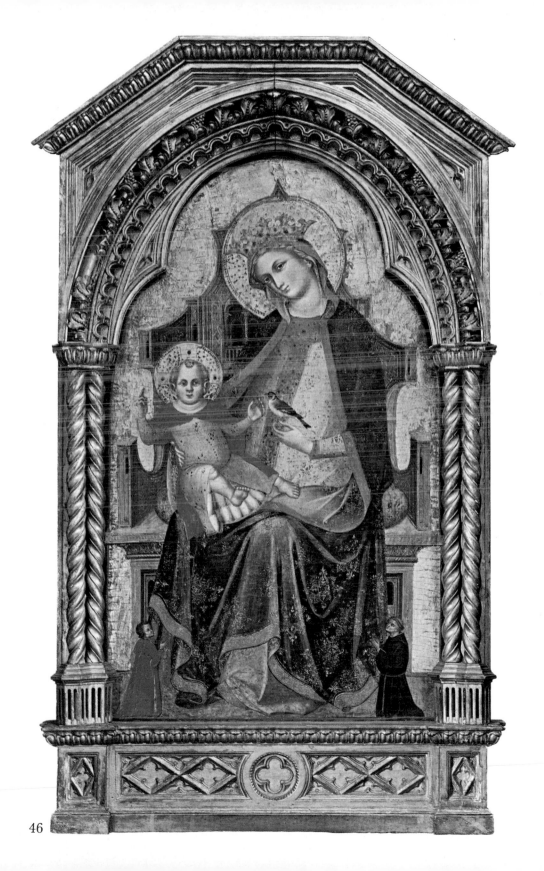

46

47

48

47. **Venetian Master, Flagellation of Christ.**
First Room, p. 21
48. **Venetian Master, Entombment of Christ.**
First Room, p. 21
49. **Giovanni Bellini, Madonna and Child.**
Red Velvet Room, p. 52

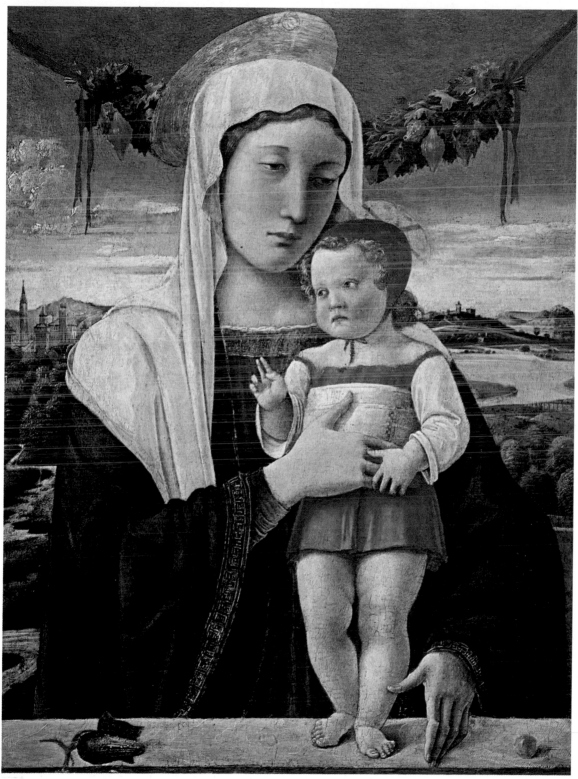

49

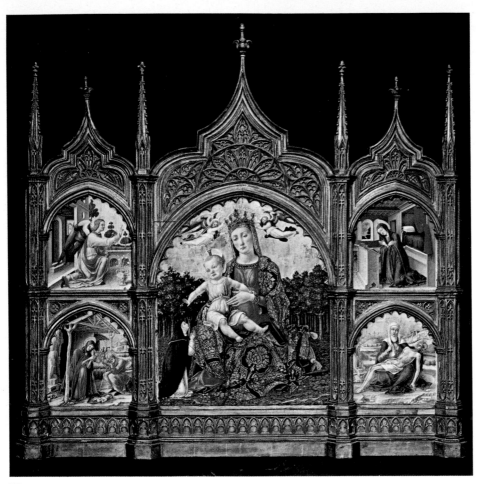

50

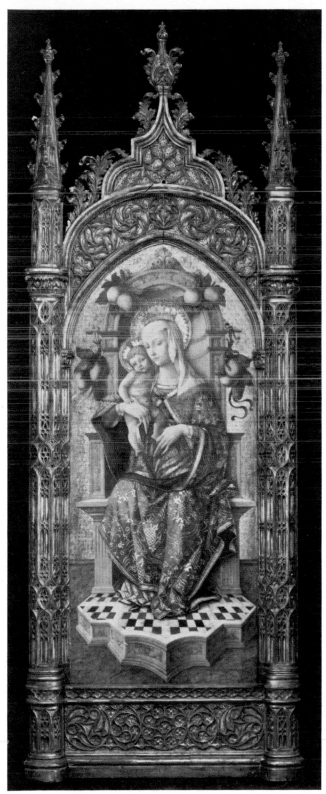

51

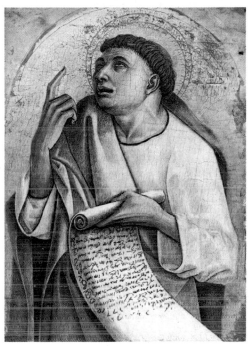

52

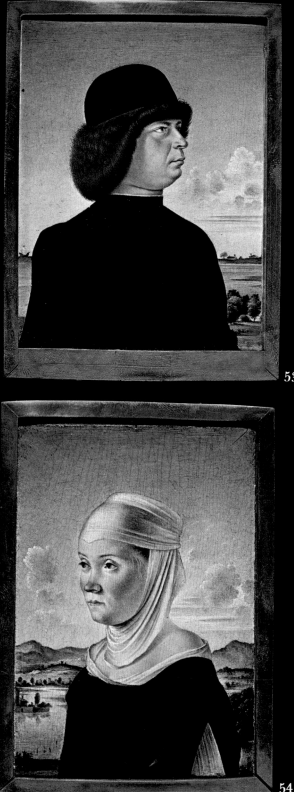

53

54

55

56

**Jacometto Veneziano,
Portrait of Alvise Contarini.**
Red Velvet Room, p. 54
**Jacometto Veneziano,
Nun of San Secondo.**
Red Velvet Room, p. 54
Verso of 53
Red Velvet Room, p. 55
Verso of 54
Red Velvet Room, p. 56

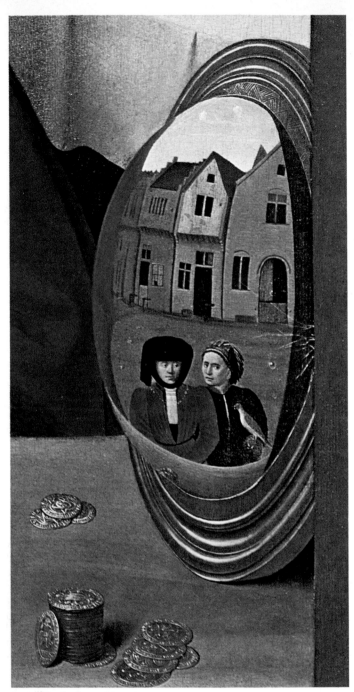

Detail of plate 57

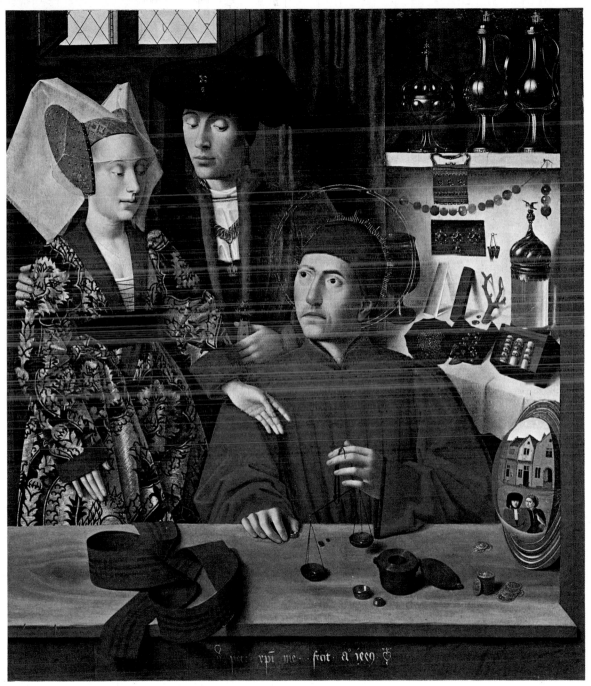

57

57. Petrus Christus, St. Eligius.
Flemish Room, p. 79

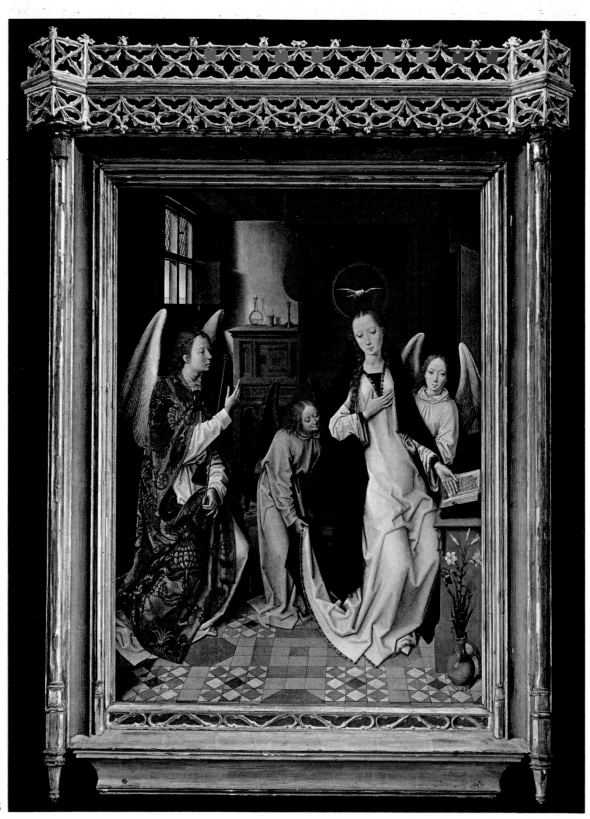

58

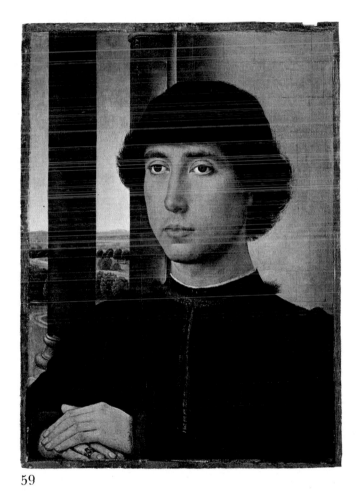

59

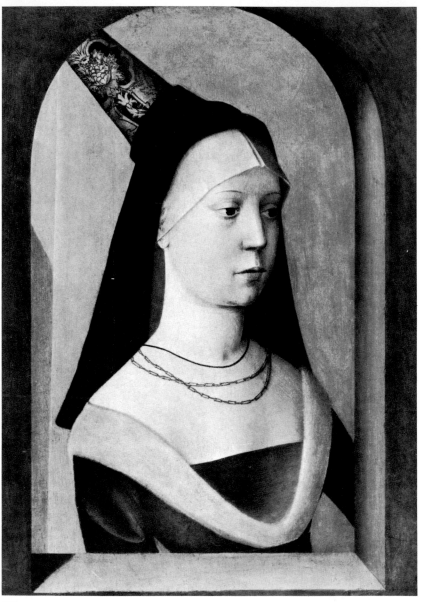

60

**60. Franco-Flemish Master, Portrait of a Lady
(Margaret of York).**
Flemish Room, p. 83

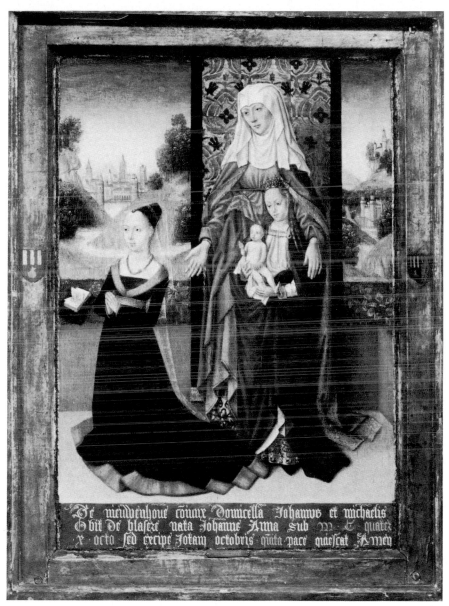

61

61. **Master of the St. Ursula Legend, Virgin and Child with St. Anne Presenting a Woman.**
Flemish Room, p. 85

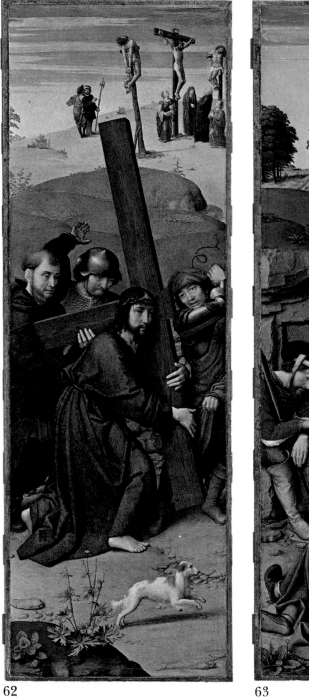
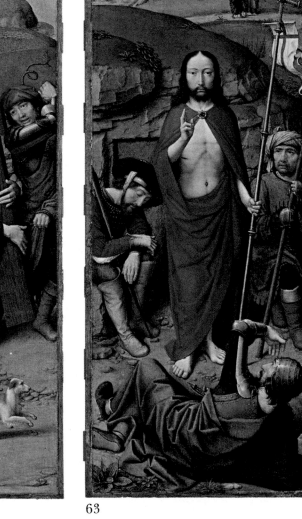

62

63

62. **Gerard David, Christ Bearing the Cross and the Crucifixion.**
Flemish Room, p. 88

63. **Gerard David, The Resurrection with the Pilgrims of Emmaus.**
Flemish Room, p. 88

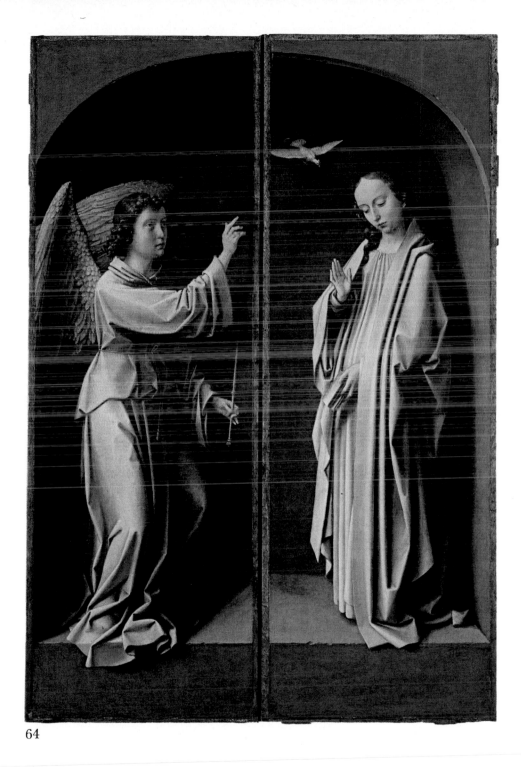

64

64. **Gerard David, Archangel Gabriel and the Virgin of the Annunciation.**
(originally the outer side of the panels 62 and 63)
Flemish Room, p. 88

65

65. **Jean Fouquet, Descent of the Holy Ghost upon the Faithful.**
Flemish Room, p. 87
66. **Simon Marmion, Lamentation of Christ.**
Flemish Room, p. 84

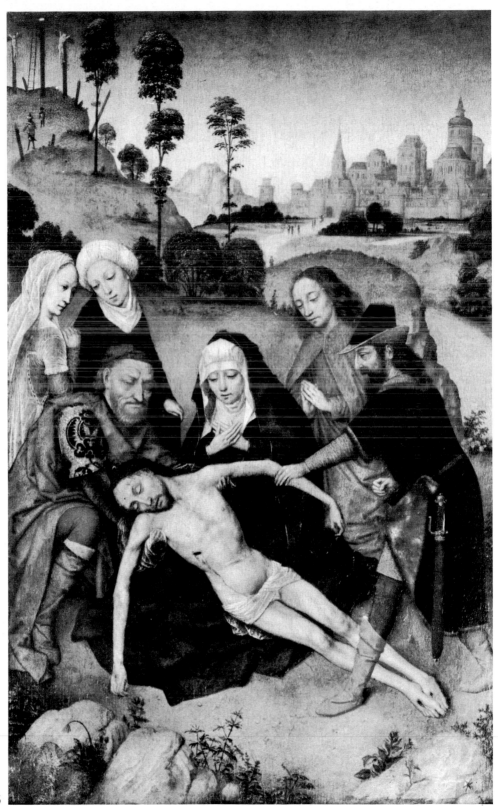

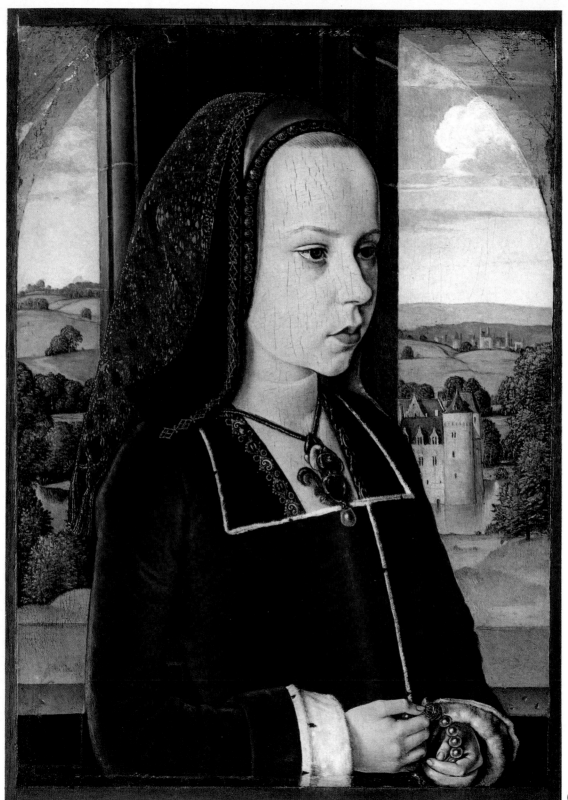

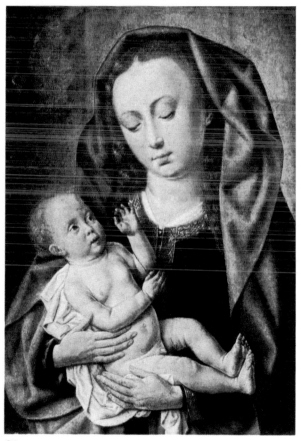

68

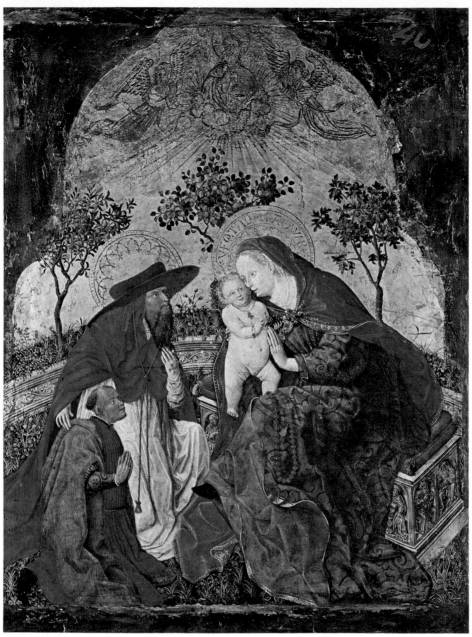

69. **German Master, Madonna and Child with a Donor Presented
by St. Jerome.**
Flemish Room, p. 86

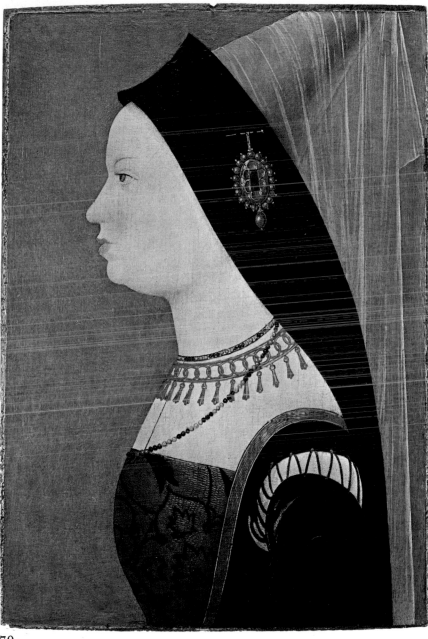

70

70. Hans Maler of Schwaz, Mary of Burgundy.
Flemish Room, p. 85

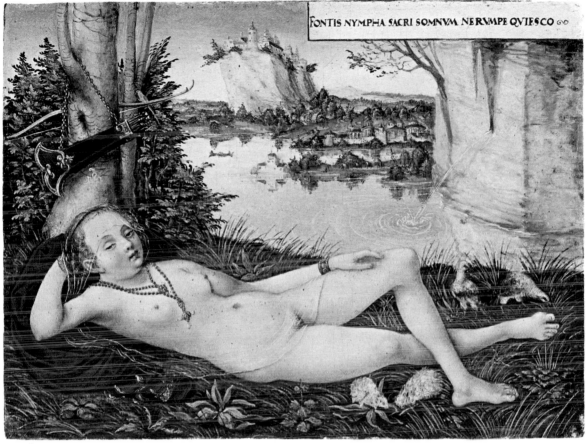

FONTIS NYMPHA SACRI SOMNVM NERVMPE QVIESCO ∞

72

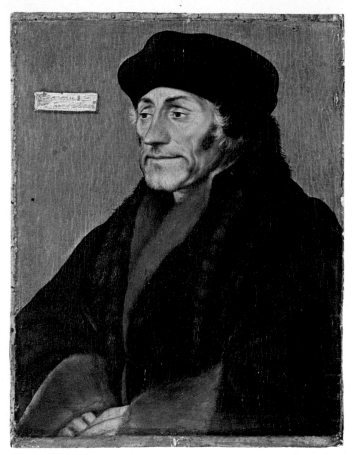

73

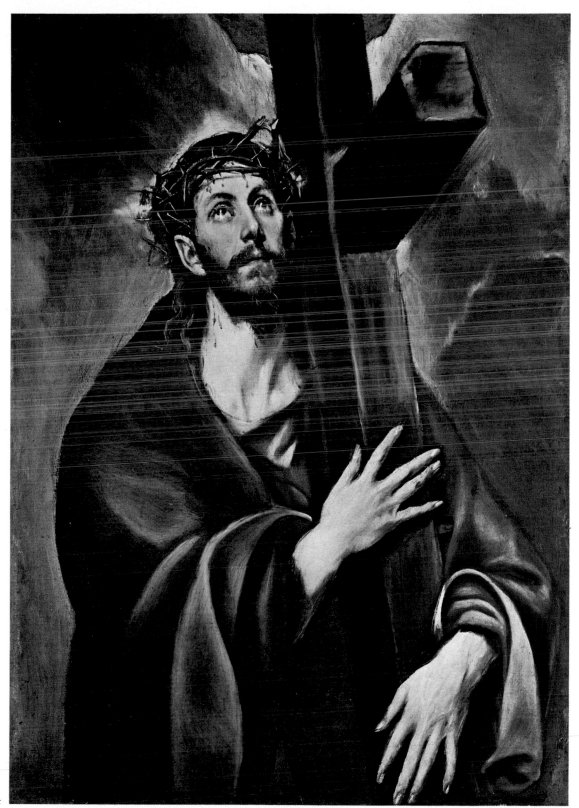

74

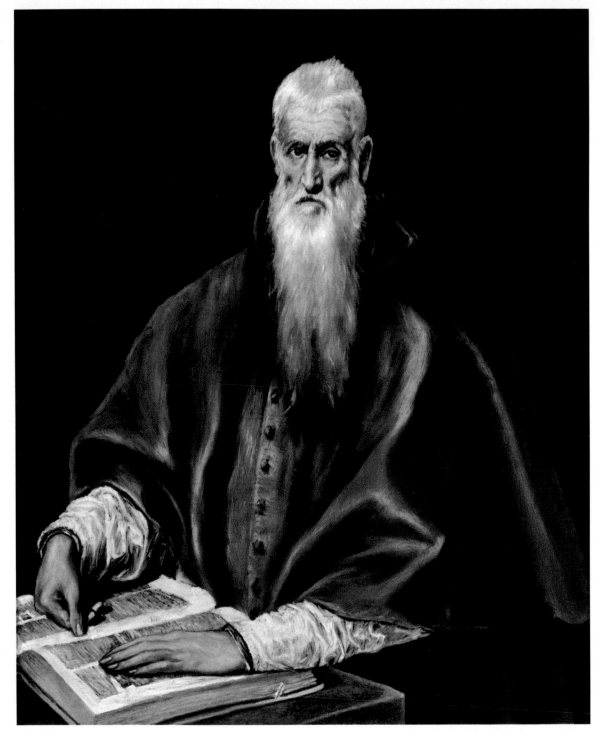

75

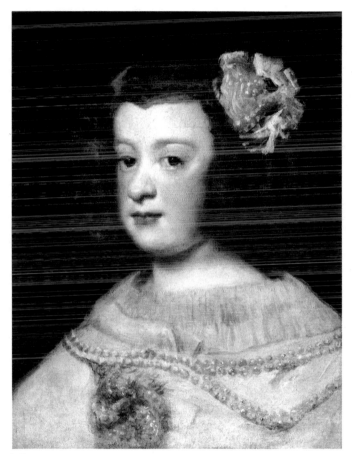

76

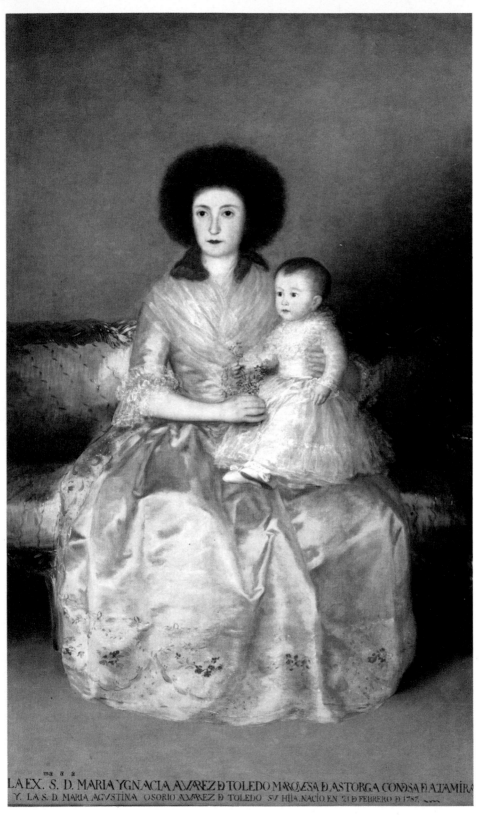

LA EX. S. D. MARIA YGNACIA ALVAREZ D TOLEDO MARQVESA D ASTORGA CONDSA D ATAMIRA
Y. LA S. D. MARIA AGVSTINA OSORIO ALVAREZ D TOLEDO SV HIIA NACIO EN 21 D FEBRERO D 1787

77

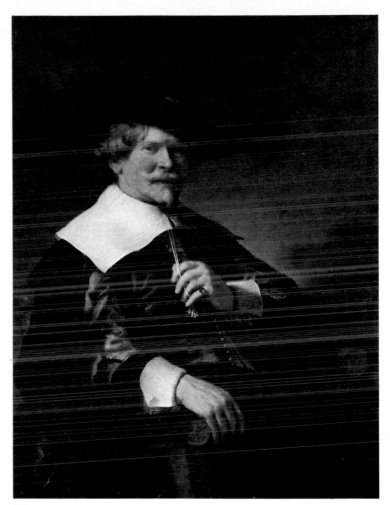

78

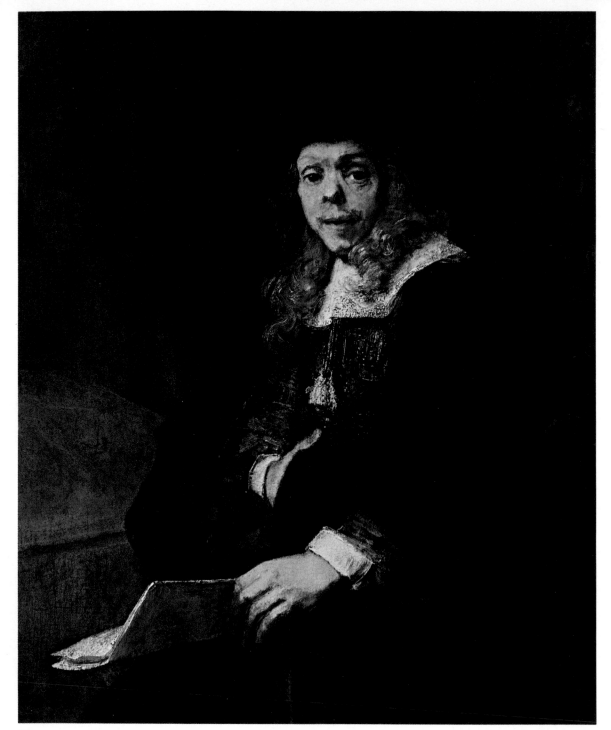

79

79. **Rembrandt van Rijn, Portrait of Gérard de Lairesse.**
Sitting Room, p. 73

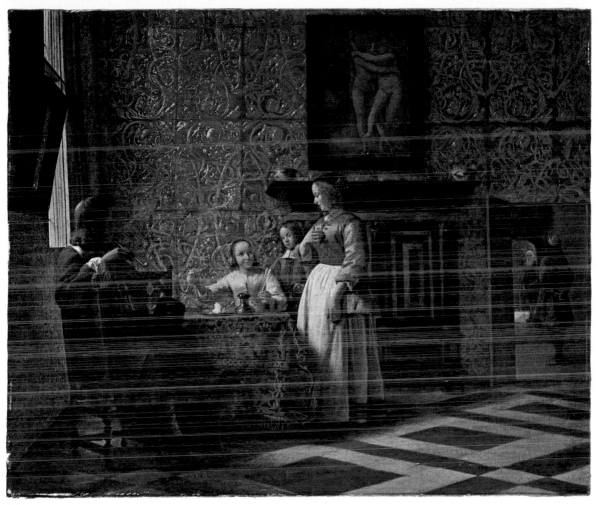

80

80. **Pieter de Hooch, Interior with Figures.**
Sitting Room, p. 75

81

81. **Gerard TerBorch, Portrait of Jan van Duren.**
Sitting Room, p. 74

82. **Gerard TerBorch, Portrait of Margaretha van Haexbergen.**
Sitting Room, p. 74

Detail of plate 83

83. **Jean Auguste Dominique Ingres, Portrait of the Princesse de Broglie.**
Special Gallery, p. 91

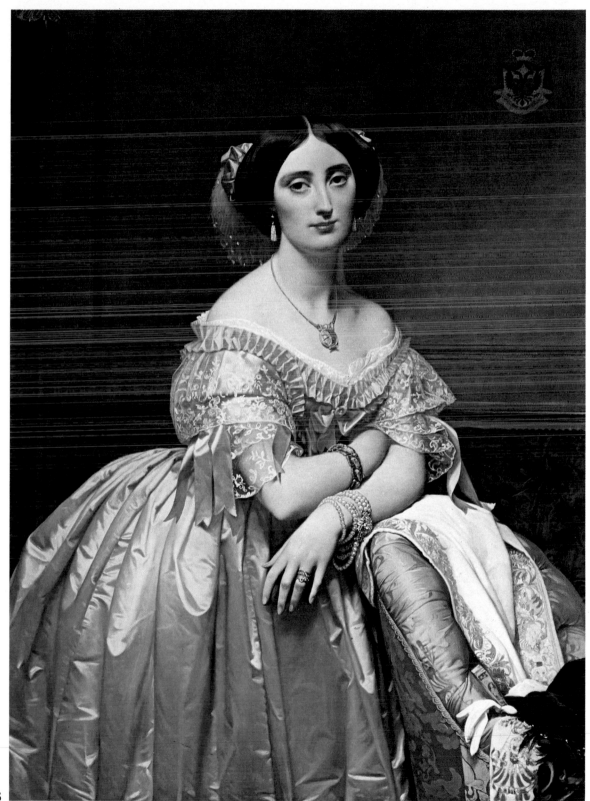

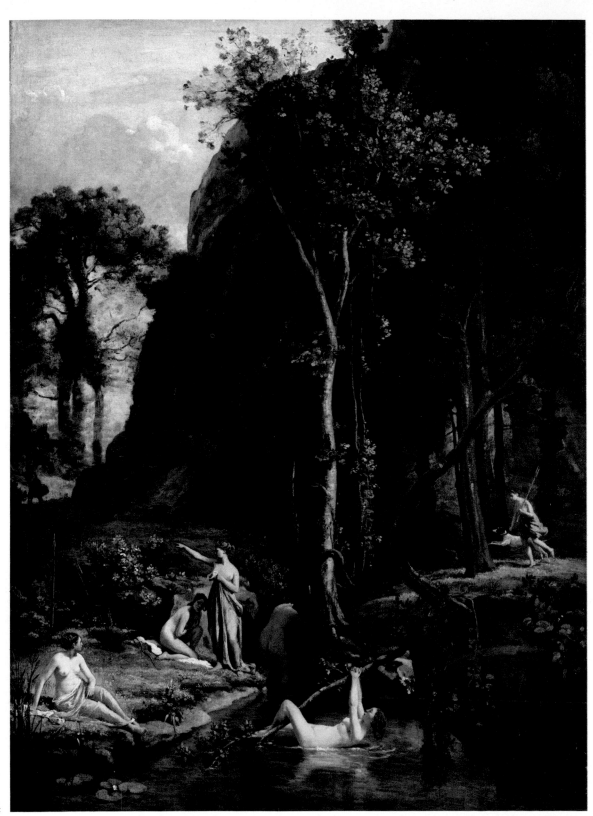

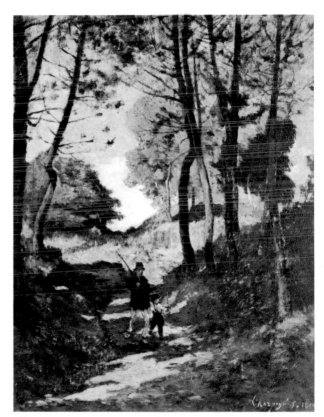

85

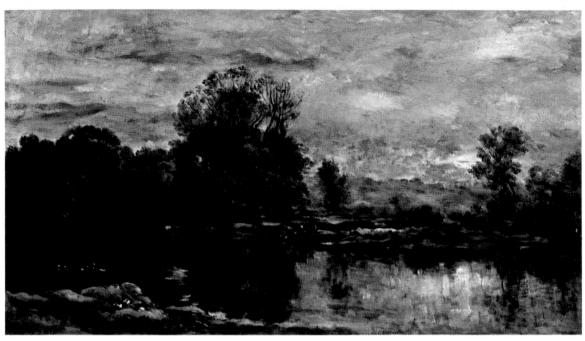

86

86. **Charles François Daubigny, Landscape with Ducks.**
Grand Gallery, p. 97
87. **Théodore Rousseau, L'Etang.**
Grand Gallery, p. 97
88. **Claude Monet, Landscape near Zaandam.** (Overleaf)
Grand Gallery, p. 98

87

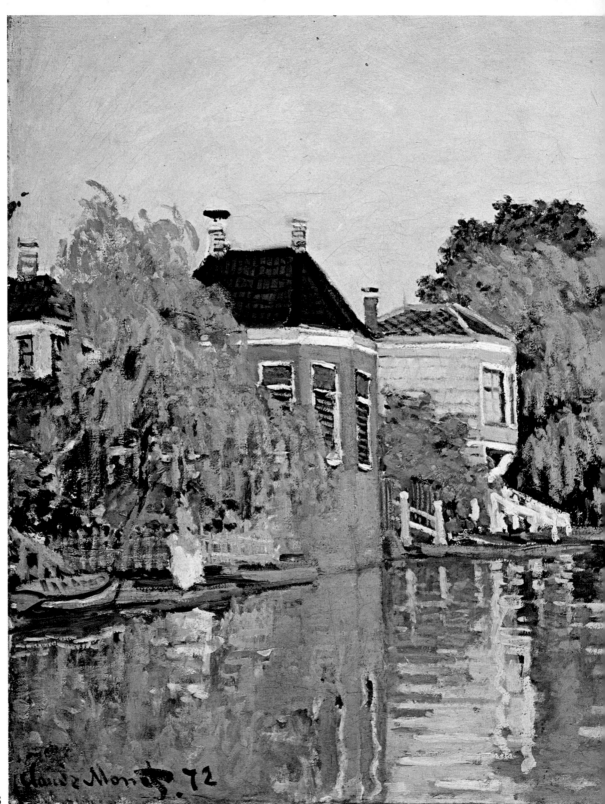

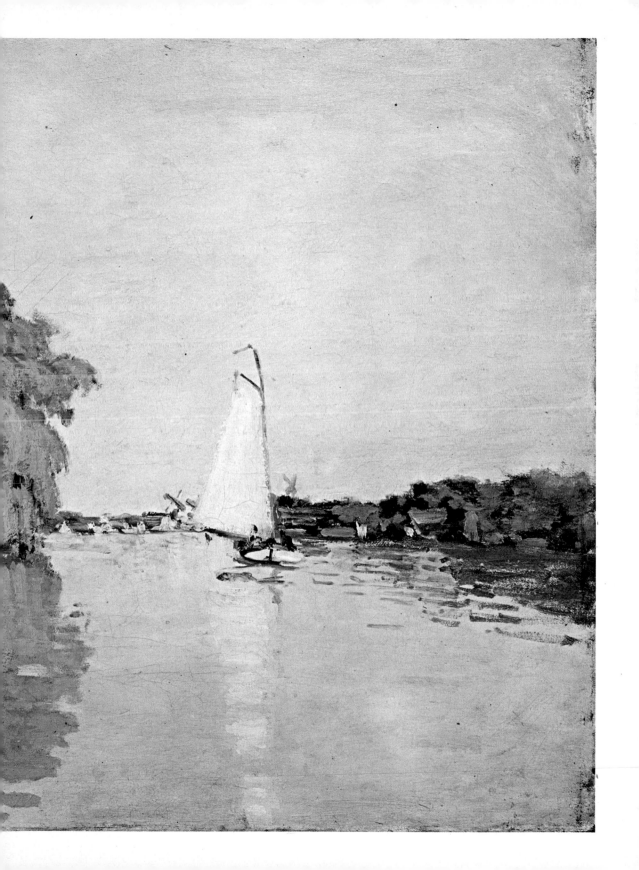

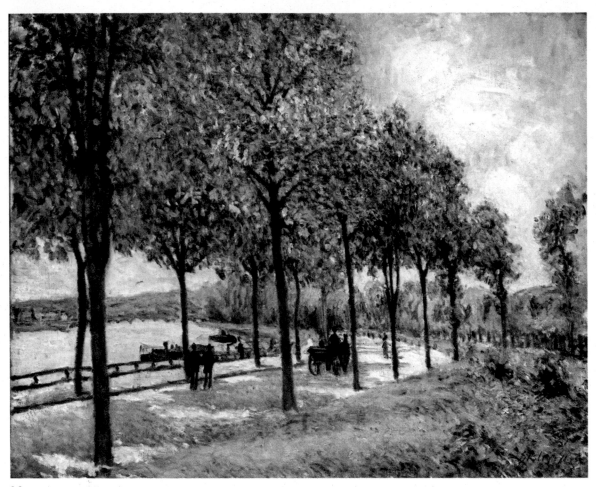

89

89. **Alfred Sisley, Alley of Chestnut Trees.**
 Grand Gallery, p. 98
90. **Camille Pissarro, Potato Gatherers.**
 Grand Gallery, p. 98

90

91

93

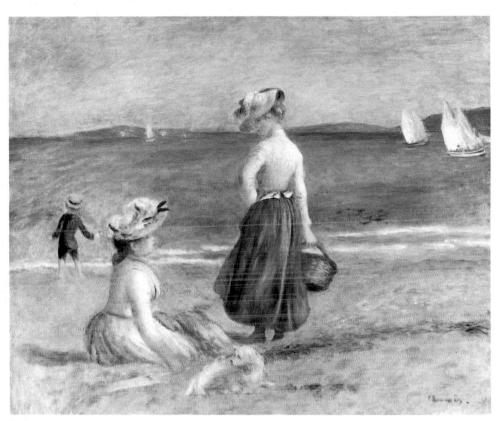

94

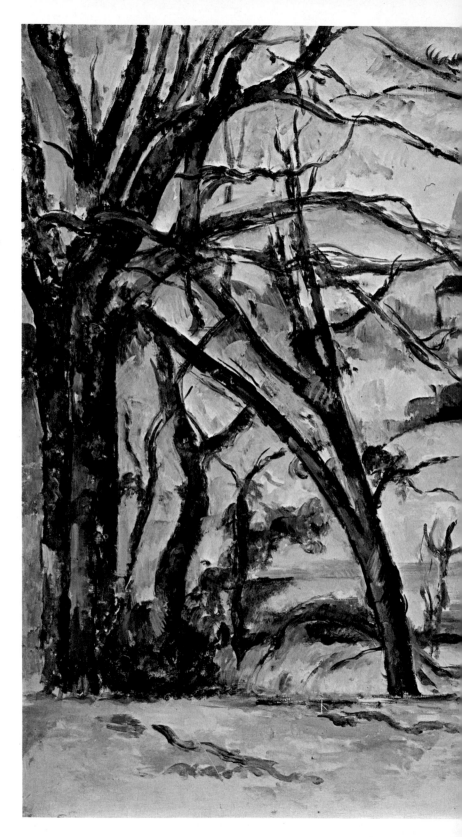

95. **Paul Cézanne,
House behind
Trees on the Road
to Tholonet.**
Special Gallery,
p. 92

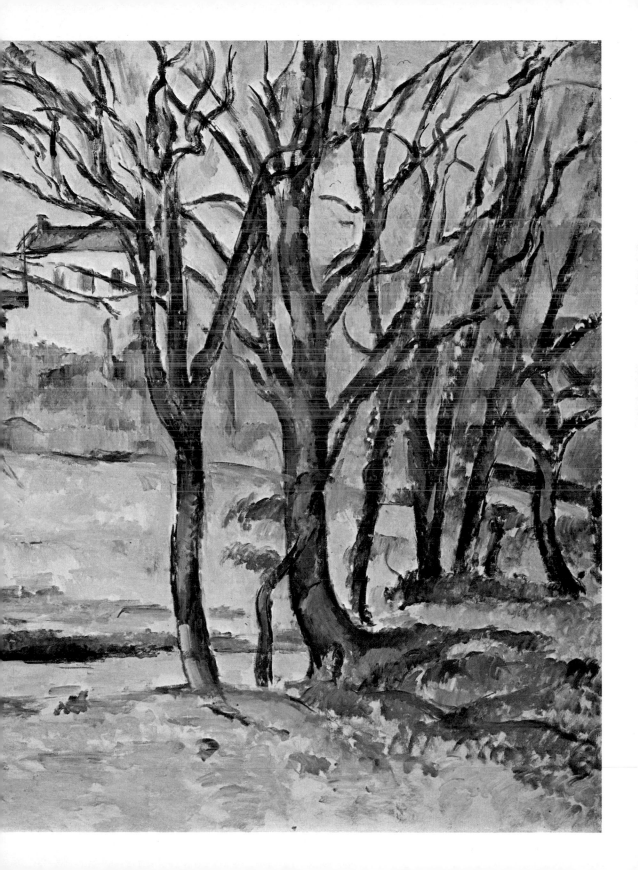

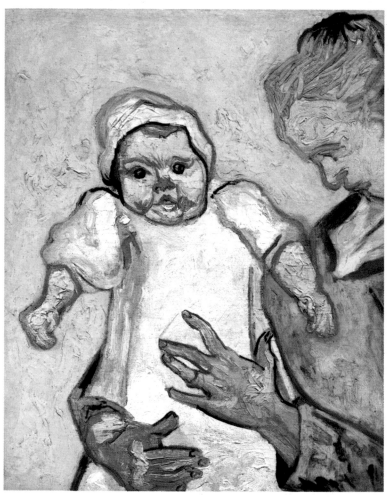

96

96. **Vincent van Gogh, Madame Roulin and Her Baby.**
Grand Gallery, p. 99
97. **Paul Gauguin, Tahitian Women Bathing.**
Grand Gallery, p. 99

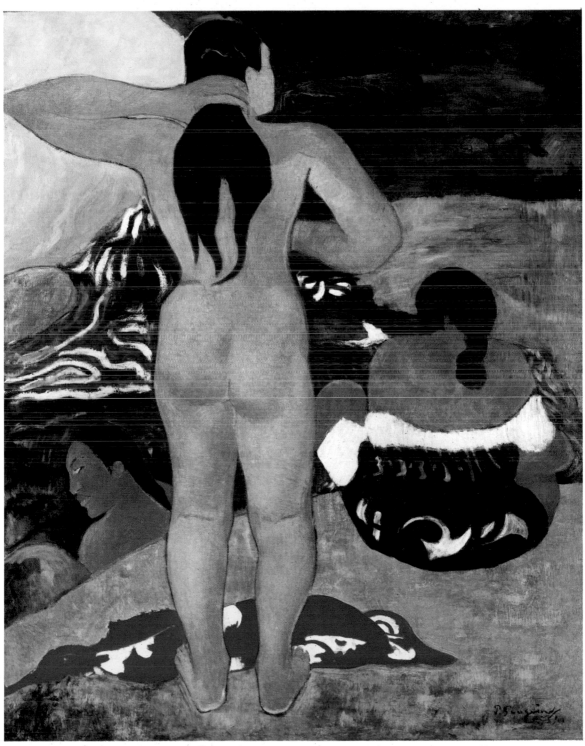

97

98

98. **Georges Seurat, Study for "Sunday Afternoon on the Island of the Grande Jatte."**
Special Gallery, p. 93
99. **Georges Seurat, The Mower.**
Special Gallery, p. 93

99

100

100. **Edgar Hilaire Germain Degas, Landscape.**
Grand Gallery, p. 100
101. **Edouard Vuillard, Interior with Figure Sewing.**
Grand Gallery, p. 100

101

102

103

104

104. **Paul Signac, View of Collioure.**
 Grand Gallery, p. 100
105. **Paul Signac, Fishing Boats, Concarneau.**
 Grand Gallery, p. 101

105

106

106. **Paul Signac, Place Clichy.**
Special Gallery, p. 93
107. **André Derain, Houses of Parliament at Night.**
Special Gallery, p. 95

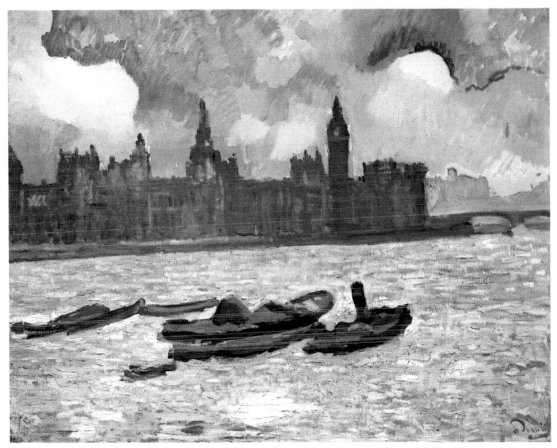

107

108

108. **Henri Edmond Cross, Valley with Fir.**
Grand Gallery, p. 101
109. **Georges Braque, House behind Trees.**
Special Gallery, p. 95

109

110

112

113

114

115

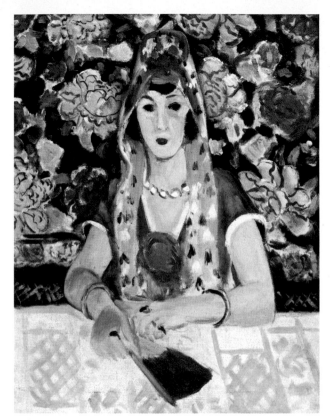

116

117

118

119

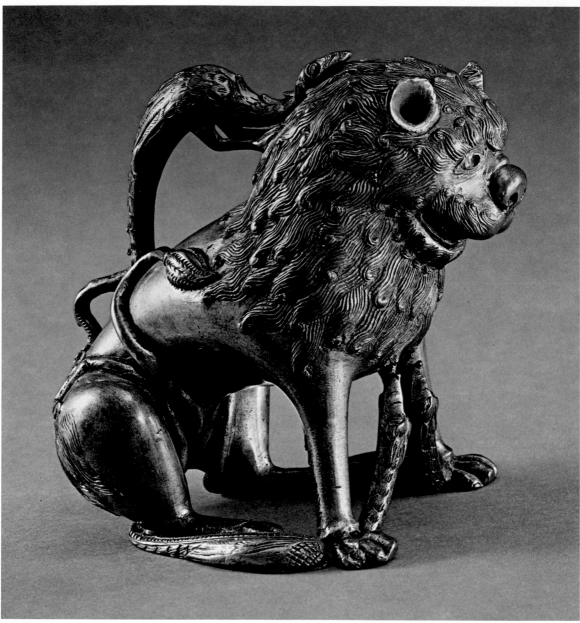

121

121. **Bronze lion aquamanile,**
North German.
Flemish Room, p. 79

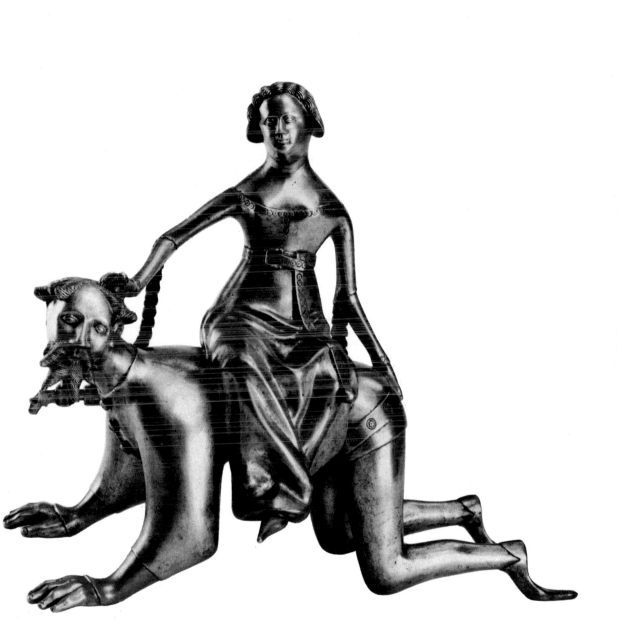

122

122. Bronze aquamanile, Aristotle and Phyllis,
Mosan.
Staircase Landing, p. 62

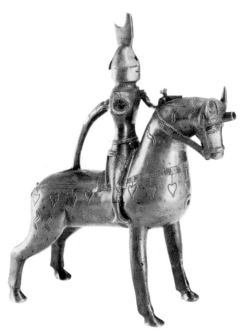

123

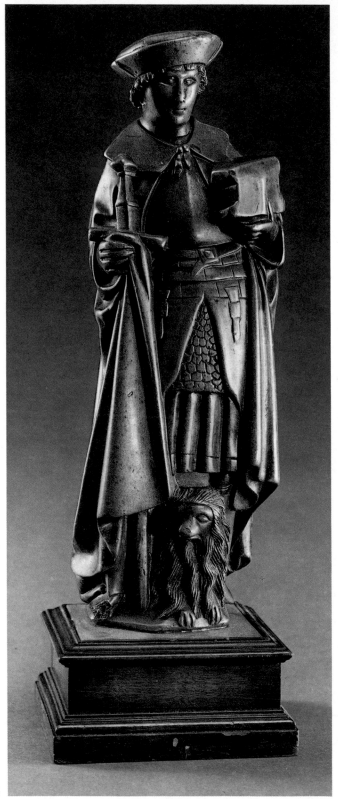

124

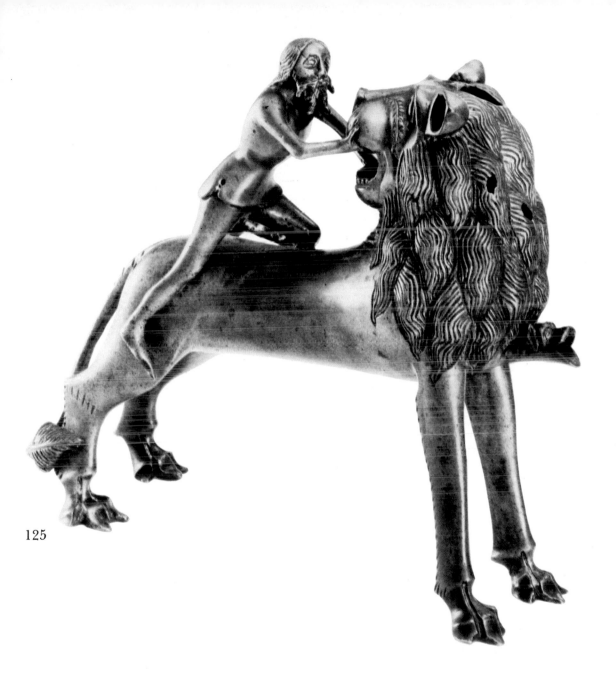

125

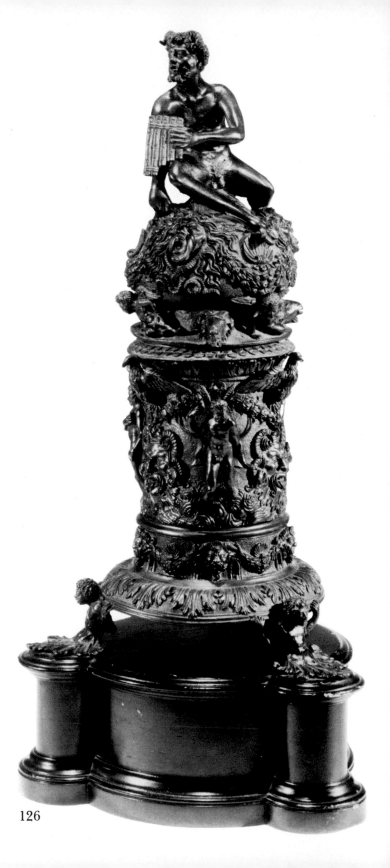

126

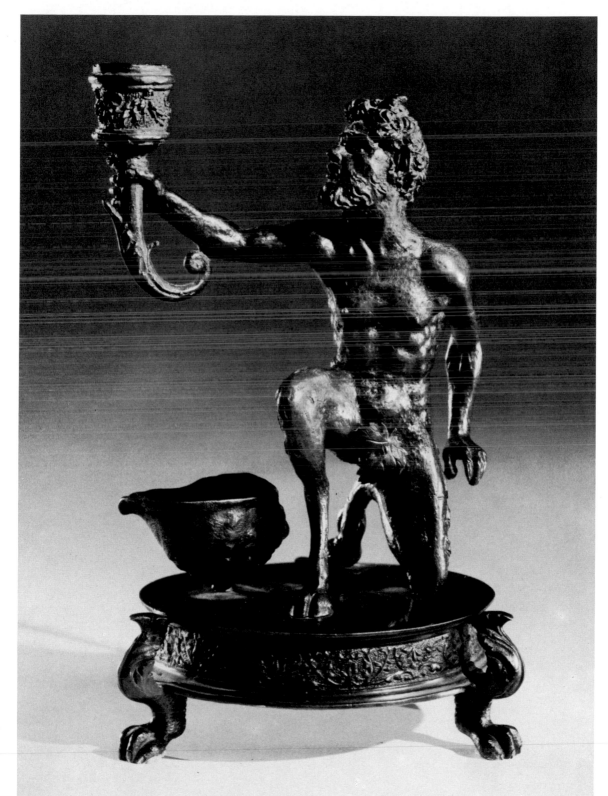

27

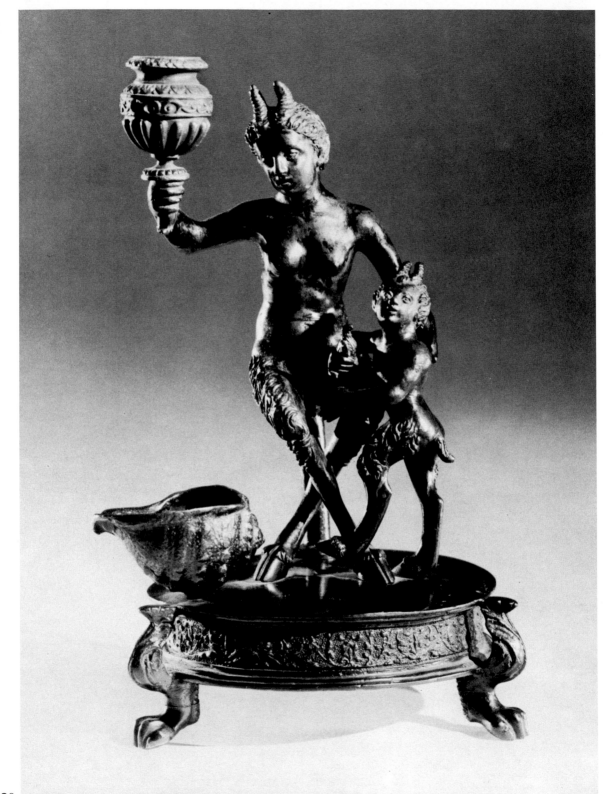

128

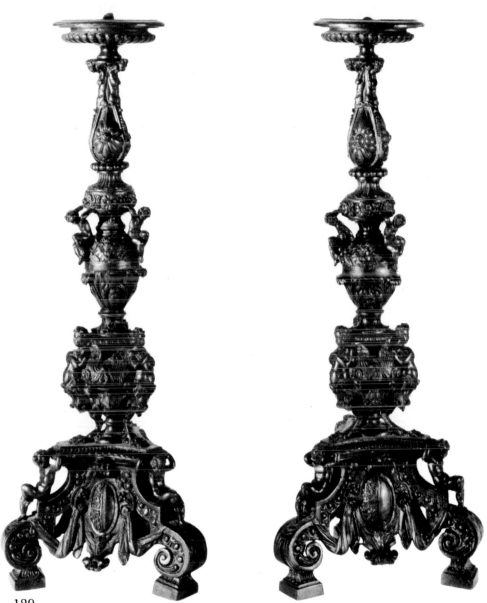

129

128. **Andrea Briosco, Satyress with Her Child,**
bronze.
Sitting Room, p. 77
129. **Niccolo Roccatagliata, attributed to,**
candelabra, bronze.
Sitting Room, p. 76

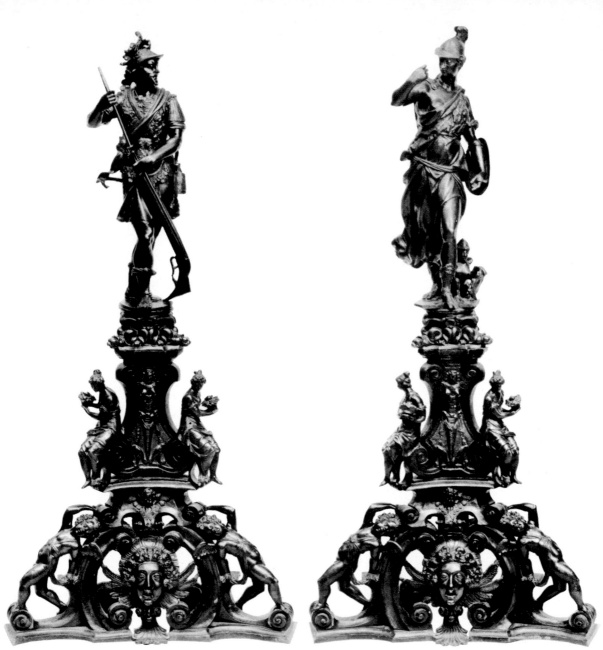

130

130. **Tiziano Aspetti, pair of andirons,**
bronze.
Staircase Landing, p. 63

131. **Table,**
Tuscan.
Red Velvet Room, p. 59

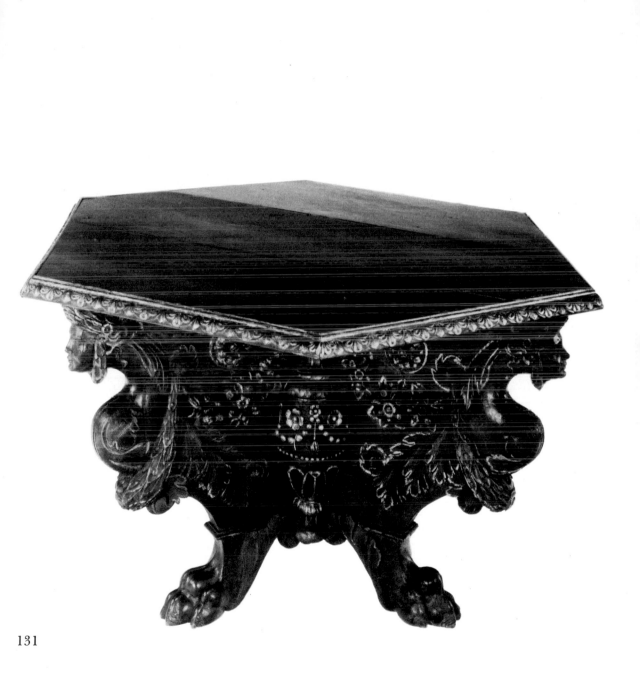

131

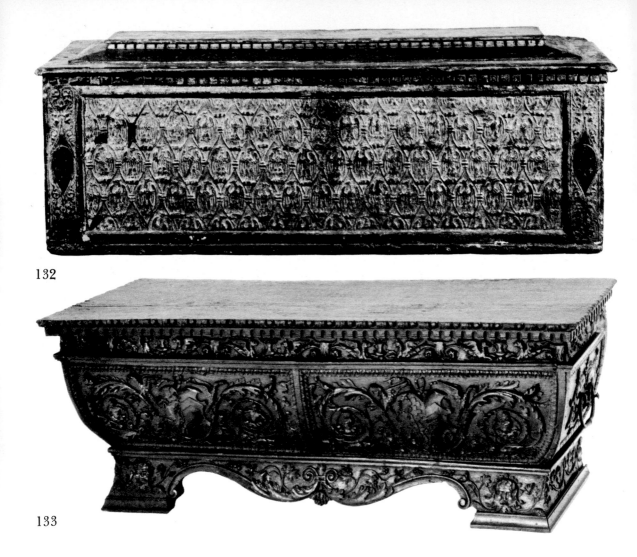

132

133

132. **Cassone,**
 Italian.
 First Room, p. 14
133. **Cassone,**
 Venetian.
 First Room, p. 22
134. **Choir stall,**
 Lombard.
 First Room, p. 19

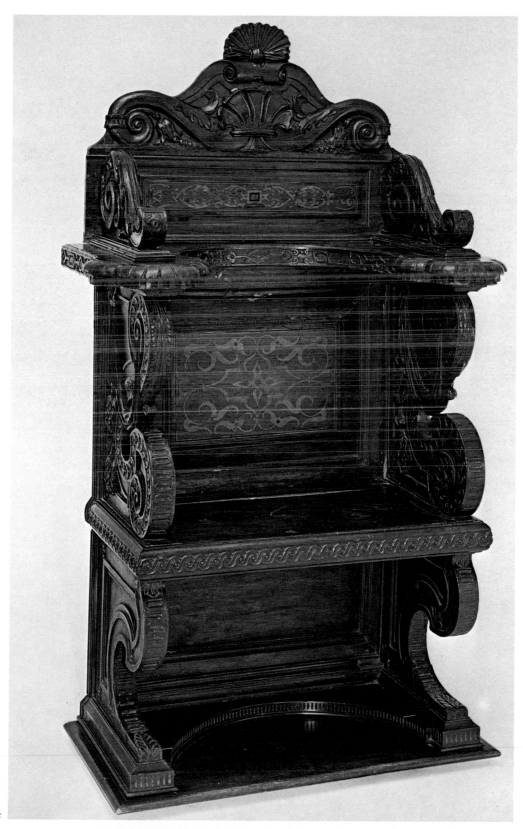

135

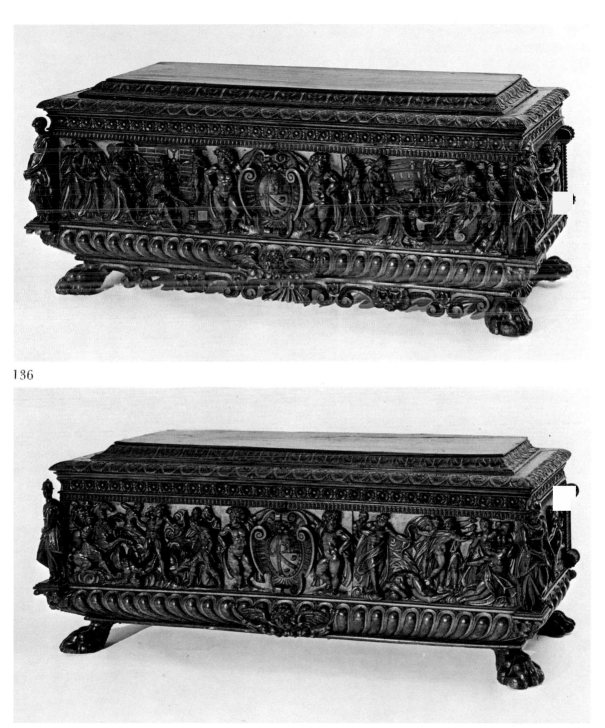

136

137

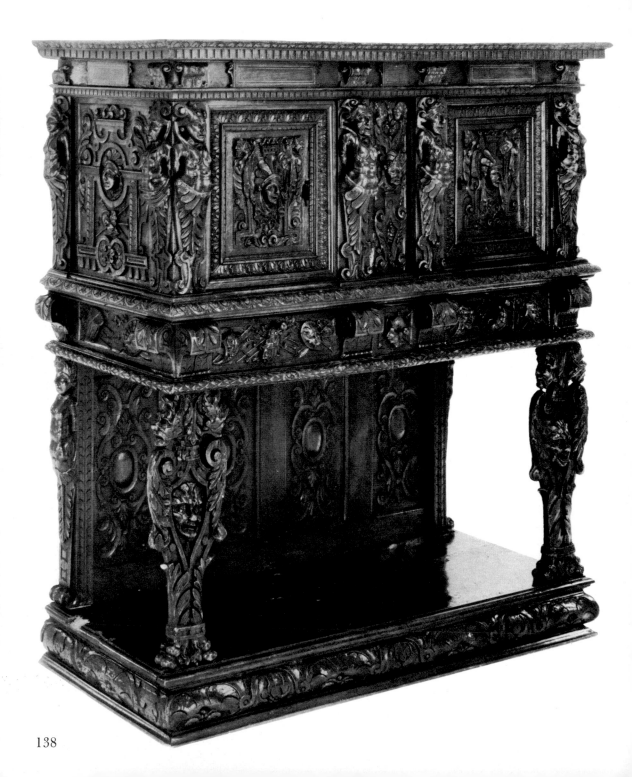

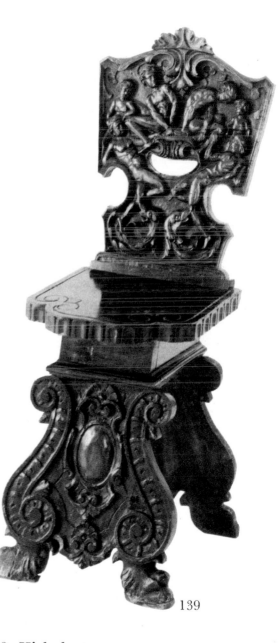

139

138. **High chest,**
probably French.
Flemish Room, p. 78

139. **Chair,**
probably French (Fontainebleau).
Sitting Room, p. 77

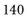
140

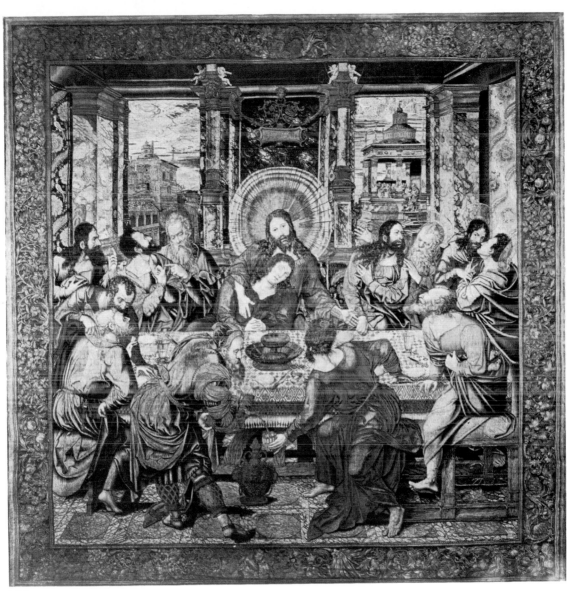

141

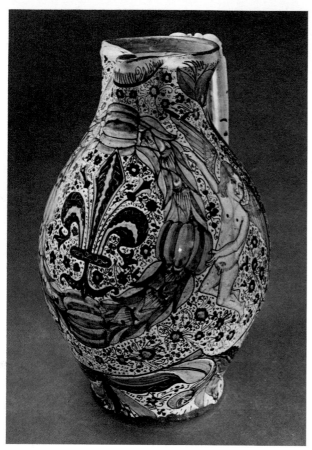

142

142. **Maiolica jug,**
 Florence.
 Second Room, p. 33

143. **Maiolica jar,**
 Florence.
 Second Room, p. 32

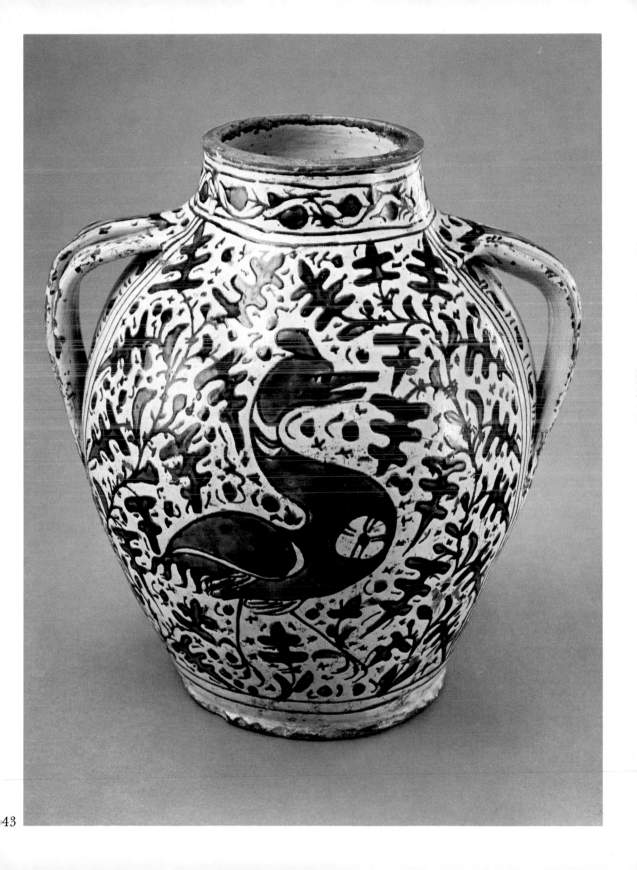

43

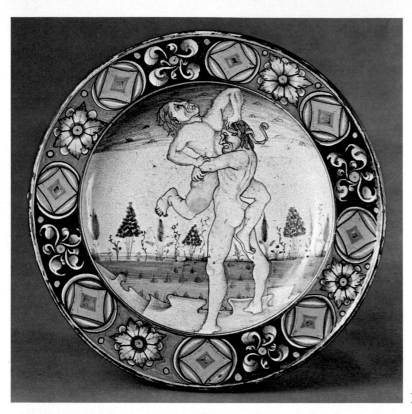

144

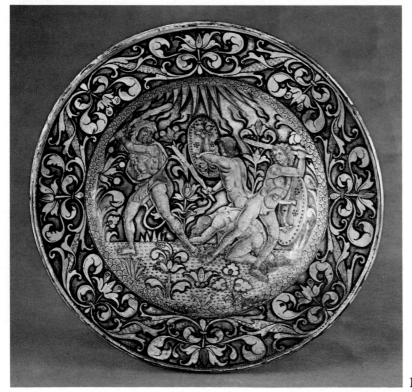

145

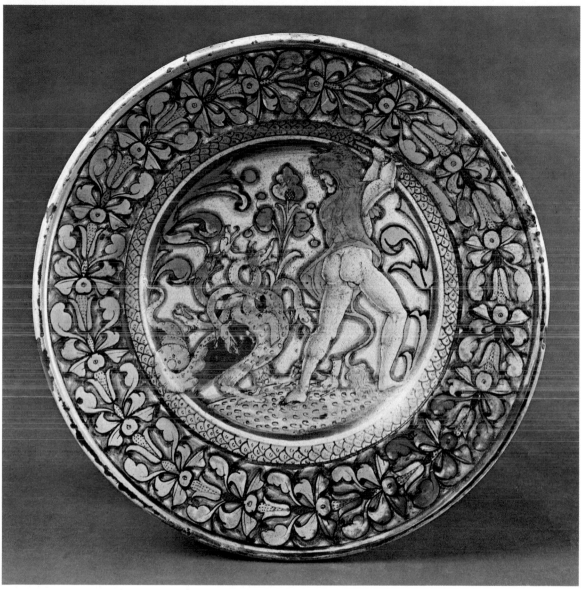

146

144. **Maiolica plate, Hercules and Antaeus,**
 Deruta.
 Second Room, p. 33
145. **Maiolica plate, Hercules Slaying the Giants,**
 Deruta.
 Second Room, p. 33
146. **Maiolica plate, Hercules Slaying the Hydra,**
 Deruta.
 Second room, p. 33

148

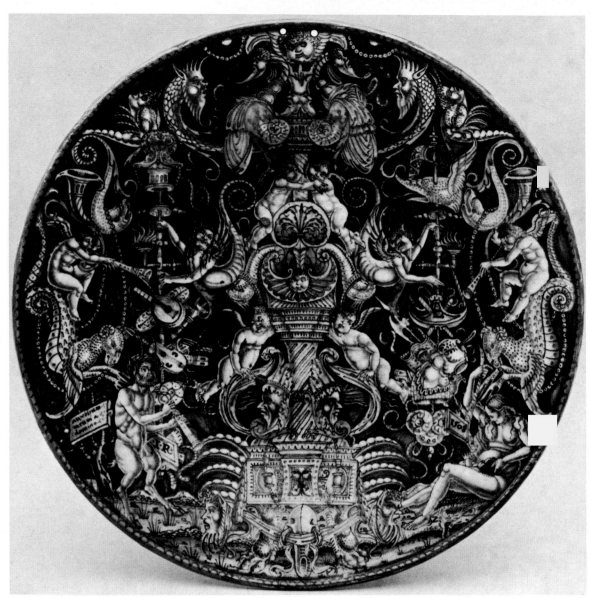

149

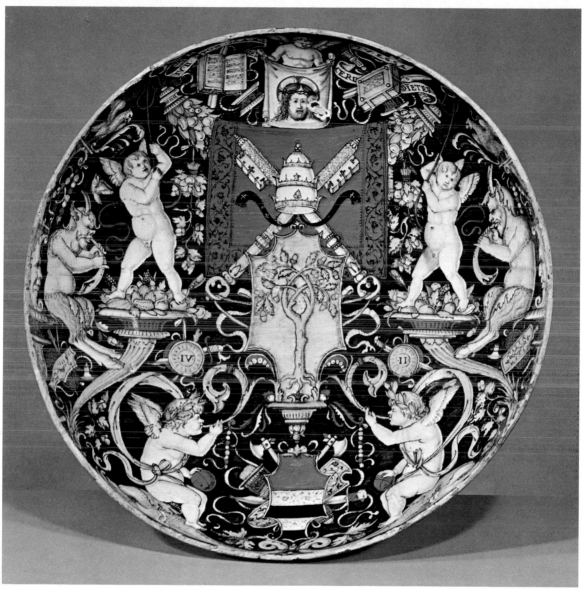

150

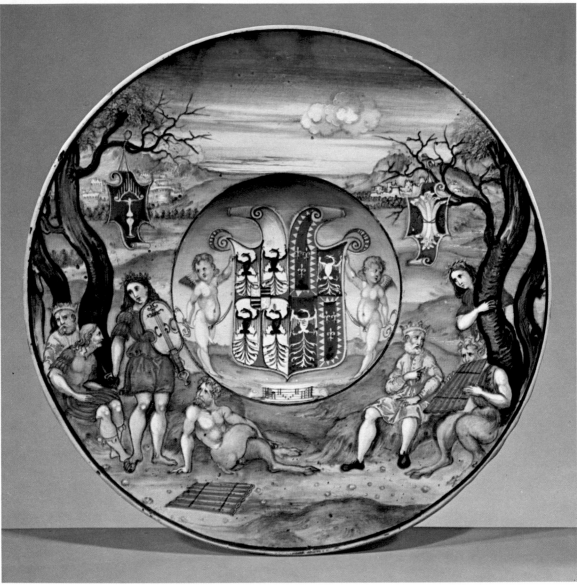

151

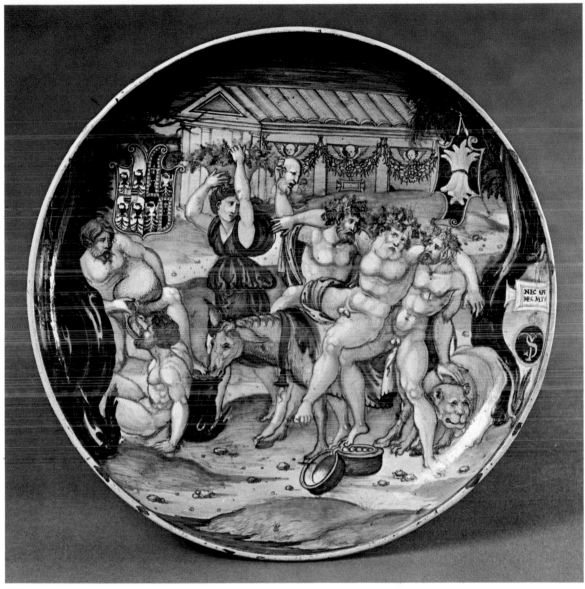

152

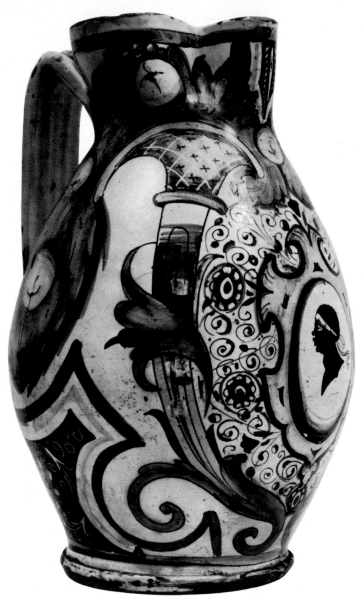

153

153. **Maiolica jug,**
 Caffaggiolo.
 Second Room, p. 43

154. **Maiolica plate, Sisters of Phaëton Changing into Poplars,**
Francesco Xanto Avelli, Urbino.
Second Room, p. 43

155

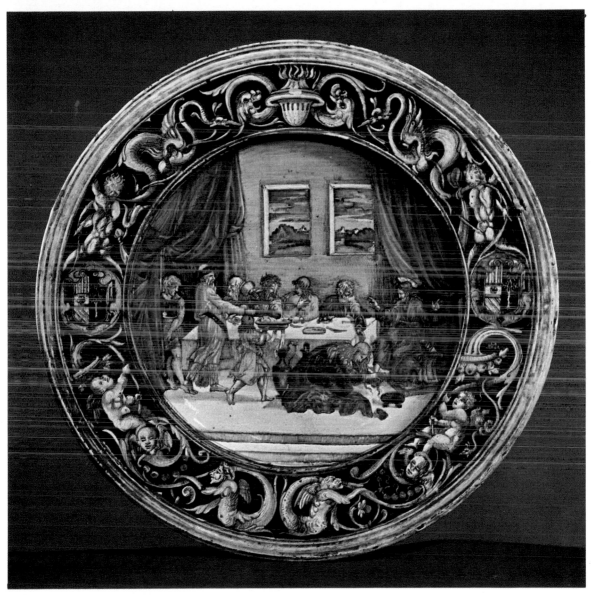

156

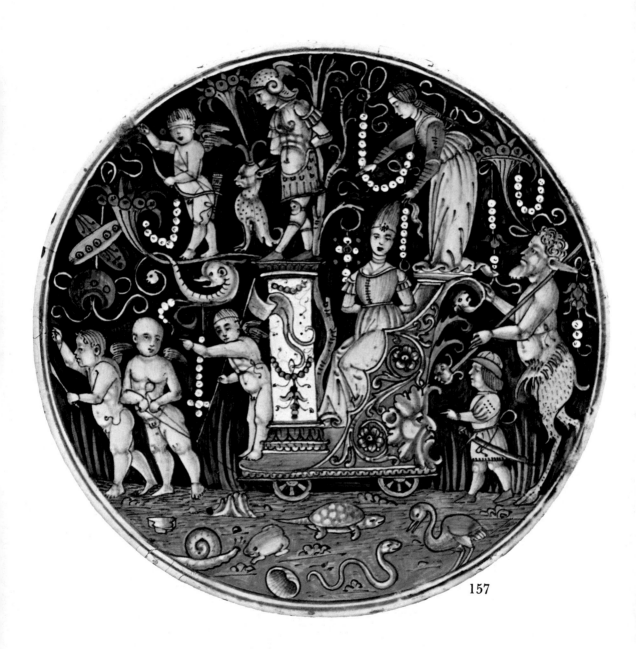

157

157. Maiolica roundel, Triumph of Love,
Castel Durante.
Second Room, p. 35

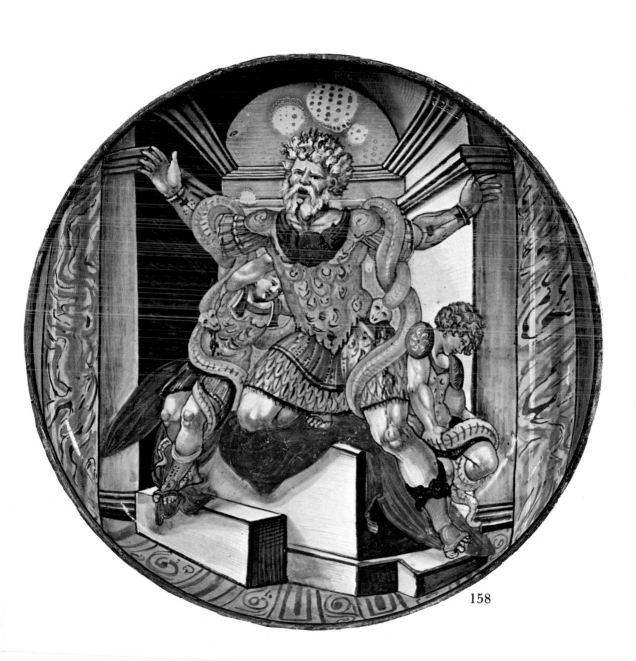

158

158. Maiolica plate, Death of Laocoön,
Francesco Xanto Avelli, Urbino.
Second Room, p. 40

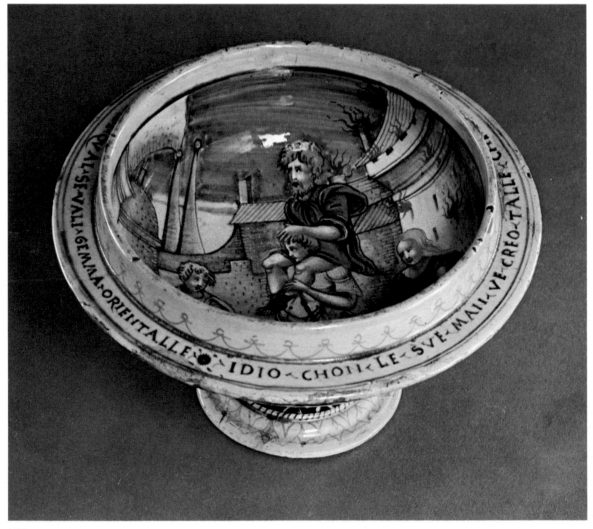

159

159. Maiolica bowl,
with 160, part of a confinement set showing Aeneas and Anchises, Faenza.
Second Room, p. 42

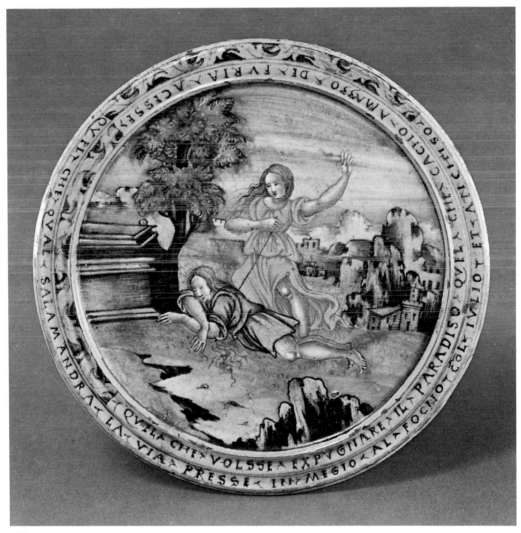

160

160. **Cover for 159,**
 showing Pyramus and Thisbe.
 Second Room, p. 42

161

162

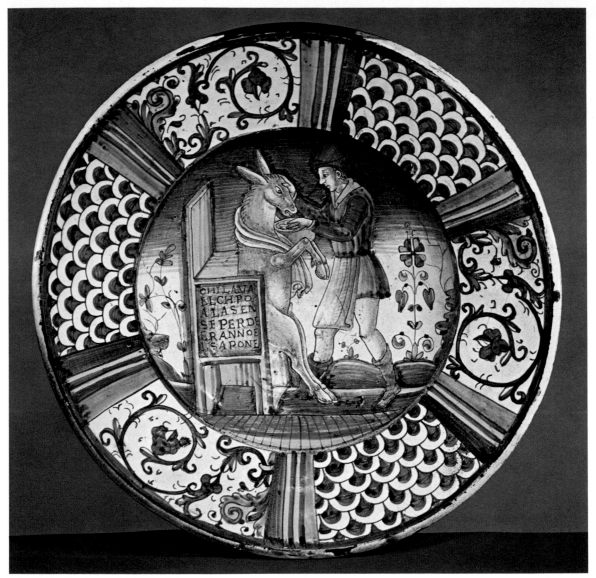

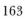

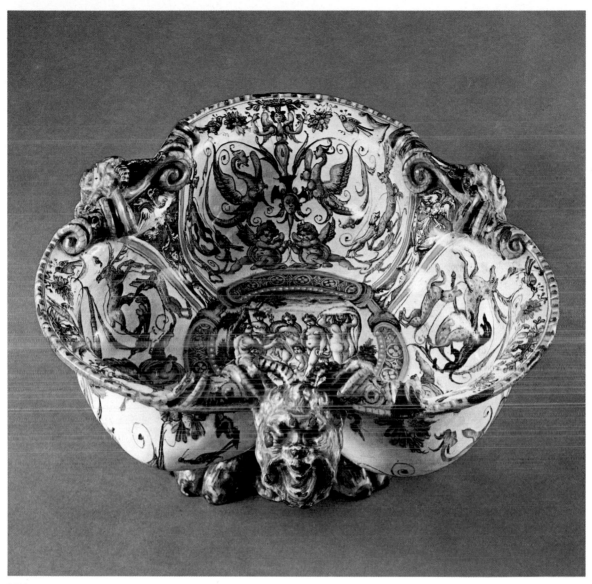

164

163. **Maiolica plate, Man Washing the Mouth of an Ass,**
 Deruta.
 Second Room, p. 41
164. **Maiolica wine cooler, Judgment of Paris,**
 Urbino.
 Second Room, p. 38

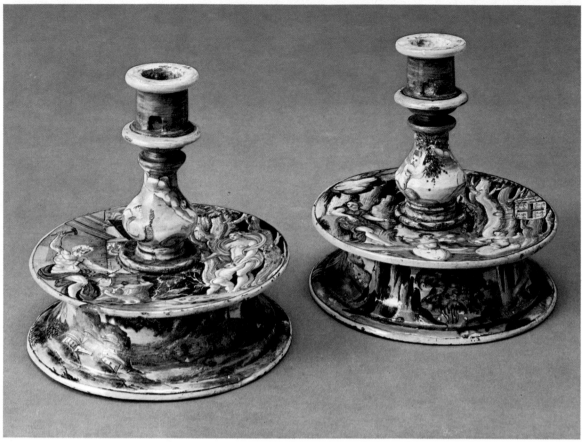

165

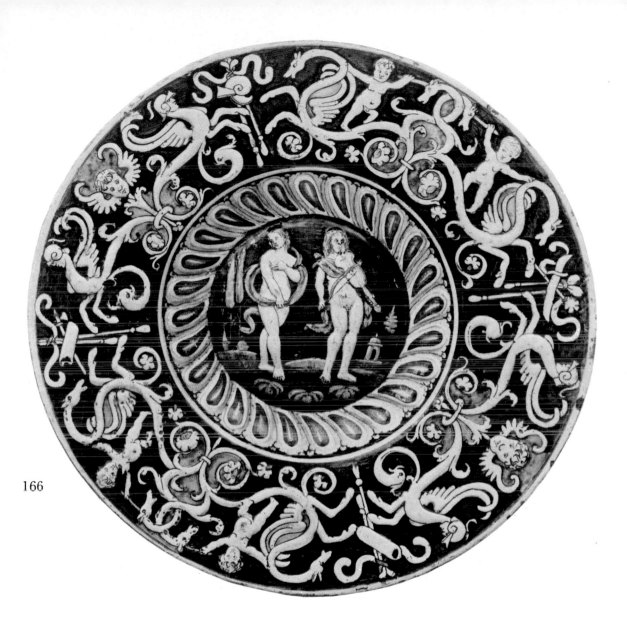

166

165. **Maiolica candlesticks,**
Vulcan Forging the Arrows of Cupid, and the
Birth of Castor and Pollux,
Guido Durantino, Urbino.
Dining Room, p. 45

166. **Maiolica plate, Orpheus and Eurydice,**
French.
Dining Room, p. 45

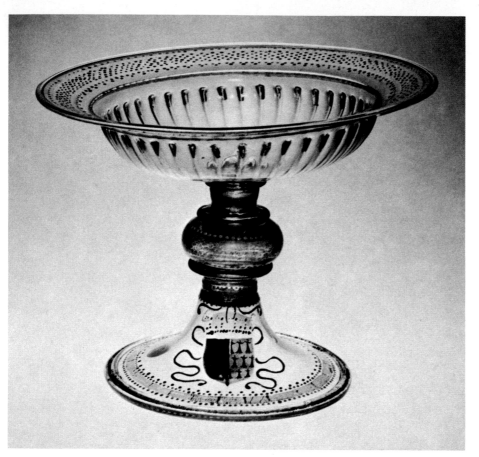

167

167. **Glass tazza,**
 Venetian.
 Dining Room, p. 45
168. **Faïence salt cellar,**
 St.-Porchaire.
 Dining Room, p. 47

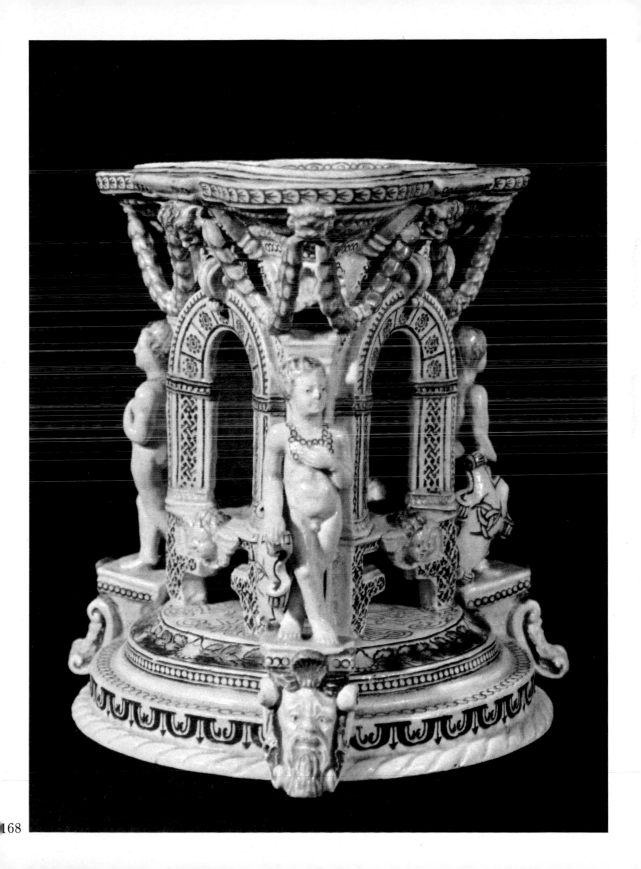

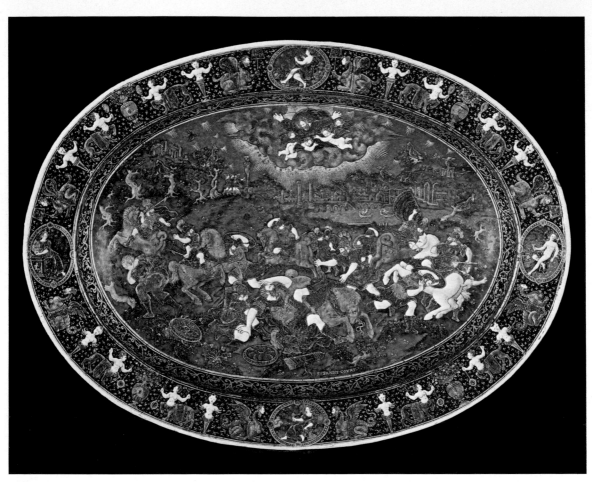

169

169. Enamel plate, Conversion of St. Paul,
Suzanne Court, Limoges.
Sitting Room, p. 77

Detail of plate 169

170

171

172

172. **Stefano da Verona, Wild Man.**
p. 103

173

173. **Antonio Pollaiuolo,**
Study for the Equestrian Statue of Francesco Sforza.
p. 103

174

175

177. Canaletto, East Front of Warwick Castle.
p. 104

178

179

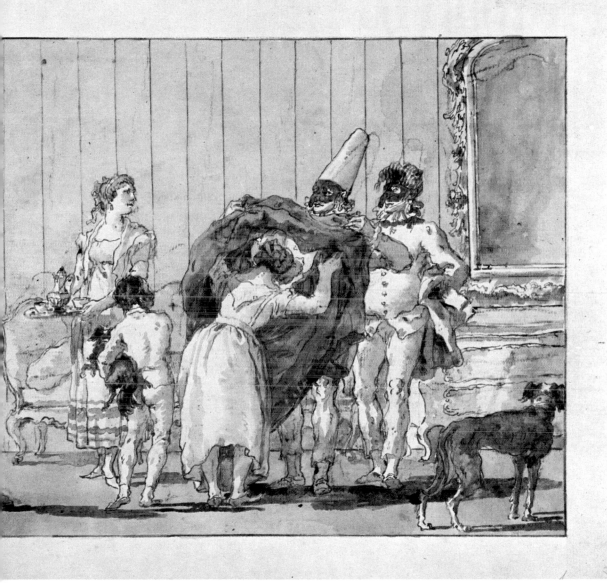

181

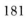

181. **Hieronymus Bosch, Two Pharisees.**
 p. 104
182. **German Master, Virgin and Child with Donor.**
 p. 104

182

183

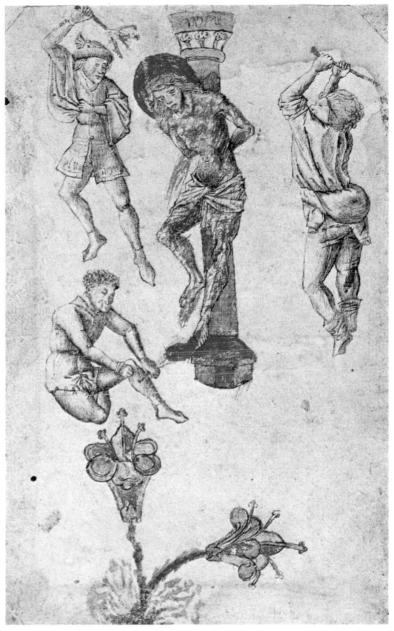

184

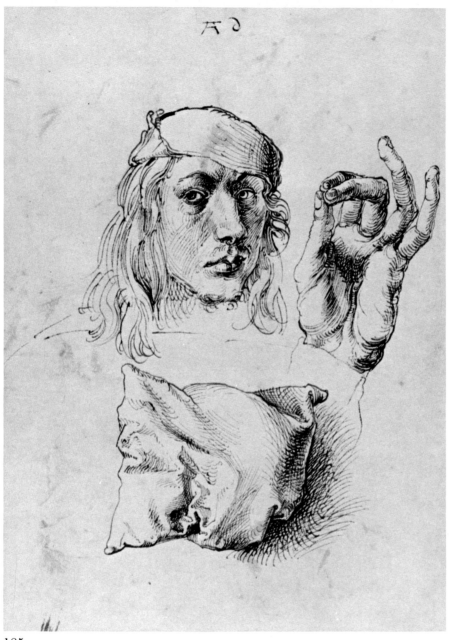

185

185. **Albrecht Dürer, Self-Portrait at Age Twenty-Two.**
 p. 104

186. **Albrecht Dürer, Holy Family in a Trellis**
 p. 104

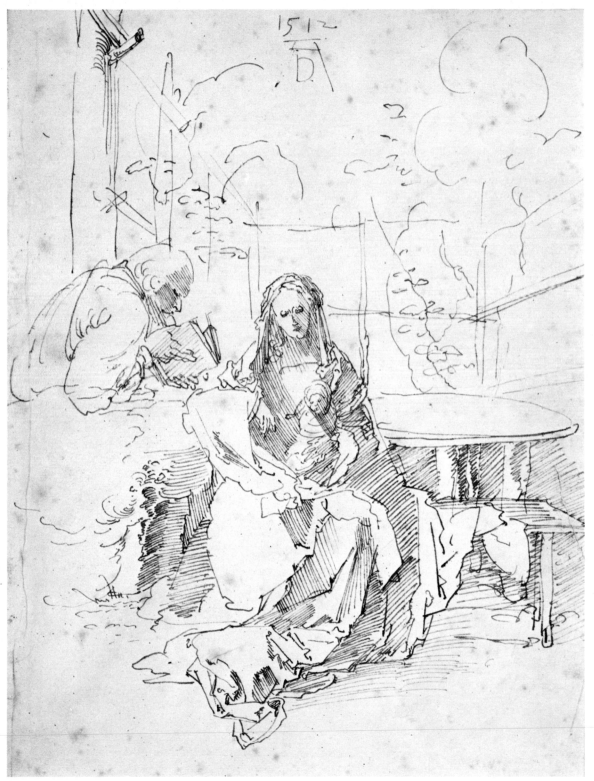

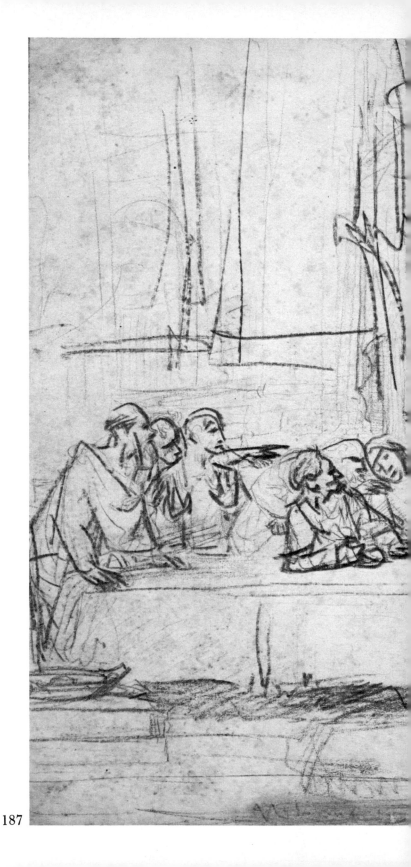

187

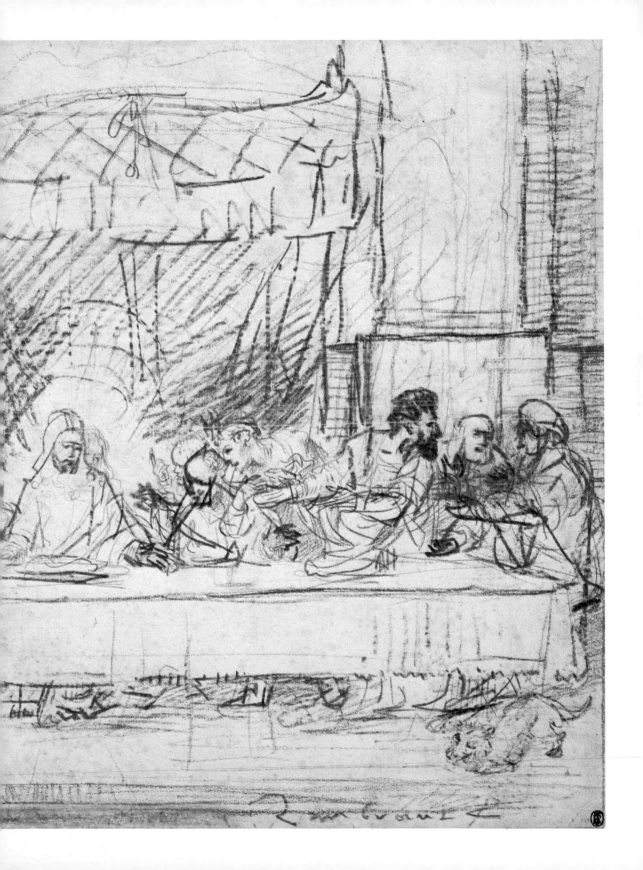

189

190

 191

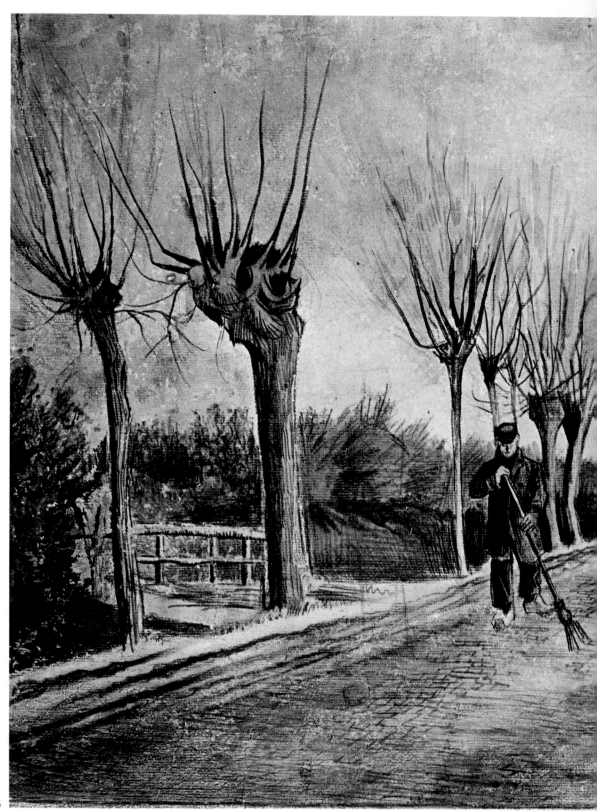

193

194

195

196

198

197, 198. **Maurice Prendergast, pages from a Boston sketchbook.**
p. 105

List of Artists
and
Floorplan

List of Artists Represented

Numbers in italics indicate plates.

Floor Plan

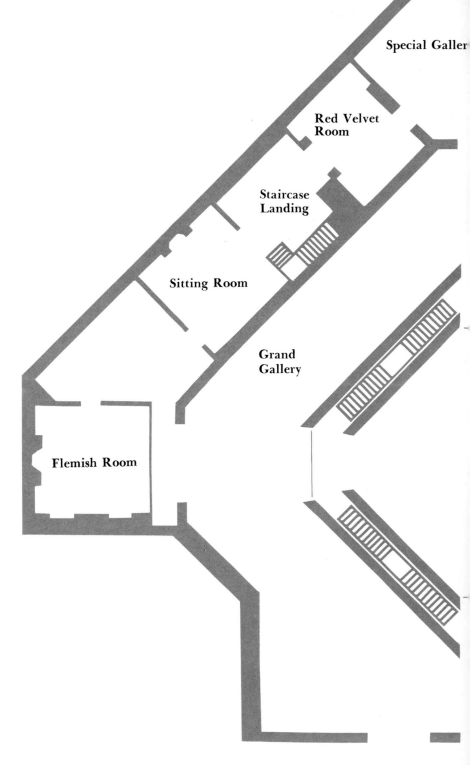

Special Galler

Red Velvet
Room

Staircase
Landing

Sitting Room

Grand
Gallery

Flemish Room

Entry from

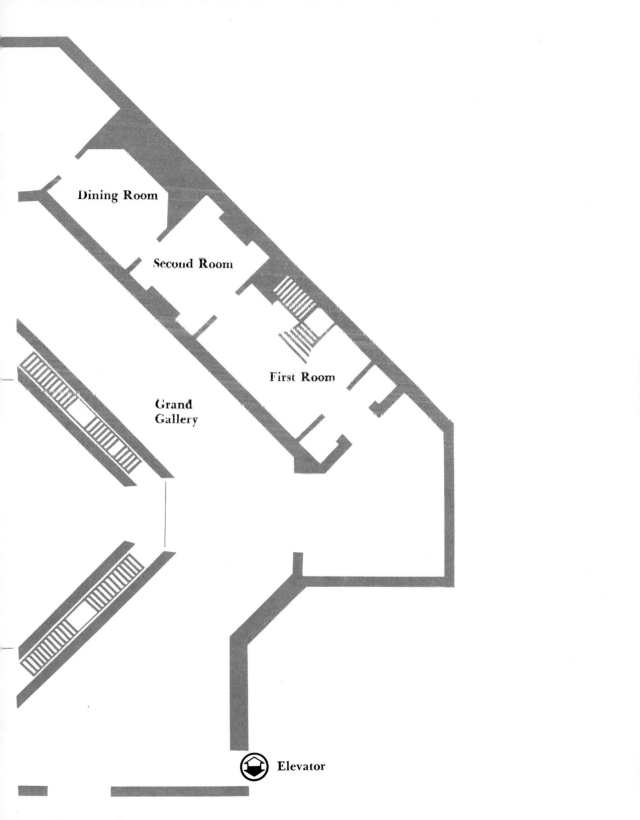

Dining Room

Second Room

First Room

Grand
Gallery

Elevator

Western European Arts

Floor Plan

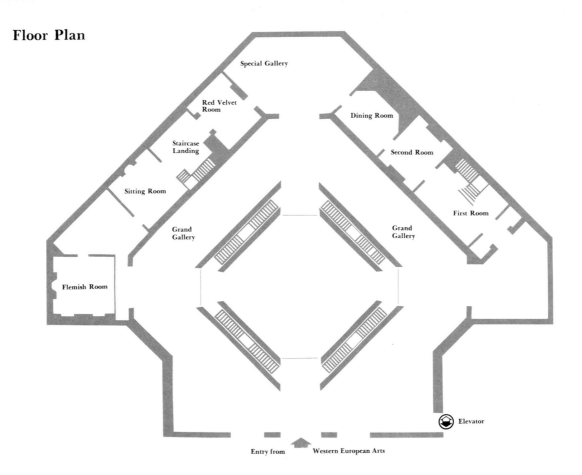

Location of exhibited paintings and objects by room. The numbers correspond to plate numbers. Drawings and other objects not included in the listings below are not on continual exhibition.

First Room, 1, 2, 4, 6, 7, 8, 9, 10, 13, 14, 18, 20, 21, 23, 24, 25, 30, 38, 46, 47, 48, 132, 133, 134.

Second Room, 3, 5, 11, 12, 26, 27, 29, 31, 32, 37, 39, 40, 45, 52, 142, 143, 144, 145, 146, 147, 148, 149, 150, 151, 152, 153, 154, 155, 157, 158, 159, 160, 161, 162, 163, 164.

Dining Room, 140, 165, 166, 167, 168, 170, 171.

Red Velvet Room, 15, 16, 17, 19, 22, 36, 41, 42, 49, 51, 53, 54, 55, 56, 123, 126, 131, 136, 137.

Staircase Landing, 28, 33, 34, 35, 43, 44, 50, 122, 130, 135, 141.

Sitting Room, 74, 75, 76, 77, 78, 79, 80, 81, 82, 125, 127, 128, 129, 139, 156, 169.

Flemish Room, 57, 58, 59, 60, 61, 62, 63, 64, 65, 66, 67, 68, 69, 70, 71, 72, 73, 121, 124, 138.

Special Gallery, 83, 92, 93, 95, 98, 99, 102, 103, 106, 107, 109, 113, 114, 115, 116.

Grand Gallery, 84, 85, 86, 87, 88, 89, 90, 91, 94, 96, 97, 100, 101, 104, 105, 108, 110, 111, 112, 117, 118, 119, 120.